Theatrical Improvisation

THEATRICAL IMPROVISATION

THEATRICAL IMPROVISATION

SHORT FORM, LONG FORM, AND SKETCH-BASED IMPROV

JEANNE LEEP

WITH A FOREWORD BY
KEEGAN-MICHAEL KEY

palgrave
macmillan

First published in hardcover in 2008 by PALGRAVE MACMILLAN® in the United States - a division of St. Martin's Press LLC, 175 Fifth Avenue, New York, NY 10010.

Where this book is distributed in the UK, Europe and the rest of the world, this is by Palgrave Macmillan, a division of Macmillan Publishers Limited, registered in England, company number 785998, of Houndmills, Basingstoke, Hampshire RG21 6XS.

Palgrave Macmillan is the global academic imprint of the above companies and has companies and representatives throughout the world.

Palgrave® and Macmillan® are registered trademarks in the United States, the United Kingdom, Europe and other countries.

ISBN: 978-1-137-29923-9

The Library of Congress has cataloged the hardcover edition as follows:

Leep, Jeanne, 1968–
 Theatrical improvisation : short form, long form, and sketch-based improv / by Jeanne Leep ; with a foreword by Keegan Michael Key.
 p. cm.
 Includes index.
 ISBN 0–230–60467–6
 1. Improvisation (Acting) I. Title.

PN2071.I5L43 2008
792.02′8—dc22 2007041188

A catalogue record for this book is available from the British Library.

Design by Newgen Imaging Systems (P) Ltd., Chennai, India.

First PALGRAVE MACMILLAN paperback edition: February 2013

10 9 8 7 6 5 4 3 2 1

For D.A.R.

CONTENTS

CONTENTS

Figures

FIGURES

FOREWORD

BY KEEGAN-MICHAEL KEY

UPON BEING ASKED TO WRITE THIS FOREWORD, the first thing that popped into my head was, "I now have to *prepare* a foreword." I have chosen to "work on" this. Work on and prepare are words not thought to be synonymous with improvisation—but words that are very familiar in the realm of theatre. I have heard from abundantly talented people over the years about how terrified they are by improvisation. Typically, the theme of these fear-filled rants is that there is no preparation. There is also the ever-present question, how do you practice or "work on" something that is by nature "spontaneous?" When I engage in discourse with actors, whether it be in a social or academic atmosphere, if I ask, "Why not try improv?" frequently the answer is, "Oh, I'm not really that funny." Throngs of actors have been paralyzed by this interrogative, when in fact it contains the biggest misconception in all of improvisation. Relationship and character are the measuring sticks by which we judge well-performed improvisation, not humor and cleverness.

In the improv community some believe, me included, that we owe a debt of gratitude to the television show *Whose Line Is It Anyway* for bringing improvisation into the purview of the general public, but paradoxically, it has cast a stigma. Being billed weekly as a comedy made it paramount that every moment of the show be filled with gut-splitting laughter, leaving any moment of equally engaging poignancy or pathos on the cutting room floor. I, for one, feel that this left an inaccurate imprint on the masses. Indeed, improvisation is mostly used to generate comedy in the arena of popular theatre, but it still remains an emotionally multifaceted art form.

I have found that students of academic theatre will often shy away from improv. Yet, the craft of starting an improvised scene is not much different than setting up an outline to write a thesis paper, which these self same students may perhaps face with a dread of labor, but not terror. Our audience gives us a thesis statement in the form of a suggestion and off we go; it's not that much different. The rebuttals to this comparison usually go something like this: but I have time to write a paper. I can't think on my feet like that!

Consider the alacrity that's used to soothe a baby when it's agitated. We all come to the rescue with time-honored coos and funny faces and peek-a-boos, and we do it with lightning speed. Also, I am sure I'm not the only one who begins to backtrack with an instant flurry of creative excuses if I've put my foot in my mouth. These reactions are products of organic social training, ergo, we as humans already know how to improvise.

Improvisation is as kinesthetic as it is mental. Reacting in the moment to what has just happened is as natural to this art form as it is to tennis. The only difference is that your brain is the racket. When one has the opportunity to feel true spontaneous connection, we inherently know something special has taken place on stage. Improvisation can help work as a barometer of what it feels like to be "in the moment," a phrase that significantly resonates with the likes of both actors and improvisers.

I always thought improvisation supplemented and enhanced my scripted theatrical work. One may ask, how can not knowing what you're doing or making it up as you go along aid you? If anything, it nurtures a lack of discipline, or negates adhering to a style of acting, or creates a temptation to paraphrase. I admit that I have witnessed these things. I have also witnessed other things.

I have witnessed actors who are impervious to mistakes. During my tenure as a graduate student at Penn State, there was an older actress whom I admired greatly. Her preparation for a role was meticulous—every prop placed just so, and her entrances from backstage seemed as choreographed and purposeful as her onstage blocking. Though I always was in awe of the emotionally mnemonic houses she constructed in order to navigate her life on stage, it seemed to me the house was made of cards. As I watched through the eyes of an improviser, I could not help but think, "What will she do if a prop falls off the table?" In improvisation a mistake is simply a gift you weren't expecting. If a set piece falls, or a line is forgotten, or an entrance is missed, it's as if so many gems have fallen in your lap. Instead of bemoaning the fact that you're ensconced deeply in the *Actor's Nightmare*, you should rejoice that this may be the only moment in your entire career to inhabit your character freely, to breathe as another, fettered by nothing, if only for a brief moment, but the coalesced mind of you and your shared creation.

I have witnessed actors become writers without them even knowing it. For what is an improviser, if not, as a few sapient men have said, an "instant playwright." I have witnessed commercial copy, theatre workshops, and countless films become infinitely better due to an improvised line of dialogue. We as an audience have been privileged enough to see a depth of character that we didn't know existed, revealed before our very eyes. One need only recall four improvised words uttered by one of the greatest known contemporary film actors of our time: "You talkin' to me?"

In the demanding world of theatre, cinema and television, it appears to me that it would behoove every actor to put a new club in their bag, if you'll pardon my allusion to golf. Perhaps it would benefit the formally trained actor to think of nonscripted material as simply another facet of a bigger art form we know, simply as acting. As a "formally" trained actor I have had the privilege of studying the venerable sub-form known as *Commedia dell' arte*. This progenitor to our modern day forms, which will be discussed in this book, was one of the most popular performing art forms of its day. We consider *Commedia dell' arte* to be a style of acting. I would invite any and all, to consider it a skill. Each show was held together by a mutual understanding of character and given circumstances, between the players. The palpable cohesion, then and now, comes from a universal set of rules under which we play. In the world of improvisation, knowing the rules is tantamount to knowing your lines. It seems one should know the rules of a game in order to know how much skill it takes to play the game.

Keegan-Michael Key holds a Bachelor's in Fine Art from the University of Detroit-Mercy and a Master's of Fine Arts in Acting from The Pennsylvania State University. He is one of the founding members of the Planet Ant Theatre in Hamtramck, Michigan, where he has directed several productions. In 1999, he wrote the interactive play *Big Mama's Wedding*. He has taught at the University of Detroit, Second City Training Center, ImprovOlympic West, Mosaic Youth Theatre, and Wayne State University. Key is a member of the Actors Equity Association, Screen Actors Guild, and The American Federation of Television and Radio Artists. He was also a contributing essayist to *The Second City Almanac of Improvisation* by Anne Libera. A Detroit native, Key got his start in comedy at Second City, the premiere improvisational company in North America. He was a company member and writer first with Second City–Detroit and then with Second City e.t.c. in Chicago. While working in Chicago, he was nominated for and won a number of Joseph Jefferson Awards, which honor excellence in Chicago theatre, for his work in revues such as *Holy War, Batman!* and *Curious George Goes to War*. Key joined the cast of MADtv in January of 2004 where he created memorable characters such as Coach Hines, Dr. Funkenstein, and the "Whole 'notha level" guy.

ACKNOWLEDGMENTS

I WOULD FIRST AND FOREMOST LIKE TO THANK THE MANY PRACTITIONERS OF IMPROVISATION I interviewed for this project. Keegan-Michael Key, Ron West, Margaret Edwartowski, Charna Halpern, Nancy Hayden, John Sweeney, Joe Janes, Antoine McKay, and Cherri Johnson. Thank you for your time, interest, and extensive creative thought on this project. I would also like to thank the efforts of Clifton Highfield and Chuck Charbeneau for their e-mail interviews, and Pete Ryberg for his interview on Mercury Theatre.

I am in particular debt to the members of River City Improv, past and present, for not only their interviews, but also their support and encouragement of this project. I owe a huge debt to the past and present members: Leah Carpenter, Bob Dekker, Judi DeJager, Christopher DeJong, Beth DeVries, Michele Dykstra, Todd Herring, Marc Evan Jackson, Kirsten Kelly, Tracey Kooy, Adam Mollhagen, Wendy Nance, Dave Noe, Mary Jane Pories, Melissa Rozeboom, Russ Roozeboom, Mike Ryskamp, Matthew Sahr, Teresa TerHaar, Davy Tyson, Kiff VandenHeuvel, Nate Vandenbroek, Jeff VanHaitsma, Joel Veenstra, Dan Voetburg, Marty Wondergem, and especially my co-monarch and current supreme tsar Rick Treur. This group of highly talented and creative individuals is responsible for my never-ending love of improvisation and has often renewed my passion for improv when the tedium of the research wore me down. This book would not exist without all of them.

Thank you to Keegan-Michael Key for not only writing such a thought-provoking foreword, but also engaging me in such lively discourse on the art of improvisation throughout this project.

I would like to gratefully acknowledge the help and support of my mentors, Dr. Blair Anderson, Lavinia Moyer Hart, Dr. David Magidson, and Dr. Phoebe Mainster, for their assistance, advice, and encouragement on this research adventure. Thanks to Gillian Eaton and Cynthia Blaise for their support of this project and my abilities. Special thanks to Dr. Melanie Herzog for her advice, encouragement, and wisdom on everything related to publishing. Special thanks to Julia Melzer for her beautiful designs,

photography, and patience. Thanks to Becky Rice for her deeply organized help with permissions and faxes. Thank you to all my colleagues at Edgewood College for their support of this research for the many years it has spanned. Thank you also to my mentors and colleagues from Calvin College, and particularly to Michael Van Denend who saw the potential for partnership with River City Improv since it began.

Thank you to great people at Palgrave Macmillan for publishing this book—to Farideh Koohi-Kamali, Julia Cohen, Kristy Lilas, and Brigitte Shull especially for their help and to Oscar Spigolon for the cover design. Special thanks to Maran Elancheran from Newgen Imaging Systems for help with editing and corrections and to Katjusa Cisar for help with proofing.

I would especially like to thank Deena Conley, Marijean Levering, Stephanie Lincecum, and Amy Lane whose friendship, advice, laughter, and encouragement has kept me going when the journey seemed impossible.

Thank you to all my students, past and present, who have embraced the improvisational spirit that infuses all my classes. Thank you for not dropping. Be not afraid.

I would also like to thank my family—my parents, my siblings, and their families, as well as all the Leeps and the Toths and those related—for their support of my crazy life in theatre.

And most importantly I would like to thank David A. Raagas for his love, encouragement, support, and patience over the many years this project has spanned. I dedicate this work to the man who knows more about dedication than anyone I know.

CHAPTER 1

THEATRICAL IMPROV IN PERFORMANCE

IMPROVISATION REMAINS A DIFFICULT TERM TO DEFINE IN THE THEATRE community, as it means different things to different theatre artists, all of whom might claim, and rightly so, to use improvisation in their work. To some improv means spontaneously creating bits, like stage business, within a performance of a previously written script. To others improv is a tool or an acting methodology used to help actors in the rehearsal process find a route into the characters they are playing. A large population of audience members would recognize a "night at the improv" as a review of stand-up comics where an occasional off the cuff comment to the audience mixes with a finely polished routine. Improvisation is seen by others to be "theatre games" that can be played in front of an audience with amusing results. Taking this step further, other groups see improv as the ultimate ensemble work, creating a spontaneous connection with the other players on stage during unplanned scene work. To still others improvisation is a hybrid of this ensemble work where the unplanned scene work is performed, transcribed, and then polished for performance.

With all these theatrical definitions attached to one word, much has been written about improvisation in the theatre, particularly as a teaching tool for the actor. The trend to use improvisational games as tools for actors working on characters for performance in the rehearsal process started with contemporary improvisation pioneers like Viola Spolin and Keith Johnstone and certainly informs the perspective of this book. This study, however, aims to compare and understand those forms of improv that have evolved beyond a tool for the actor in rehearsal or process drama for social/individual change, and have emerged on the theatre performance stage itself. Certainly there are many improvisational groups (the socially charged work done by Augusto Boal, for example) that seem to cross the boundaries of improv as

performance and improv for social change. The parameters of this study have been set by looking at improvisational groups that 1) use improvisational forms of performance, 2) are performed primarily by actors with input from the audience primarily coming in the forms of suggestions rather than actions, and 3) are performed by groups whose primary goal it is to entertain and engage the audience through humorous or thought-provoking entertainment.

WHAT'S BEEN SAID

It seems deeply non-improvisational to look critically and analyze the world of improvisation in theatrical performance from a scholarly point of view. After all, improvisation in theatre, according to Adam McKay in his tongue in cheek analysis of improvisation in *The Second City Almanac of Improvisation*, "is an art form so simple and visceral that often people show up for performance with a six-pack or wearing a referee shirt. That's pretty raw" (Libera 108). In fact, much of the world of improvisational theatre has been relegated by some academics to the equivalent of warm up exercises, charade like games, or "garage band" type performances. Yet, this area of performance thrives and grows, and these small local groups provide creative innovation that later can be tapped by more well-known and therefore respected companies like The Second City.

Despite the small number of scholarly works devoted to improv, much has been written about it. There are basically three types of improvisational books and articles available: the *how to*, the *what is*, and the *history of*. The *how to* category contains books and articles explaining the ins and outs of improvisation as a performance, creating a guide for readers who feel they understand the art to some degree and now want to do it or get better at it. An excellent example of this style would be *Truth in Comedy* by Charna Halpern, Del Close, and Kim "Howard" Johnson, which is a written manual in a workshop format of useable improvisational techniques for performance, culminating in an explanation of how to perform ImprovOlympic's then signature long form improvisation, the Harold. Likewise, veteran improvisational performer Andy Goldberg wrote a manual of improv in short form performance called *Improv Comedy*. This book neatly explains how to put together a working improv troupe and addresses some of the very fundamental questions regarding how to put improv on stage. Mick Napier's *Improvise: Scene from the Inside Out* takes a more advanced look at a system of improvisation and shows improvisers how to take an improvised scene beyond a basic analysis. Napier offers solid *how to* advice on creating a successful scene on stage by analyzing the good and the bad of the rules of improv and offering interesting and useful ideas to grow beyond them.

Some *how to* books are primarily comprised of improvisational exercises, like Spolin's groundbreaking work *Improvisation for the Theatre*. Spolin's games, while not necessarily intended for performance, laid the foundation for other *how to* improv books. Such is the case with *Theatresports Down Under* by Lyn Pierse, which is an excellent manual for short form players and explains everything from how to form a Theatresports team to how to play specific games in performance. Theatresports is also the topic of Keith Johnstone's *Impro for Storytellers* and provides notes to performers of Theatresports, breaking down various categories of improv on stage and addressing how to avoid pitfalls of performance.

The *what is* category might be where those same fans of the form started their reading, as these books explain the nature of improvisation in a philosophical sense, showing a difference between the art of improvisation in the theatre and a straight play. Such is the case with Johnstone's 1979 first book, *Impro*, which explains his philosophy of spontaneity in addition to providing exercises to use in workshop. While this book also contains a bit of *how to*, it is much more theory based than his newer, more practical *Impro for Storytellers* published in 1999. Not all books in this category contain a combination of *how to* and *what is*; *Improvisation in Drama*, by Anthony Frost and Ralph Yarrow, outlines who some of the major improvisational groups are in drama, what these groups are doing, and why they use improv. This category also contains larger comparisons of improvisation in all the arts, such as *Improvisation, Hypermedia and the Arts since 1945*, by Hazel Smith and Roger Dean. This book takes a scholarly look at comparative improvisation as it grows in the arts, adding a medium to an existing improvisational form to create a whole new form. Because it covers all the arts, it does not spend much time in the realm of improvisational theatre, however. While these types of books are handy to better understand the development of improvisation, they leave the practitioner to pick out useable nuggets of wisdom to apply to their art. Likewise, the *how to* category can be short on explanation of why improvisation in performance is important, as they are often written by enthusiastic practitioners of the form who do not see the need to preach to the choir.

History of books have often looked at one individual company or style such as Theatresports, The Second City, or The Compass and trace the history of that particular group's development or how one group merged into another. Such is the case with *Something Wonderful Right Away, an Oral History of The Second City & The Compass Players*, by Jeffrey Sweet. As actors from The Compass helped form and joined The Second City, their histories became intertwined, making this book a blended history of two groups. Janet Coleman's book, *The Compass*, takes Sweet's work one step back, focusing on the formation of the theatre that later became The Second

City. Other books, like Sheldon Patinkin's *The Second City, Backstage at the World's Greatest Comedy Theater*, look at a particular troupe from a blended perspective of chronology and star performers who dominated an era of performance. The 2004 *The Second City, an Almanac of Improvisation*, by Anne Libera et al., provides an interesting sampler of information on how The Second City develops and creates their shows. With 29 contributing authors, this truly is a useful almanac of *how to* and *history of* that provides the reader with a sense of how The Second City has used improv to create their shows, while analyzing the other elements that make their style great—such as actor training, ensemble work, and directing at Second City. In *Something like a Drug, the Unauthorized Oral History of Theatresports*, Kathleen Foreman and Clem Martini utilize an interview format to chronicle the development of Theatresports as well as address issues in their form such as gender on stage and differences in Theatresports practices. An interesting scholarly work on the growth and culture of improvisation, Amy Seham's thought-provoking book *Whose Improv is it Anyway? Beyond Second City* looks at the development of several improvisational theatre companies with a focus on "gender, race and power in improv comedy" (xi).

While all these writings are extremely valuable for understanding improvisational theatre, very little *comparison* of styles, forms, histories, and companies has been written about this growing art. This book will do that by looking at the dominant forms of improvisation in performance and by looking at local and national companies that participate in these forms.

IMPROV FOREST OF THE ARTS

Improv, of course, is not restricted to theatre alone. Music, dance, film, and the visual arts all have improvisational areas. If we think of all the arts that use improv as a forest, each of these art forms would have a tree, or perhaps group of trees. One tree is planted closely to another improv tree; a music tree is near a theatre tree, with dance and visual arts trees nearby. They start as individual things, but as they grow and develop, their branches intersect and intertwine, creating even more complicated performance events that use more than one improvisational art source. Part of the beauty of a thick forest canopy lies in the overlapping of trees, creating in their intertwining branches an almost indistinguishable ceiling of leaves. If one really wants to know how these canopies are formed, one must carefully follow trunk to limb, then branch to leaf of several trees to see where they intersect. And then, eventually, it is quite possible for the trees to cross pollinate and evolve into something new.

If we think of performance improvisation in theatre as a single tree, the same intertwining of branches occurs within the single art form of improv, this time from a shared trunk. As shown in figure 1, the different purposes

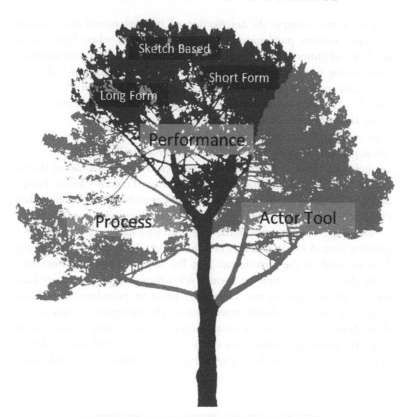

Figure 1 Improv Tree

of improv in theatre create three separate large branches: 1) improvisation as performance, 2) improvisation as a tool for the actor, and 3) improvisation as process drama or a tool for nonactors. As these different aspects of theatrical improv grow, the three intertwine at times and at other times sprout in a whole new direction, sometimes intersecting with each other. So, at times, Augusto Boal's socially charged theatre games might take on a performance nature, as the process drama for social change intertwines with the improvisational performance. Sometimes a character exercise, not really meant for an audience but as a tool for actors working on a play, can be so engaging it appears to be improvisation for performance—and maybe it is for that one moment. Certainly many improv performances have stemmed from a Viola Spolin exercise for the actor not truly intended for performance.

Like a tree canopy, the intersection of improvisational styles occurs naturally, without preplanning. A tree senses a space where light can be reached and grows to fill that space. The end result is a beautiful matrix of intertwining foliage. Likewise, improv in performance has reached to fill the vacant spaces in theatre, and new limbs have grown from the existing branches. A new canopy is developing and growing in the theatre community where the forms of improv in performance sometimes blend with improv as actor training or improv as process drama. The trend of 24 Hour Theatre, where plays are written, rehearsed, and performed in 24 hours, serves as an example of a blend of performance improvisation and a traditional theatre experience. Also, theatre companies like the San Francisco Mime Troupe and The Tectonic Theatre Project use some improvisational elements when creating new works—furthering the reach of the improvisational limbs.

The huge, old improvisational tree may well have lots of other trees growing around it that appear to be similar and might have, in fact, sprung from the seeds of the performance tree. But improvisation in performance is the oldest, largest trunk from which other theatrical improvisations have sprung. On that ancient tree a long limb has three branches—short form, long form, and sketch-based improvisation. The metaphor of a tree is used throughout this book, as one area of improvisation branches into another and cross-pollinates, making the entire art form grow and change. But in order to understand how the improv tree grows, it is important to understand its roots.

BRIEF HISTORY OF IMPROV IN PERFORMANCE

Comedians, be they performers or writers, have known about "the rule of three" for centuries. This rule states that funny things come in threes for no good reason other than the unproven fact that three entertains an audience better than two or four (*Truth* 89). Likewise, for no particular reason, improvisation in performance has followed this rule by natural comedic evolution. The forms of improvisation as performance fall into three variations: short form, long form, and sketch-based improvisation, all of which have sprung from a common history of performance, and then branched into more distinct categories.

Improv as performance has a long history in Western theatre prior to modern times. Aristotle reported that tragedy and comedy at first were presented in improvisations, as spontaneous creation of the moment, presumably with no script and little planning (33–34). Beginning in ancient Greece and Rome, in approximately 300 BC, actors began creating tales with mythological and domestic themes. These actors were called mimes, which are not to be confused with our current use of the word "mime"—a silent clown who

uses no tangible props to create an invisible yet tangible presentation. These ancient mimes spoke and were highly skilled in performance techniques of stage combat and acrobatics. Actors in the earliest Greek form were called *phylakes*, which means gossips. Their work was farce-like and probably highly physical, as they took myths and made them farcical and familiar. Hercules was a favorite of the *phylakes*, as was the motif of love and other relationships between the sexes. This popular theatre coexisted with the more formal classical theatre of Greece and later with the many entertainments of Rome. In Greece, the *phylakes* wore the same costumes as the Attic comedic theatre. Later, after the Romans conquered Greece and embraced much of their culture and religion, the *phylakes* in Rome remained servants of the Dionysiac cult and thus retained their costume of Greek comedy, complete with short vest, tights, and phallus in place. These performances used a stage platform that could be set in any available space, and became the forerunner of the modern raised stage. These early mimes played stereotypical roles (the lover, the quarrelling couple, the strong man, and the servant), took a familiar plot, and created the dialogue as they went along, hanging the dialogue on the familiar frame of the plot (Bieber 129–146). As the Roman Empire grew and entertainment delights flourished, the ancient mimes evolved into a new form of mime, notorious for its lack of prudent behavior on stage. As the mimes became more scandal ridden, and the rise of Christianity in the Roman Empire took hold, the art of mime once again changed with the times. Companies toured in Europe, making their meanings clear with artful mimicry (Duchartre 25). All Roman theatrical art forms struggled to survive in the shadow of the Christian Church, which found much immoral in the heritage and performances of the mimes; but the human need for storytelling is impossible to repress, and the comedic performances of old were reborn in the arms of the Bible stories of the Catholic Church. Reworked for the largely illiterate congregations, the familiar characters of old comedy were renamed and tacked onto the story of salvation. The use of theatre as a tool to teach Christianity grew over several hundred years from short, literal reenactments of scripture dialogue during mass to the main event at festivals outside the church with the entire community involved in the pageant. Examining the scripts from these plays reveals the same stock characters layered onto to the familiar Bible stories. Sampson is now the strong man, Noah and his wife are now the quarrelling servants, etcetera. They also show that "script" is a lose term, as often these texts imply unscripted physical action or at times interaction with the audience. And despite their serious purpose, they are full of humor and irony, clearly geared to be performed, not read. These Bible stories eventually morphed into morality plays where an original story was told that had a Christian moral at the end, greatly expanding the number of scenarios available for performance.

As the renaissance dawned, the theatre of mime came back into vogue, and a new art emerged from the traditions of old—the *Commedia dell' arte.* The *Commedia dell' arte* built on the traditions of the ancient mimes to develop new forms for the newly enlightened audiences. All members of the company would know a plot and each actor would play the same part at every performance, creating stock characters that eventually became so well-known they earned their own names. A company included a number of stock characters, including the young lovers (Inamorati), the maid (Columbine), the gossip (Ruffiana), the old father (Pantalone), the doctor (Dottore), the captain (Capitano or Scaramouche), and several variations of clowns (Harlequin, Scapino, Pulcinella, and Pierro to name a few). All the performers would know the basic plot, but the details and the lines of the performance would be created on the spot for each performance (Watson 100–102). To make a modern parallel today, a well-known story like Cinderella has certain scenes that most everyone knows. If a *Commedia* group did Cinderella, each member would know the order of those scenes, but the exact words and physical business of the wicked stepmother as she tells Cinderella that she is not going to the ball might change in every performance. Likewise, everyone in the company knows that the prince and Cinderella meet at the ball, but exactly what they say and exactly when they dance might change from show to show. This allowed for changes to be made that would tailor a performance to a particular audience and included references to local information. Indeed, as a populist art form for the masses, *Commedia* may have been used to entertain as well as provide an identity to the lower-class audiences who primarily attended it (Watson 103).

A *Commedia* show included a great deal of physical comedy, from acrobatics to mock fighting. Dialogue at times could be unnecessary because of the physical business, or *lazzi*, used in a performance (Duchartre 36). In fact, the term slapstick is named for the device used to hit characters in *Commedia*, which made a loud sound without inflicting a great deal of pain. While much in the productions may have been physical, the stories grew from situations well known to the lower classes and often reflected their opinions toward the aristocracy (Watson 100). This in turn created the opportunity for a bit of social satire, creating not only an identity for the audiences but also a medium to reflect the values and ideas of those in attendance—in short, making their work seemingly more truthful to any particular audience. This art form had broad appeal and survived as a populist form of theatre while other more scenically splendid forms flourished at established Italian and French theatres. Like the ancient mimes, the *Commedia* troupes could perform nearly anywhere, as they merely set up a platform to create their stage. While much is made of the performers' improvisational skills, Duchartre reminds contemporary readers that the

companies contained actors who could perform comedic pieces as well as regular written plays (29). So *Commedia* actors were just that—*actors* who became famous for improvisational work, but who also were familiar enough with regular theatre to present scripted work. As the actors themselves combined the talents of traditional acting and improvisation acting, the idea of *commedic* elements intertwined with scripted material and began to take hold as the popularity of *Commedia* groups grew. *Commedia* troupes toured widely outside of Italy, with their influence felt in Germany, England, and France. France embraced the traditions of the *Commedia* most heartily—despite some disputes with foreign-speaking troupes—and their physical humor gained popularity with Parisian audiences. Moliere, who borrowed characters and scenarios and inserted them into his own masterful plays, created a permanent record of the stock characters so familiar to audiences of that time. In fact, Moliere thought the *Commedia* actors to be fine examples of natural acting and used comedic techniques in training actors in his own troupe (Duchartre 99). And while Moliere may have borrowed comedic techniques and characters most directly, the influence of *Commedia* spread throughout Europe. The Germanic people had their version of a *Commedia* clown called Hans Sachs, and England's street performers and puppeteers developed Punch and Judy based on *Commedia*. Moliere was not the only playwright to borrow *Commedia* characters, as Duchartre notes, "Shakespeare made the acquaintance of Pantaloon, and spoke of him in *As You Like It*" (80).

The influence of this golden age of improvisational performance continued to trickle through theatre history until modern day, when improvisation experienced a revival as performance. The stock characters derived from the *Commedia* characters can still be seen in many modern plays as well as modern sitcoms—the lecherous old man, young lovers, conniving or bumbling servants, and side kicks. But perhaps the most enduring elements of the *Commedia* and the history that produced it are of the mix of social satire, physical comedy, and entertainment for the masses.

Today improv is used for a variety of purposes, but if we look at the various forms of improv, the oldest of these is improvisation in *performance*—not an acting tool for spontaneity or a way to develop a character. The idea that an audience can be enlightened and entertained with a spontaneous performance is nothing new; however, devising training techniques that tap into that spontaneity as part of formal actor training is considered modern.

Perhaps the first person to devise a system that formally incorporated improvisation as part of actor training and to write that system down was Konstantin Stanislavski. Rightly famous as an acting teacher, director, and actor, Stanislavski used improvisational techniques to help actors better

understand the characters they played. His methodology encouraged actors to think, for example, of what they would do *if* they were the characters:

> Truthfulness is the blending of all your powers and thoughts with your part through the little magic word "if." For it is only when you have achieved the fullest possible harmony within yourself that you are able to merge truthfully through that word with the character you are representing.
>
> The rhythm of your heart has assumed the rhythm of your hero. Your thought tells you, "if I am Raskolnikov, what will arouse fear in me?" And by a process of the deepest possible self-analysis, you try to establish those of your organic qualities which you could project into the conditional circumstances of your part so that the force of your attention should isolate only a certain scene from Raskolnikov's life. (Stanislavski 189)

He also reawakened the idea that the action on stage was as important as the words spoken—perhaps linking modern theatre to *Commedia lazzi*. Stylistically, Stanislavski's aim was a far cry from the fast paced, energetic, and seemingly caricature-like acting of the *Commedia*, yet both styles were aimed at finding the truth of a performance and making that message clear to the audience. Stanislavski encouraged actors to pay attention to their given circumstances, to use their own emotional memory to help understand a character, and, most importantly, to use their imagination. He was famous for saying that if an audience wanted to see the text, they could read it at home—it was the subtext they came to see (Moore 28).

At first glance, it would appear that Stanislavski had more to do with traditional acting methods than with improvisation. And that might well be true. But while his works might be remembered for their realism and their naturalistic action, he also unleashed the power of imagination applied to the art of acting. The idea that acting was a conscious means to the subconscious, and that verbal action depends on physical action rippled through the theatre world. Stanislavski applied improvisation to theatre, and while he was not the only person to do so in his time, he extended the most influence not only because of his writings, but also because of his students who also wrote their interpretations of his ideas. Vsevelod Meyerhold, his contemporary, invented a system of groundbreaking physical and visual techniques that applied movement to the theatre. While his work was important at the time, and is still studied for its influences, Meyerhold's inability to adapt to the political climate of his own time cut short his work. Stanislavski remained flexible during times of political chaos, adapting both his acting system and his moderate political views to survive. In short, he improvised in life as well as in theatre. The system Stanislavski created was something he did not dictatorially impose on others, rather he encouraged new companies and new actors to find their own system. With this encouragement to tap

into one's own creative powers, an avenue was opened for what has become contemporary improvisation in performance.

Improvisation as performance has moved into the modern mainstream of theatre circles since the late 1940s when Viola Spolin began her work with the Young Actor's Company where she cultivated her theater games. Her son, Paul Sills, enrolled at the University of Chicago in 1948 and soon began using his mother's theatre games in his theatrical work. Later he developed this into The Compass, which in turn evolved into The Second City. Not long after that, in the mid-1950s, Keith Johnstone began his own theatre games, first for education, then for actor training in England. Both Spolin and Johnstone were working independently of each other, but both were attempting to create a method of spontaneity. Both first used children and later applied the ideas to adults. While Spolin did not create the Compass Theatre or The Second City, she is called the high priestess of improv by Compass historian Janet Coleman, as virtually everyone associated with those theatres at that time acknowledged the influence of her approach to theatre on the growth of their theatres (Coleman 23).

Johnstone began working as a teacher, then as a play reader, then as a developer of new plays. His ideas on spontaneity became well known with the publication of his book, *Impro*, still used by many as a handbook for acting and highly influential in the development of Theatresports. But Johnstone did not stop creating with the publication of the book in 1979. He writes in his latest book, *Impro for Storytellers*, that he was searching for a new way for theatre to attract an audience with all the passion and enthusiasm of a sporting event (1). Soon after, he developed Theatresports, which has become an international phenomenon with teams in Canada, Denmark, the United States, Australia, Norway, Holland, New Zealand, Germany, France, and the United Kingdom. Like Spolin's work, Johnstone's writings and message spread quickly in the theatre community, and as Theatresports has spread throughout the world, his ideas of spontaneity and improvisation have also inspired new forms of improvisational theatre. For example, Yellow Man Group from Japan cites Johnstone as one of the main influences in the formation of their improvisational group, although they do not consider themselves primarily a Theatresports troupe (Kinugawa 1).

CONTEMPORARY FORMS OF IMPROVISATION

Improvisation in the second half of the twentieth century has developed into three forms, but it began with one form—Spolin's theatre games. Spolin's work slightly predates Johnstone, giving her the edge on the first modern form to be developed. Her initial work was as a director of straight plays for and with children. Through this work, she developed her own directing

system that turned the rehearsal period into a series of games. She developed a theatre game to conquer almost every problem a young actor could have—from vocal volume issues, to lack of emotion, to an inability to move freely in the space of the stage. While she solved these problems, she also unleashed a creativity in the actors that later inspired them to create their own plays. Coleman writes of Spolin's early work in Chicago where the text for a play was improvised from the day's newspaper (30). These techniques helped actors develop a sense of self on stage, as well as the ability to understand the beats of a scene. Her son, Paul Sills, applied these ideas to his work at The Compass. Later, her improv games were used in the development of The Second City. Both of these theatres used improvisational techniques in the development of a script, which was eventually transcribed in order to be performed in a similar manner for different audiences night after night. The material was fresh and timely, relevant to the late 1950s and early 1960s in America (Patinkin 2–13). The adaptation of improvisational forms in rehearsal to eventually create a scripted piece is, in this study, understood as sketch-based improv. Here, the actors are essentially the playwrights, perfecting the sketches in rehearsals and sets until it is complete enough to be transcribed. A "reverse" playwriting process, this method makes the entire ensemble the writers of a show.

Johnstone, in his quest to create a theatrical sporting event, turned his creative energies to a fast-paced and mildly competitive theatrical event where teams of actors would compete in short theatrical games. These games have come to be known as short form improv, though they are also called "spot improv" or "handles." Here, actors take a suggestion from the audience and apply it immediately to a scene and are, so to speak, put on the spot to create an instant sketch.

Long form developed over time and combines elements from sketch-based and short form improvisation. Developed by Del Close and Charna Halpern, long form seeks to create a complete evening of theatre based on audience suggestions by getting a theme and creating scenes that are revisited in the course of the form. Eventually, the intent is that the scenes will tie together, creating a complex, thought-provoking, and entertaining show that interweaves material from start to finish. More importantly, this form creates a spontaneous link between the performers and the audience as all know the performance will never be repeated again. While every live theatrical play is never quite the same twice, long form pushes the extreme of that rule, creating a unique show nightly (*Truth* 133–147).

All three forms share not only their origins but also some techniques. These techniques can be divided into three categories: warm-up games, exercises, and performance games. Warm-up games and exercises are not usually intended for the public view. Warm-up games break the ice

and help create energy and focus. Exercises, like most of Spolin's games, are designed to help develop a specific element in improvisational acting. Performance games are the scenarios and sketches that use audience suggestions to create a short performable scene for an audience. While sketch-based and long form do not on the surface seem to use performance games, these games are the basis of what they are and are interspersed throughout the work.

"RULES" OF IMPROVISATION

While improvisation and rules seem incompatible ("you just make this stuff up, right?") all forms of improvisation in performance share some specific rules. It is a popular misconception among those who have never performed improvisation that it does not have any rules at all and is simply wandering on stage having a good time. A new member of River City Improv explained her beginning experience with improvisational theatre: "I just joined River City Improv last July. And I thought I knew what improv was, but it's not what I thought it was at all. And it is not easy... I thought it would be really easy, just joking around. But it is more [...]. And that's made me somewhat more persistent to succeed at it" (RCI personal interview). This new member identifies the passion many improvisers feel when beginning to understand the techniques employed when performing improvisation. In fact, that addiction to the energy that improvisation on stage creates between performers and audiences became the title of at least one improv book: *Something Like a Drug, the Unauthorized Oral History of Theatresports*, by Kathleen Foreman and Clem Martini. Because improvisation doesn't always work, when it *does* work on stage, it creates a desire to replicate that feeling of success. The rules developed to help improvisers get that successful feeling, or improvisers' high, more quickly and effectively.

How rules are learned in improv is a bit controversial. Some improvisers maintain that one doesn't need to know these rules before starting to improvise, as these are discovered along the way, naturally, from the work itself. Other improvisers maintain that much time can be saved if new improvisers understand the basic rules of improvising before they begin. Regardless of when these rules become known to new improvisers, some guidelines exist as to what helps improv work well on stage. These rules can be divided into four categories:

- The Why, or the focus and goal rules;
- The Do's, or the "yes and" rules;
- The Don'ts, or blocking rules;
- The How, or the justification rules.

The Why: Focus and Goals

This category asserts that, first and foremost, truth is funny. Andy Goldberg, author of *Improv Comedy*, put it this way: "You can be as extreme as you want. You can play anything you want. As long as you treat anything you do on stage as reality for that moment, the audience will believe you. You can become a toaster if you want to, as long as you behave like a toaster would in the given situation" (Goldberg 19). If the idea that truth is funny is the focus of improvisational theatre, then the goal of improv in performance is tight ensemble work. Therefore, the second element of this rule maintains that it is the job of an improvisational actor to make his or her partner look good (*Truth* 43). In fact, this is something the historical *Commedia* actors understood, as Duchartre reports of the improvisational actor-author Riccoboni, who wrote in his *Historie du theatre Italien* in 1728:

> ...For the drawback of improvisation is that [for] the success of [the] event, even the best actor depends upon his partner in the dialogue. If he has to act with a colleague who fails to reply exactly at the right moment or who interrupts him in the wrong place, his own discourse falters and the liveliness of his wit is extinguished. (Duchartre 32)

If both actors in an improvised scene strive to make the other performer look his or her best, both actors appear to be more clever and talented than they would if one were pulling the other through the scene by dominating the conversation and upstaging his partner. These two assumptions dominate this category of rules, but there are a few others that apply to improv's focus and goals as well. Simplicity is key in creating a clear, solid improvised scene. Too much information or too convoluted of a plot idea creates confusion for the actors on stage, and therefore the audience.

Also, committing to the physical nature of improv early in the process is a tremendous asset. As Stanislavski recognized the importance of the visual clues actors provide to an audience for the subtext to be understood, likewise, improvisational actors can communicate not only the subtext but also an entire text without the use of any words at all. Verbal wit and quick responses are necessary, but so is physicality—to literally jump into a scene.

Finally, learning from others is a universal aspect of improvisation, and this involves listening. Ensemble work should create an atmosphere where everyone involved is feeding off the talents and skill of others by listening and truthfully responding to what has been said.

Do: "Yes And"

Any good improvising book or teacher will tell you an important element of creating a scene with other people on stage is the ability to accept what

has already been said and build on it. This little trick has been named "yes and" by the doers of improv for years; in fact, the corporate name for ImprovOlympic (now known as IO) is "Yes&" (*Truth* 46). *Truth in Comedy* devotes a whole chapter to the idea of agreement, stating:

> The "yes, &..." rule simply means that whenever two actors are on stage, they agree with each other to the Nth degree. If one asks the other a question, the others must respond positively, and then provide additional information, no matter how small: "Yes, you're right, and I also think we should..." Answering "No" leads nowhere in a scene. (*Truth* 46)

Outside ImprovOlympic, this rule has acquired different names including "agreement," "accept and build," or "forward the action." The idea remains the same regardless of the name, which is that each player will create a more interesting scene when they reflect each other's ideas rather than force their own ideas onto a scene. When this rule is followed, it creates a situation where improvisers feel empowered to believe there are no bad ideas. If each idea is furthered and committed to, each idea has the potential to become something great.

Don't: Blocking

If "yes and" is the thing to do on stage, then "blocking" is the thing to avoid. A foil to the idea of "yes and," blocking in improv can be defined as anything that inhibits the scene from going forward. Denying the reality created by your peers, forcing your own ideas, saying no to an idea on stage, or, just as bad, saying "yes, *but*" are all forms of blocking. Milo Shapiro, creator of IMPROVenutres.com relates an excellent story of a block: In 1991, he auditioned for an improv performance group; part of the audition included the standard improvisation game, Freeze. In this game, two players act in a brief, original scene, and at any time a third player can stop the action by yelling "freeze." The players who start the round remain frozen as the new person tags one of them out and takes the same physical position and then begins a new scene most often about a completely unrelated topic. At this particular audition, Shapiro witnessed many auditions at mixed levels. He explains what happens:

> "Fred" freezes a scene, taking the place of a young man who had one hand outstretched in the air. His character has his back to his fellow scene mate, "Pete." Fred says nothing, so Pete starts the scene for him by saying, "Say, could you pass me down one of those cans of peas on that shelf you're reaching?" Fred replies, confidently, *"How* could I do that? I'm a *statue!"* (Shapiro 1)

This story illustrates how Pete's offer, "can you pass one of the cans of peas?" is neatly blocked by a denial of the reality that Pete had already established. The first player to either speak or form scenic elements with gesture establishes the reality, and it is the next person's job to further that reality. When a player responds as Fred did in the above situation, it forces Pete to either deny the reality he already established or continue with his own reality that would be working in denial of Fred's. Fred's kind of response, which does not agree with what was said, and does not build on what was said to further the scene, creates a confusing scene that goes nowhere. Del Close mentions this rule in his interview with Jeffrey Sweet in *Something Wonderful Right Away*, "Don't deny the verbal reality. It's said, it's real. 'What about our children?' 'We don't have any.' That's wrong. Same is true with physical reality. If another actor physically establishes something, it is there and you mustn't do anything that says it's not there" (Sweet 141). In *Truth in Comedy* that Close cowrote, the origins of this story appear. Apparently Close was on stage with Joan Rivers when that bit of dialogue came up. Close asked about the children, Rivers denied having any, and Rivers got a huge laugh from the crowd, but at the expense of building the scene (*Truth* 48).

This brings up another large "don't" in improv—don't make jokes. Going for the quick funny might get a performer attention on stage, but it works against the idea of ensemble, and often at the expense of the reality of the scene. Improvisers are quick to point out that improvisational comedy is not the same as stand-up comedy. Detroit improviser and Second City director Nancy Hayden describes this rule as an outcrop of why people improvise at all: "It's why you are there to do it. If you are there to create interesting scenes, or if you are there to be 'hey look at me I'm jumping up and down telling jokes!' I think *that* is a hell of a lot more work. The jumping up and down telling jokes thing. You might as well just go and do stand-up" (personal interview).

Another element of the "don't" rule is to avoid questions within a scene. This rule has some flexibility as there are games that require questions and scenes that do the same. But when a scene starts with player one asking "Where do you want to go?" he has established nothing. Player one has essentially dumped the entire scene building on player two, whose response will actually set some parameters of the scene. Questions don't build a scene, they put it in neutral and hinder its ability to grow, therefore subtly blocking the scene. Like all rules in the arts, sometimes the rule of "no questions" is broken with phenomenal results. One such example is the question game, where players are only allowed to ask questions in the scene. But as a rule of thumb, starting with questions in an improvised scene does not further the action.

Another rule that can help avoid a subtle block is the "no strangers" mantra. Scenes that start with two strangers must spend more time establishing

who these people are and what they are doing. If two players start a scene and pretend to know each other, they have already furthered the scene by skipping the formalities of getting to know each other. This, like the "no questions" rule, is certainly flexible. Many fine scenes have begun with two strangers—be they in a fast food restaurant or on a park bench. But creating characters that know each other helps avoid blocking because agreement is already established as the actors have agreed to know each other and therefore have a past history of some kind on which to draw.

How: Justification

The final group of rules is the "how do we do this well" or the justification rules. This group is a collection of ideas that have helped improvisers further action beyond "yes and" and "don't block." Early improvisers understood the necessity of this rule; Close reports it was Compass member Elaine May who said, "the actor's job is to justify" (Sweet 142). This category is a collection of rules and ideas that help the actors of improvisation quickly justify the action at hand. If it is the actor's job to justify, then the experienced improviser knows that, if everything truly is justified, there are no mistakes in a scene. Some ideas that help actors find that justification include being specific with all choices, staying in the moment, and establishing "who what/who where." "Who what/who where" is a quick mantra taught at many improv workshops as the first things established in the beginning lines of a scene. The first player establishes who the other player is and what they are doing: "Mom, making cookies with you is my favorite thing to do!" The second player establishes who the other character is and where they are. Now with this given line a logical, no-blocking response would be, "Me too, son! Let's put red sprinkles on this tray before we put them in the oven! That's your father's favorite." This establishes the other character as the son, while accepting the idea that she is the mother and that they are making cookies. The reference to the oven puts them in a kitchen, while mentioning the father creates a new element on which to build the scene further. This is a nice little logical way to "yes and" a scene without blocking. But the response of the mother character does not need to be the "logical" choice in order to fulfill the "yes and," "don't block" rules. If it truly is the actor's job to justify, this can be done in an almost limitless way. For example:

- *As mother tends an outdoor fire*: "Yes, son, me too. It helps me forget that we lost our home at Christmas."
- *As mother hops around in zero gravity*: "Yes, and this batch should turn out better now that we learned that cookies in space don't need baking soda to rise in the oven!"

- *As mother looks worried and says probingly*: "Yes, it's really sweet of you to stay with your mother in the hot kitchen on the first day of summer vacation when all your friends are outside playing softball."

None of these answers deny or block what the first player had already established. All of them justified what had been said and lay the groundwork for a scene to grow in a more specific direction.

Another handy tool of justification is the "call back." The call back is nothing new to theatre or to comedy for that matter, but a well-placed reference to something done earlier in a scene or a performance can not only help justify things in a round about way, but also tie a show together to create a more cohesive whole. Referred to by Johnstone as "reincorporation," call backs work well if they are not overused, and require that everyone on a team listen and remember what was said and done previously so it can be reincorporated later. Sometimes a call back does not have to be a verbal reference; it can be a simple posture taken by a player that echoes one used earlier. At times, so many ideas can come forward in an improv scene that not all of them get picked up and used. A call back can justify ideas on stage at a slightly later time. They also help performers be specific with their choices. The authors of *Truth in Comedy* explain:

> When making choices, specifics are always better than generalities. Specifics add dimensions to the work and to the characters. If an actor offers someone a ride in his Z-28, it gives us more information about his character than if he had just offered a ride in his "car." Just knowing whether a player drives a Yugo, a Studebaker, a Ford pickup truck or a BMW tell us a great deal about his character. [...] The more specific the choice, the easier they connect to further scenes, and players should always be aware of connections. Characters in a future scene may pass a stalled car by the side of the road; if that car is a Z-28, then a connection is made. (105–106)

Starting a scene in the middle is another tool improvisers use to justify the action. Scenes have a beginning, middle, and end. Skipping the beginning leaves the audience and the players to fill in the information that would otherwise turn into exposition if the scene began at the start.

While improvisation is about agreement and scene building, conflicts do arise. A person can agree with another player's established reality while seemingly in conflict. Goldberg explains:

> Here's an example of something that seemed at first like denial but actually became the hook for the scene. The audience suggestion was "giving up a friend." Archie Hahn did the scene with me as a guy who was about to tell his best friend that he didn't want to be friends anymore. His reason was that

I wasn't a good friend. He began by asking me how many years we had been friends. I said fifteen, he said no, we had been friends for twenty-five years. At that point it seemed like denial, but he immediately justified it by saying that if I had been a good friend, I would have remembered how long it had actually been.

The plot twist is a device that might appear to be conflict but is not. Something that appears to be one thing and later turns out to be something else is not denial. An apparent stranger, for instance, may turn out to be your long-lost brother. A detective investigating a homicide may later turn out to be the murderer. (Goldberg 17–18)

There are literally hundreds of "rules" created by various improvisational groups to help further the action of their improv form, but generally they all can be placed in one of the four categories: Focus and Goal, Yes And, Don't Block, and Justify. For example, various Theatresports companies have created some terms to define what happens on stage, such as Instant Trouble: "Immediate action that establishes conflict but doesn't establish narrative. (e.g. Suddenly turning into a werewolf)" (Foreman 188). This would fall into the Don't Block category. As each team creates mini-rules to help cure specific problems their actors face, new terms and seemingly new rules will be created that would be difficult to list. Often troupes will have different names for a rule that essentially is the same principle. In any case, individual players can mentally categorize their own list of rules into these four groups.

RULES IN PRACTICE: RULES BROKEN

Like the trees of a forest, the rules in performance intertwine and become difficult to trace to their branches. Yes and and Don't Block seem to be two sides of the same coin, making it difficult to categorize some specific rules in just one category. And when watching or performing improv, rules become like lines in a script; one must forget them and play the moment to make them come to life on stage.

According to Halpern, Close, and Johnson, while the general rules are important, there still are no unbreakable, rock-hard rules in improv. Nearly all improv rules can be broken "under the proper circumstance" (*Truth* 34). They explain:

> Anything can happen in improv. The only rule that can never be broken is the rule of agreement. Experienced improvisers may decide to cut loose in a scene and break as many improv rules as possible, and the scenes are usually very funny... Even though, they are simply playing a game—the "Rule-Breaking Game," and the performers all agree to participate. (35)

Having taught improvisation to hundreds of students since the publication of the book, *Truth in Comedy*, Charna Halpern adds to the idea of rules, "These are tools to help you be a strong improviser. But anything can happen in improvisation and something that I tell a student not to do in one piece might be exactly the right thing to do in another (Halpern, personal interview). To that, the rule of agreement does not mean that the characters have to agree with each other on stage. Rather, the actors need to agree and accept each other's ideas.

In his book, *Improvise: Scene from the Inside Out*, Mick Napier explains that rules can be broken in a more direct way: "[...] I'm not a big fan of The Rules. They help people think in a particular way, and that way of thinking is often death to good improvisation. [...] What's more, I've seen hundreds of scenes that don't violate any of The Rules of improvisation that make me yearn for naptime" (9).

Ultimately, improvisation is acting. More is required of an actor than simply knowing the lines in order to achieve greatness. Likewise, improvisers must get beyond the basics of the rules to excel on stage. The crucial tools an actor brings to the stage of mind, body, and voice and must be trained and honed for performance. While there are several rules to improv, just knowing them in theory cannot transform a novice improviser into an expert. Second City improviser Kiff VandenHeuvel explains:

> My professor Sun Dun Yee in mathematics used to teach the game *go*. And he said it very succinctly—and the same is true of acting and the same thing is true of improvisation—a moment to learn, a lifetime to master. Take martial arts. You can learn everything you need to know in a book, but it takes discipline and training and practice to get it. (personal interview)

Ultimately, the most important aspect of improvisation is the improviser herself. Like any art form, improv takes training, dedication, and a willingness to experiment with forms and styles. While working on rules alone won't make one a fantastic improviser, working on one's self is more likely to foster success. Because of the collaborative nature of the art, improvisers have to hone their skills in a number of areas beyond improv. The best improvisers need to have a strong work ethic, solid social skills, and an intellectual curiosity about the world off the stage.

While improv does not only apply to theatre, and improvisation in theatre has more than one major limb, this book will look at improvisation in theatre focusing on the branch of improv in performance. Again, this one branch has three major limbs, short form, long form, and sketch-based improv. While this chapter has looked at the history and similarities of all performance improvisation, Chapter 2 will explain short form by

using examples from practitioners of the style to explore the form, finding similarities in styles and identifying principles of short form. Chapter 3 will look at long form with a focus on long form improv companies to identify principles of long form. Chapter 4 identifies the principles of sketch-based improvisation using The Second City of Chicago and Detroit to explore this format. Chapter 5 looks at new trends in improvisation in performance that grow from the branches of short form, long form, and sketch-based improvisation. Finally, Chapter 6 examines teaching performance improvisation in an academic setting as well as creating a campus performance group that may well operate outside the traditional theatre department.

The branches of performance improvisation sometimes overlap and sometimes connect with other forms—for example sketch-based improv often uses improvisational music; however, for our purposes, only these three limbs will be discussed and compared. Because each contains a spontaneous element, each is improv. Because of the actor/audience/performance relationship, we know this is theatre, and not film or dance. The improv forest trees of theatre, music, and dance might be so closely planted that leaves touch, but this study will focus on the branches of improvisational performance in theatre, while acknowledging the intertwining of all the improvisational arts.

SHORT FORM IMPROV—LIVE AND DIE BY THE GAME

TO MOST IMPROVISATIONAL PERFORMERS, short form is the equivalent of theatre games. Short form can also be referred to as improv games or as spot improvisation—because scenes are made on the spot from audience suggestions. While short form games have the longest history of use in the contemporary theatre scene, sketch-based improv slightly supersedes it as performance, as it took a few years for the games to come out of the rehearsal rooms and onto the stage (Coleman 25).

If we think again of the entire tree of improvisation, short form is deep in the trunk of the tree before it branches into the three major limbs of improvisational theatre: performance, actor tool, and process drama. Consequently, elements of short form can be found in each of these areas of improvisation. For example, most, if not all, of Spolin's theatre games are short form, but many are short form exercises for actors and not necessarily intended for performance. This puts some short form games also in the "branches" of actor tools. In her book, *Theater Games for the Classroom*, Spolin's games become a tool to improve "students' ability to communicate through speech and writing and in nonverbal ways as well. They are energy sources, helping students develop skills in concentration, problem solving, and group interaction" (2). This goal puts the games packaged for teachers and designed to assist students in the branches of process drama.

Short form grows all through the tree of improvisational theatre, but short form *in* performance, and not as a tool to help create a performance, will be the focus of study. Here, we will look at short form that hangs on the branches of improvisational performance. This branch of performance improvisation is clarified by the overarching goal of the performers

themselves. Certainly a group of short form games given by students in a classroom or by actors in the rehearsal hall can be very entertaining, creating some form of a performance. Likewise, short form given in performance might have other benefits than sheer entertainment. Still, when one purpose dominates other benefits, that purpose becomes the key as to where to categorize the short form games. This chapter will look at those short form games and performance groups that aim to entertain through public performances.

While games in theatre are firmly set in the trunk of the improvisational tree and are one of the oldest elements in the metaphorical tree of improv, one must travel up the limb of performance before these games resemble what improvisers today call short form games. Games can be defined as scriptless scenes restrained by sets of rules on which all players agree. As Wendy Nance of River City Improv explains, "Short form games are based on skeleton sketches or rules. Once these game 'rules' have been established, then the player is free to improvise within the periphery of the sketch itself" (Nance personal interview). Games in all areas of theatrical improv share the traits described by Nance; however, Russ Roozeboom, also of River City Improv, explains how these games develop into a performance mode:

> While each game shares elements of improv theory (yes-and, gift giving, etc.), variations on these themes (guessing games, character games, physical movement games, verbal dexterity games) allow performers to provide an audience with several seemingly very different types of games. Usually the best results come from performers using the constraints provided by the rules of the game to effectively showcase the humorous aspects. By this I mean that each game tends to have a hook/gimmick/modus operandi that when used effectively will likely amuse an audience in the short term. Often the use of these constraints negates an in-depth development of the scene or characters, but can result in quick payoffs for the audience with regards to humor. Because of short form's reliance on each game's particular constraints, the scenes are usually short in length, say 3–7 minutes. (Roozeboom personal interview)

THREE VARIATIONS OF SHORT FORM

Short form improvisation can be grouped into three basic styles. First there is the competitive format used by Theatresports, which employs the use of teams competing against each other with moderators of some kind, be they judges, emcees, or some combination thereof. Second, stemming from the team competition, is the individual competition used by the popular television show *Whose Line Is It Anyway?* This quasi-competitive format supposedly gives points to individual players, but as *Whose Line* was fond of

saying, "the points don't matter," as entertainment value supersedes competition. The final format of short form is the noncompetitive format where the games are played without the use of score keeping of any kind. A troupe plays a series of short form improvisational games, sometimes with the use of a moderator to introduce the games and get suggestions from the audience and sometimes without even that role, with individual players taking turns introducing a game and getting suggestions as needed.

TEAM COMPETITION FORMAT:
THEATRESPORTS; THE POPULISTS' THEATRE

Keith Johnstone originated the idea of theatre games modified for a competitive improv performance with the birth of Theatresports. In *Something Like a Drug: An Unauthorized Oral History of Theatresports*, Johnstone describes his inspiration from a popular theatrical form:

> Wrestling was the only form of working-class theatre that existed. It clearly wasn't a sport because it was often presented on cinema stages and the expressions of agony were all played "out front." The content wasn't very interesting, but the audience was exactly the audience I wanted but didn't get in straight theatre. It was a family entertainment, and the audience was very loud—important as the performers. Sometimes the wrestlers would clamp together like magnets and let the audience scream and howl for ten minutes. (Foreman 20)

Johnstone developed from this idea a theatrical event highly interactive with the audience, feeding from the energy created by those in attendance. He also used the quasi-competitive format found in pro-wrestling to create his version of short form improv, defining Theatresports as "a competition between teams of improvisers" (*Storytellers* 2). However, *format* should be emphasized and not competition, as Theatresports should only be competitive as far as the format is concerned. Johnstone explains:

> Some people (often fervent capitalists and sports fans) condemn Theatresports on the grounds that it's competitive, but while "straight" theatre encourages competition—and I could tell you stories that you'd hardly believe—Theatresports can take jealous and self obsessed beginners and teach them to play games with good nature, and to fail gracefully. (*Storytellers* 23)

The transformation of individual players into an ensemble holds with the focus and goals of improvisation in general, that an actor's job on stage is to make his or her partner look good. Johnstone clearly tapped into that while creating this rollicking and entertaining theatrical form. Having little

good to say about the stuffy, frozen traditional actor training in his native England—which he calls "the Theatre of Taxidermy" (*Storytellers* xi)—Johnstone created an interactive theatre that he felt could help participants to creatively overcome blocks caused by poor education systems and dull actor training programs.

THEATRESPORTS HISTORY

In 1977, Theatresports began in Calgary at a small theatre called the Loose Moose, which had been used as a cattle auction house in its previous life. Designed with a steep rake in the seating area so all the farmers could have an excellent view of the cattle, the close proximity of the audience to the performers served the style of Theatresports well (*Storytellers* 2). Before the incarnation of Theatresports in Canada, Johnstone worked on a similar project in England called the Theatre Machine, a spontaneous improvisational show, lacking the structure of Theatresports. Because there were no scripts, the shows managed to avoid the censorship of the Lord Chamberlain by being officially listed as a comedy class in public (*Storytellers* 2). This early work laid the foundation for Johnstone's work in Canada, where he found

> [...] in Canada, the classes went wild with enthusiasm, whereas the English had treated it like Edwardian cricket. So one can say that Canadians were responsible for Theatresports in that it was their enthusiasm that made it seem worthwhile. And in England I'd always worked with only a handful of improvisers, but in Canada I had twenty or more people desperate for stage time, and Theatresports was a way of giving them stage time. (Foreman 20)

Theatresports caught on quickly, and after one year, Johnstone brought Theatresports to Denmark where he taught at the Copenhagen State Theatre School. By 1981, there were Theatresports teams in Vancouver, Edmonton, and Toronto, with teams in Seattle and New York joining the ranks the next year.

COMEDYSPORTZ—THE AMERICAN VERSION

As Johnstone's creation quickly spread to cities throughout the world, other forms of Theatresports began to appear, creating slight variants and new forms based on Johnstone's work. ComedySportz started in 1984 by Dick Chudnow in Milwaukee, Wisconsin, who based it on Theatresports' competitive improvisational games. Just as Theatresports grew with expansion teams across the world, so did ComedySportz, which began a franchise team in Madison, Wisconsin in 1985. ComedySportz remains an American version

of Johnstone's Impro games, with troupes in 25 cities across the continental USA (*ComedySportz* 1). Now both Theatresports and ComedySportz franchises can be found throughout the United States, and the creation of ComedySportz appears to have been instrumental in the licensing of the Theatresports name and format.

THEATRESPORTS ON STAGE

There is no single correct way to perform Theatresports, as evidenced by the many variations around the globe. Each country puts its own stamp into the formula of a Theatresports production as does each troupe in a city where Theatresports is performed. While the French throw slippers on stage at bad scenes and the Australians strictly time all scenes, the Danes and the Norwegians might vary the basic outline of a production to fit their countries' and their particular cities' culture.

Despite many variations, a basic Theatresports production that closely resembles the original format developed in Calgary contains some standard elements that includes competing improvisational teams, an emcee, and a panel of judges. Technicians in the booth or a musician on or near the stage (or both) are also fairly standard in this style of Theatresport. Theatresports companies often have more than two teams associated with their theatre— allowing more individuals a chance to perform on some sort of rotation. This also makes it possible for team members from a team not performing on a given night to jump in as a judge or emcee. Team members, emcee, judges, technicians, and musicians are all part of the company, as they all contribute to the creation of the scriptless show.

THE PLAYERS

A basic Theatresports event begins in a manner similar to a sporting event: lights and sound—provided by the technician and/or the musician—are used to whip a crowd into a preshow frenzy of excitement. In addition to the two competing teams of improv performers, Theatresports generally involves an emcee, compere, and a commentator or referee of some kind who introduces teams and facilitates the evening's events. Although a member of the troupe, this person usually does not perform the short form games at that particular show. Eventually an emcee welcomes the audience and encourages some kind of audience interaction, which could be anything from getting the audience to cheer on a cue, doing the wave, or tossing out candy to audience members. Johnstone explains that the emcee "welcomes the spectators and breaks the ice, perhaps asking them to: 'Tell a stranger the vegetable that you most hate!' or 'Tell someone a secret you've never told

anyone!' or 'Hug the stranger closest to you.' (I'm amazed that our specta-
tors will agree to hug each other)" (*Storytellers* 3). The emcee might next give
some brief explanatory remarks geared for those new to Theatresports, but
the pace of the show is quite important so it is not long before judges are
introduced.

Because Theatresports follows a competitive style of performance,
Theatresports has a panel of judges similar to that of an ice-skating or
gymnastic competition where points are given to each team following their
performance. Like the emcee, the judges do not participate in the short form
games but are part of the Theatresports company, and often may be part of
a different team not competing that night. The panel of judges ultimately
decides the winner of the evening's competition while contributing to the
entertainment, as judges are encouraged to play a bad guy/evil villain per-
sona. Three judges are the norm, though this can vary; judges often enter
robed in black and play to the crowd for boos. "Bicycle horns hang around
their necks (these are the 'rescue horn' used to honk boring players off the
stage). Their demeanor is serious, it being less fun to boo light-hearted
people" (*Storytellers* 3).

The two competing teams are introduced individually, after which a
judge and the team captains go to the center of the stage for a coin toss.
As in many sports, the coin toss decides which team will start. Players not
featured in a particular short form challenge sit on the sidelines and watch
the action, much as baseball players wait in the dugout for their turn at bat.
These sidelined players do more than simply watch; they digest the games to
see if there is a way to reincorporate references from one game into another
seemingly unrelated game played later in the evening.

MUSICIANS AND TECHNICAL SUPPORT

Musicians become an extra member of each team in a performance, adding
sound effects and background music for both teams as the performance
unfolds. Most Theatresports groups include an improv musician in their
ranks, while some utilize the work of a sound engineer in a booth, with
hundreds of musical and sound effect tapes and CDs ready to play as the
action unfolds. These musicians and sound people must improvise with
the action, and can further or change a scene with their contributions just
as the spoken word can. In Australia, Chris Harrot originated the role of
Mr. Music, responsible for live and original music designed to fill gaps, fur-
ther scenes, and support choices made on stage (Pierse 6). Other teams that
are not so fortunate as to have a musician capable of playing live improvised
music suitable to the show at hand have depended on improvisers in the
booth like Vanessa Valdes of Calgary's Theatresports. In *Something like a*

Drug, she describes how she surrounds herself with hundreds of tapes for a show, all of which she has through time come to memorize. At any moment in the action that can be furthered by music, Valdes will pick the appropriate tape. She explains, "The most fun, I think is if you can get it spot on, the kind of music that the environment needs, or just to mold a scene, get a scene going forward or bring it to its natural end, you know, just to make a nice package. That's always the best time" (Foreman 156).

CHALLENGES

The winner of the coin toss begins by challenging the opposing team to a specific category of short form game. The challenge does more than begin the action; it narrows the type of game that is played in an individual set, ensuring many variations of the short form style throughout the event by drawing on many different game categories. It can also be entertaining in and of itself depending on its phrasing.

And what exactly is a game category? They are, in a nutshell, broad styles of games that share similarities, like guessing or physical restrictions or large groups. The categories themselves are loose—one group might consider a game one type, another would categorize it a different way. Some improv groups use game categories to a great extent, others don't at all. To complicate the matter, in addition to the lack of exact categories agreed upon by all improvisers, the same games often go by different names. While that can be confusing, it is also part of the fun, as new games, or renamed games are always being invented. Still, while new games are continually being created, there are some basic, broad categories from which to choose types of games. Some of these categories contain many games; for example, the perennial favorite "guessing game" category has hundreds of games, as any game that requires guessing unknown information in any fashion can be filed in this category. Themes can be pasted into just about any category of games.

Although the actual challenge takes very little time in the program, the challenges frame the action for the audience and build the order of the show that can be the difference between a good program and a poor one. Like the order of songs at a concert, the order of games helps build the energy of the event, but this order is not usually completely predetermined before a show. The trick with stating a challenge is to allow enough room within it so that both teams are not required to perform *exactly* the same game, or kinds of game, in the same evening—for example, an evening of only guessing games might be dull. Teams can challenge each other to a specific game, a type of game—giving the opponents a category of games to choose from—or to a specific theme, say a scene involving a murder, or a duck, or a murder and a duck. Teams can also combine elements and challenge each other to a

specific game or type of game with a theme, like a guessing game involving a murder and a duck. Teams, however, should be careful not to narrow the challenge too far to avoid playing games that are too similar in nature and therefore provide the audience with little variety. At the other extreme, overly broad challenges or challenges that include too much inside improv jargon can leave new audience members scratching their heads to see the relationship between the game category and the challenge itself.

Depending on how the challenge is worded, the category might be narrowed so that both teams eventually perform a guessing game, but each game will have a different type of structure that adds to the variety of the program. A challenge can be the broad guessing game or the challenge can narrow the scope to "a guessing game involving two people." By putting that "two people" stipulation on the challenge, the number of guessing games from which to choose narrows. So if a team receives the challenge of a guessing game involving two people they might perform a game like Blind Date, where two players leave the auditorium and the audience is asked for two famous people, dead or alive, real or fictional, who would be unlikely to go on a date. When the players return, each learns who the other player will be, but must guess their own identity based on clues given by their "blind date."

A guessing game that greatly contrasts to this game would not involve the guessing of identities. An example would be Mime Debate, in which two players are left to guess a verb, adjective, and noun, solicited from the audience that is the topic of their debate. A more complicated version of charades, each debater has two teammates assisting him or her by miming the specific words that must be guessed while the debaters carry on a fictional debate. The action swings back and forth between debaters in timed 30-second intervals. Because specific words are being debated, and not identities, and because the format and the rules of the game are quite different than Blind Date, these two games could work well in a show together. Furthermore, Blind Date has two performers, while Mime Debate needs up to seven. Teams could include in their challenge the number of people allowed to be in a scene, that is, "a two person guessing game," which would then make these games incompatible for the same challenge. Ultimately, the games chosen depend on how specific the challenge is.

In another example, team one might challenge team two to an "elimination game." This category narrows the challenge to games that eliminate players who make a mistake of some kind. Eventually, one player will emerge as the champion of the game as the other members of the team falter or err in some way. The challenging team can tighten the challenge further by asking for a "directed elimination game." Here, one team member directs the actions of other teammates within the framework of a game that also

eliminates players who err in some way. The "director" in these types of games generally cannot be eliminated, but assists the elimination by creating situations that make it difficult for other players to succeed. Here again, one player (beyond the director) will emerge victorious at the end as other team members are eliminated.

As there are fewer elimination games than guessing games, team one creates a rather tight, specific category from which to choose a performance game. By adding the extra element of *directed* elimination game to the challenge, the number of games available narrows further. This type of narrowing can occur in many different forms—directed elimination can become "group directed elimination," therefore insisting that the whole team be involved in the game.

As challenges can not only refer to the type of game but also the theme, "directed elimination with a famous movie theme" can easily qualify as a challenge. Taking the category out entirely and simply challenging another team to a theme like "a game involving famous movies," "a game involving movies that contain monkeys," or even "a game involving monkeys" is also an acceptable challenge. That's why many games from several different categories can be used for these types of challenges.

A performance filled with variety is the ultimate goal, and good teams consider this in creating the challenge. For example, once a two person guessing game has been used in a challenge, teams do not continue to challenge each other to two person guessing games; rather, after the two person guessing game category has been used, that category is mentally scratched off the list of games.

The way the challenge is delivered varies from place to place, but Johnstone advises that all challenges should seem important by being presented with an air of formality (*Storytellers* 13). He maintains "the unexpected and unheard-of challenges keep the players alert. [...] Take risks. Challenges that seem stupid, incomprehensible or repetitive can always be rejected (at the discretion of the Judges)" (13–14).

CHALLENGES IN MOTION: THE GAMES BEGIN

So, if team one challenges team two to a directed elimination game, team two accepts the offer, and the games begin. Team one might be challenged to a game specifically designed as a directed elimination game, and then choose to play Literary Genre. In this game, four or more players from the team surround the director of the game—another player from the team—in a loose half circle. While the director sits or devises a way to be seen without being in the way of the performers, each team member asks the audience for a literary genre. Audience members are free to call out anything that fits the

bill—from poetry to mystery, or even something that might not qualify as a literary genre in an literature class—like "how to" books or Doctor Seuss, or even the Bible.

To accept the first suggestion heard or to sift through suggestions until the best one is found is a matter of some debate in the improv community. Some improvisers feel it is fair to the audience to accept the first thing heard, creating a challenge for the actor to discover the best way to use the suggestion. Other improvisers promote wading through the suggestions until the most interesting and challenging one is heard. While this second option has the potential to create stronger scenes, the search for the "right" suggestion takes some of the spontaneity from the game. Johnstone promotes a combination of these approaches; sifting through a few responses is acceptable, but asking questions that help the audience create specific and playable suggestions is an even stronger approach (*Storytellers* 25–30). In the case of Literary Genre, this might mean asking the audience for a narrower category than simply a literary genre. A player particularly good at the mystery category might ask for a famous mystery sleuth or author, therefore tightening the mystery category from the broader category to the style of Agatha Christie, Sherlock Holmes, or Scooby Doo.

Regardless of the policy of the company, each player eventually accepts a genre. The director then gets a fictional title for the story. Depending on the way in which the audience is asked and the audience's ultimate suggestion, this can be anything from a non sequitur like "Mustard on My Car" to a parody of a famous title, like the "Grapefruits of Wrath." After all the suggestions have been gathered from the audience and accepted by the players, the game begins. As the director points to specific team members it is his or her turn to tell the story. The goal for the players as a group is to tell a story that makes sense and is related to the title while each individual player incorporates his or her specific genre into the story when directed to speak. So the story entitled "Mustard on My Car" might begin with the director pointing to a player who received "mystery" as her genre, and she might start with: "It was a dark and stormy night as Helen, the beautiful and internationally famous supermodel drove her Porsche up the winding road to the castle in Frankfurt. She was about to..." Here, the first player is getting specific with certain choices, like the type of car, the name of the character, and the place where the character is going. The choice of Frankfurt can, by its very name and with a little creativity, tie into meats that might use mustard as a condiment.

The action switches to a new player as the director points to a new actor, who may have received "how to manual" as a genre suggestion. The story picks up where it left off, but now takes on a flavor inspired by his suggestion, "...pull over and change her oil. After checking her odometer, she realized

she had gone exactly 3000 miles and it was now time to change the oil as recommended by the manufacturer. She found a place to pull over, where she opened the trunk, removed a case of oil and her ever present toolbox. Crawling under the car, she A) checked for dirt and debris, B) began..." The action switches again to another player who received "romance" as a genre. "...To wonder if she would ever see Lance again. They had met after shooting the spread for Vogue at the little frankfurter stand in Frankfurt. Their mutual passion for exotic mustards led them to each other and what began as a shared love of condiments turned into something much, much more. And after leaving Lance for her world modeling tour, she had finally made it back to Frankfurt, and (she hoped), back into his arms—her little honey mustard."

If the director is savvy, the first time a player adds to the story, the actor will get to speak for a full sentence or two, which helps to establish the story's main characters, actions, and themes, and also lets the actors establish their literary genres. As the game continues, it is the job of the director to eliminate players who do not make sense in the story, can't think of anything to say when chosen, or, in some cases, repeat words just said by a previous player. To keep the game from being hours long, the director switches the action at a rapid pace as the game continues, tossing the story line from one actor to another. The rapid-fire changes often lead to falters on the part of the actors, who are then eliminated from the game. After a player is eliminated, the story continues with a new sentence, but the story and all that has been established previously remains the same. Eventually, two players are left standing, and the plot of the story may become secondary to the one-on-one competition. When one actor finally falters, the story may end wherever it lands or with a quick sentence of closure, with the final contestant declared the winner.

After team one has played its version of a directed elimination game, team one might challenge team two to a "scene from a recent movie." This challenge is not as specific, allowing many variations and building variety into the show. There are many thousands of variations of games and scenes to be played in a challenge involving a recent movie. Certain games are designed to parody movies, and plugging in a recent movie into the format of a movie game would be another choice. An example of this would be Foreign Film. Here, a movie title is selected from the audience—in this case a recent movie—as well as a foreign language. Normally, this game is played with a made-up title gleaned from the audience, but substituting a recent film and adapting the game to a foreign release of a new film can be easily accomplished by experienced players. Two players create a scene from a recent movie in a foreign language, creating the sounds and semblance of that language to an English ear as best as they can. After each actor speaks,

another team member translates the line into English. The game involves not only presenting a scene that makes sense but also justifying the action of the actors using a foreign language with the lines of the English translators. Part of the fun here can involve incongruity, where an extremely long foreign line is translated as "no" or an action in the foreign film is justified in the most obviously opposite manner from what was presented. While an important tool, the incongruity, however, is not the point of the game, so players need to be careful not to overuse it.

In addition to adapting games designed to involve film, a challenge involving a scene from a recent movie can use nearly any improv game. For example, literary genre could attempt to retell a scene from a recent movie by substituting the title of the story with the title of a recent film. Players could then tell the story of the movie but still adapt their segment of it to the particular genre they were given.

AUDIENCE REACTION

There may be several variations on how a game is played or how a challenge is delivered, but despite these variations, the effect is the same—the audience reacts to not only what is being done on the stage, but also to the score of the judges. Theatresports encourages audience members to behave much as if they were in a sporting event, cheering exceptional performances and sometimes booing or hissing at the judges if a score is given with which they do not agree. Judges do not only score the event, they are actually in place to help performers if a scene fails. Rather than continue with a bad scene, judges can save performers from humiliation and audience members from boredom by removing bad scenes. They do judge the events, but they also function as editors, preventing bad material from being exposed to the audience for too long of a period.

Also, as in a sporting event, judges can hand out penalties for breaking the rules. Judges can give these penalties to performers as well as out-of-control audience members; "the audience member never refuses—the peer pressure is enormous" (*Storytellers* 4). Lyn Pierse, author of *Theatresports Down Under*, has seen a variety of penalties given by different Theatresports groups, but the reasons why judges hand out penalties remain fairly constant:

> Theatresports infringements such as interruptions to scenes and offensive behavior or language are punishable in different ways around the world. In Canada, players are literally "basketed" (a cane waste-paper basket is put over the offender's head). Sydney has a sin bag, into which offending audience members or player are placed for up to 60 seconds. (Pierse 9)

Penalties are not given for poor scenes, as judges' scores address that. Rather these penalties can be likened to a technical foul at a basketball game, where poor sportsmanship of some sort earns a player a technical. While Theatresports has not written down a mandate that says "we will never use foul language on stage," the goal is to present a family entertainment that appeals to many different generations. Consequently, foul language and risqué behavior of any kind is often penalized. The result of these penalties differs from the world of professional basketball but might be akin to the world of pro-wrestling in the fact that the offending party's punishment is usually a cause for much mirth and is normally objected to only for show. The penalties themselves, such as the aforementioned sin bag or basket, can be so silly they become part of the entertainment, causing more laughter than anguish for the audience and the offender (Pierse 9).

Teams, judges, an emcee, music, short form games, and a theatrical environment create a recipe for Theatresports. Like all good recipes, there are many variations to the basic ingredients, yet any substitutions, additions, or other variations can be equally good when presented with local flavor in mind. In *Theatresports Down Under*, Lyn Pierse notes that in 1994 at the time of printing, Theatresports was being played in more than 10 languages in over 50 cities throughout 15 countries (375). Because there are so many teams operating in different cultures, variations are a natural part of the development of Theatresports. Something that works in western Canada might not work as well in New York or New Zealand. Pierse goes on to cite the contributions various international Theatresports organizations have made to the development of Theatresports, as well as a number of variations these organizations originated (376–400). Adapting Theatresports for the performers, the physical situation of the performance area and the local audience are as important of elements in creating good Theatresports as any of the individual ingredients of the recipe.

THE THEATRESPORTS PHILOSOPHY IN PERFORMANCE

While Theatresports itself creates an improvised performance, Johnstone's mission has been twofold—to create interesting theatre for the masses while exploring the essence of spontaneity. In a similar fashion to Spolin, Johnstone began his improvisational journey as a teacher trying to find creative ways to help students be more spontaneous (*Impro* 20–23). However similar in creation to Spolin, Johnstone's Theatresports has put more emphasis on performance improv than on improv as a developmental tool for the actor or nonactor, yet Johnstone's work continues to mingle with the other branches of improvisational theatre. Through the skills required to create improvised performances, he maintains that his theatre of spontaneity and

Theatresports in particular can help dull, negative people become brilliant positive people (*Storytellers* 24). But the benefits are not only for the performers. Theatresports also allows the audience to have a direct input in the presentation, rather than "trying (to) think up intelligent things to say on the way home" (*Storytellers* 24).

Johnstone's two books represent the natural growth of his journey to combine popular theatre with creative spontaneity. In his first book, *Impro*, Johnstone describes many exercises and ideas that can get anyone in any group to think and act more creatively. Like Spolin's work, much of *Impro* has subsequently been used by directors and actors of straight theatre, where the "outside the box" applications can be effectively applied to scene work. Johnstone also discusses his work as a teacher and how he developed these games to help his young students not only make learning more fun, but also make them better, less inhibited students of life who are excited about reading, writing, and critical thinking as well as creative problem solving (*Impro* 20–23). The philosophy is combined with practical applications and exercises designed to help students of the theatre.

In *Impro for Storytellers*, Johnstone shares his knowledge based on years of practical hands-on experience with the form of Theatresports, and therefore to the performance branch of improvisational theatre. Because so many franchises and so many versions of Theatresports have taken root across the globe, Johnstone takes each element of a Theatresports production and clarifies the best possible, most creative way to present a performance. He looks at practical details of performance such as fielding suggestions from the audience to more philosophical elements of Theatresports, including the nature of spontaneity for teachers and directors of Theatresports.

Above all, the agenda of Theatresports is to provide entertainment while educating the members of the audience to be more creative in their approach to life outside of the theatre. Johnstone explains:

> The audience is what matters, not the performer. That's why it's wonderful if the players are humble. [...] And why shouldn't players be humble? Inspiration is something that happens to you, something that you are open to, something you can accept—but it's really a gift from somewhere else. If a show goes well, you should be pleased, but you should give your thanks to the Great Moose (the muse of Loose Moose Theatre) rather then strolling about congratulating yourself. And if the show goes badly you shouldn't punish yourself.
>
> Our real task is to reeducate people. Schools train us to be dull (i.e. to make safe choices). School is designed to produce obedient and negative people. Normal education is a branch of the military, quite clearly. (Foreman 23)

Theatre for the masses with creative expression available to all underscores the essence of Theatresports. Since Johnstone first watched a wrestling

match while thinking about theatre, the Theatresports mission has been to bring the theatre to the people. He describes this in the moments just before a show, "The smell of popcorn tells you that you're in the presence of something populist" (*Storytellers* 2).

Theatresports remains a populist performance venue driven by the audience/actor relationship and spontaneous results of that relationship. Johnstone's work, however, differs from his pro-wrestling inspiration in that it does more than entertain and engage the audience. While professional wrestling's goals lie in financial gain, the foundation of Johnstone's Theatresports philosophy grew from a desire for creative and spontaneous thinking to take root in the minds of the masses. Johnstone's belief that normal education stifled the creative thought processes as well as spontaneous reactions is reflected in his interpretation of a theatrical production. The idea of performing a show without a script in a semi-sports venue takes the normal planning and preparation for a theatrical event and turns it on its head. The preparation does not come in learning lines and blocking movements, but in learning to react truthfully to the situation in which you are placed, whatever that situation may be. While Theatresports includes the two other branches of improvisational theatre, actor training and process drama, it remains a performance venue with nonperformance benefits springing organically from its limbs.

INDIVIDUAL COMPETITION FORMAT:
WHOSE LINE IS IT ANYWAY?

Despite the fact that Johnstone left England to begin Theatresports in earnest, a very popular version of short form improvisation began in the United Kingdom in 1988 called *Whose Line Is It Anyway?* In the improv forest *Whose Line* uses a theatrical form tangled at the top of the branches of improv in performance, as it mingles with other media to create a show originally performed live, but seen by millions in a taped television show format. Styled after Johnstone's theatre games, *Whose Line Is It Anyway?* premiered not on the stage but on British radio, and quickly moved to television, which brought improvisational theatre to many people who had not before seen it or even heard of it. This program, begun in 1988 and hosted by Clive Anderson, used four rotating cast members to play short form games in front of a studio audience. An American version of the show began in 1998, hosted by television personality Drew Carey.

WHOSE LINE IN MOTION: IMPROV WITH A NET

Like Theatresports, *Whose Line Is It Anyway?* uses a point system, but here the judges and emcee are rolled into a host, and teams have been

eliminated—replaced by four players. As the host introduces games, players perform them without challenges of any kind, making the point system a matter of formality. The American version in fact declares at every show its mantra "everything's made up and the points don't matter" (*Whose Line* 1). ABC hosted the American version of the show, describing it on their website, "Not a talk show, not a sitcom, not a game show, *Whose Line Is It Anyway?* is a completely unique concept to network television. Four talented actors perform completely unrehearsed skits and games in front of a studio audience. [...] It's genuinely improvised, so anything can happen—and often does" (*Whose Line* 1).

Ron West, who performed on the British version and served as an improv consultant to the American version in addition to performing and directing for The Second City, explains the differences between improv for stage and improv for television as "a different beast. And it's not bad, or better or anything like that, it's just different" (personal interview).

Overall, that "different beast" has different goals dictated by the medium in which it is presented. Because of the marketing needs created by television, the goals for *Whose Line* become quite different than improv on a stage, which in turn influences the game choices as well as the group's ensemble work. "On *Whose Line*, the main point is 'Is it funny and can Ryan [Stiles] and Colin [Mochrie] do it?' It's not about improv; it's about TV, and having a consistent commercial product. It is very important to understand that the goal for TV is different than the goal for the stage" (West personal interview). That goal is to be as funny as possible to attract more viewers, and ultimately more advertisers to buy commercial time. West maintains that the difference lies in the breaking of a basic improvisational rule—going for the joke as opposed to creating a scene:

> Games on stage are about working together to build a scene. It's a scene thing, not a joke thing. On *Whose Line*, it's about making jokes. For example, the game Superheroes, a staple of *Whose Line*, (they love to open the show with that game) is about coming up with jokes and a justification. It's an old game. It's a version of Controlled Actor. At its core, Superheroes is a pimp game. "Pimping" means putting your fellow player on the spot. The audience applauds seeing Player A dig his way out of the hole Player B dug for him.
>
> Superheroes is very structured so they can get in and out and get a laugh. They come in, think of goofy super heroes, then justify how they get out. On stage there are many more variations. (personal interview)

But it is not just going for the joke and simplifying games that separates this TV version of improv from its stage version counterpart. A staged show has the luxury of time. If a game or the entire performance runs a few minutes longer than planned, generally this is not a problem. However on television,

time is literally money, leaving no room for lengthy games or lots of sponta-
neous dialogue with the studio audience. West explains how this affects the
taping of the show:

> Getting the suggestion, last night in a game here [at The Second City
> Detroit], took two minutes for a game we wanted to do. That's okay, in the
> theatre. I cannot do that on TV. That's a tenth of my show. That is a tenth
> of my program. So I cannot spend that amount of time. I have to have it
> there and ready to go. I can't listen to an audience shouting, "proctologist"
> for two minutes. So what will happen for example with the songs, Drew will
> say, "Who here thinks they have an interesting job?" And the audience starts
> shouting things out. And Drew will say, "What is that, zoo keeper? Okay,
> good." And now we know, okay, we've got the suggestion, and now we start
> taping again and Drew goes to that person, "What is your job? Okay you're
> a zoo keeper; okay let's sing the zookeeper song." So what you don't see is the
> wading through the forest to get zookeeper. (personal interview)

This time limit not only affects how suggestions are gathered from the
audience, it also dictates the kinds of games that work on TV. Often many
of the same Theatresports games are used, but the nature of the medium
dictates a different approach to choosing a line-up. Part of West's work on
Whose Line? involves creating new games for TV. He maintains that he has
created a "jillion games" but some are simply better suited for the stage due
to the length of time it takes to get to the comedy of a game. He explains an
example of this problem with a guessing game:

> Guess the Phrase A. K. A. Phrase-Am-I doesn't work on TV. It's the game
> where you send someone out, and you decide what phrase that person has
> to say, something like "all the kings horses and all the kings men," and then
> you call that person back. You can't control the time element of Phrase-Am-I
> and time is absolutely crucial on TV. On TV, it is not enough that there is a
> guessing element to the game. TV (or perhaps more accurately, *Whose Line*)
> demands that every game be funny right away. The way for them to be funny
> right away is with jokes. (personal interview)

The fact that *Whose Line* is taped in front of a studio audience also dictates
some big changes in the way the show is put together. Due to the time limi-
tations involved in taping a show, and the large number of people employed
to do that task, the audience is not always involved in creating suggestions.

> Our show, *Whose Line*, takes about, well, you're on your butt there for some-
> where between three or four hours. But a lot happens in that three or four
> hours. [...] The audience at a *Whose Line* taping is very involved, but the
> audience can't give all the suggestions because we get the same things all
> the time. Second City gets the same things all the time in the theatre and it

doesn't matter. We can't put the same thing out on TV all the time. What I'm saying is the studio audience will tend to give us the same dumb suggestions. So for some of the suggestions *we* have to say, "Colin and Ryan are mountain climbers, and Wayne shows up as a fisherman, and Kathy comes in as God." We have to do it because the audience will never do it. It's like a time saving device. The players on *Whose Line* don't know what they are going to get, but sometimes *we* have to present them with the suggestions for a repetition factor and for an interest factor. (West personal interview)

Perhaps the biggest difference between staged improvisation and a taped improvisation program remains the time delay involved in bringing a show to the audience via television. While there is a small amount of extra time where performers might know a suggestion before they begin a game, (as with the example of zookeeper for an occupation), the time gap is minimal and, according to West, does not give anyone enough extra prep time to disqualify the performance as improvised. However, the time gap between the performance in front of a studio audience and the actual airing of that show allows for some editorial work after the fact. Because ABC has presented *Whose Line* to viewers and then sold that viewership as a product to advertisers, the ultimate package eliminates dull scenes in order to maximize profitability.

Such is the case with a popular game called Props. Here, players divide into two teams of two. Each team is given a strange object of some kind, like a three-foot spring coil or a water toy "noodle." Teams must justify the object in a use for which it was not intended. So on team A, player one could say to player two, "look at my cool new hat" while sticking the 3-foot spring on his head. Player two responds with a quick, witty line, like "Wow, you can get 110 channels in your brain!" As soon as two or three lines have been exchanged between players one and two on team A, the action quickly switches to team B, which repeats the justification game with their crazy object. The action moves back and forth between teams A and B; likewise, the player initiating the justification with the object also alternates within a team. In a regular live performance, each team might have 3 or 4 chances to justify their object, maybe more if things are going well, maybe less if the game is bombing. In taping for television, West explains the formula all changes, "The games on *Whose Line* always look great, like props because after they've shot 40 prop lines you get six or seven great prop jokes" (personal interview). By editing out the dull, failed moments, games have a much higher potential to look great. West notes that each half hour television program is not taped individually however, allowing for even more editing choices:

You tape more than one show at a time. They tape maybe 30 games. Usually three shows come out of that. Maybe 6 games a show, so that's 18 games that

actually get used, leaving 12 games that end up on the floor completely. Each game that is kept they take out about half, easily. Like when they do Scenes from a Hat it seems to go on forever, but the final product looks great because it is cut down. (personal interview)

But while the editing might make the final package more suitable for television, the skills of the performers as seasoned improvisers cannot be underestimated. In a 2001 review of *Whose Line* performers at the Chicago Improv Festival, William McEvoy noted the performers were highly skilled and talented improvisers in front of a live crowd outside the television studio. The performance, in fact, laid to rest the notion that in order to get a program's worth of good material the *Whose Line* actors might need to improvise for several hours. McEvoy observed they might need to tape for hours to get clean, family-friendly footage based on the work he saw, but improvisational talent was not an issue (McEnvoy *Whose* 1). And the material on *Whose Line*, however edited, is performed live: "It's all improvised. To their credit, all the performers insist on it. But editing becomes their net. Improv on stage has no net" (West personal interview).

The editor of *Whose Line Is It Anyway?* might serve as a safety net for the widely distributed television show, but for the studio audience, the impact is much the same as in the theatre—some scenes work wonderfully, some are good, and some don't work at all. While the show is being created, the show is theatrical and filled with the energy created between the audience and performers in a live improvisational performance.

IMPACT OF WHOSE LINE IS IT ANYWAY?

While *Whose Line Is It Anyway?* is not in the strictest sense theatre, the impact both versions of the show have had on the art of dramatic improvisation in performance can only be described as enormous. In 2001, fan Web sites, not endorsed by the show, numbered well over 300, many designed with chat rooms where fans of the show could discuss what they enjoy most about the episodes that aired weekly. While the object of television is to have a broad viewer base so the network can sell ads to companies targeting these viewers, the unintentional result of these shows has been to increase the number of amateur groups doing short form improv across the globe. While Theatresports and ComedySportz have created franchises in many cities around the globe, *Whose Line Is It Anyway?* has helped create smaller theatre groups at college campuses, community theatres, and local venues that are devoted to improvisational short form. But to seasoned improv performers, *Whose Line* is not considered cutting edge improvisation. In an interview by Jill Bernard with *Whose Line* performer Colin Mochrie, it

becomes clear that even the improvisers on the show understand the role the show plays in improvisational circles:

> Mochrie has no delusions of *Whose Line* being high art. "It's not necessarily, ah..." Mochrie trailed off and smiled diplomatically. "I'm not dissing it, it's just we're always trying to get different stuff on and they're sometimes afraid to mix things up because it's worked the way it has. It just makes it harder for us because we're with the same people all the time, we do the same scenes all the time, and it's hard to find something new and different...but they don't seem to get it. For some reason these network executives don't get it," he jokes. [...] *Whose Line* has its place, in the improv spectrum, though. Mochrie says, "I would like to think of it as an introduction... *Whose Line* is great for what it is, it's a lot of fun, we really have a great time doing it, but it's a very schticky kind of improv, which is valid in its own right, but there are other kinds that I think people should really get into. So if it gets people interested, that's great." He and [Debra] McGrath said they love that the games are something that people can do at home. "Kids and their parents are playing them," says Mochrie. McGrath adds, "Drew [Carey] will even say...'great game to play at a party.' He's not kidding." (Bernard 2)

While this impact creates a great deal of interest, the stylized version of short form created for television is not always the best version of improv to emulate outside of those parties at home. For live theatre, West agrees:

> One thing about *Whose Line* is that it is getting teenagers interested in improvisation the way *Python* got me interested in comedy. The drawback is that kids need to realize that *Whose Line* is not the pinnacle of improvisation quality. It just happens to be the most visible. McDonald's is not the best restaurant in the world even though it is the most visible. (personal interview)

It cannot be denied that the popularity of *Whose Line*, which has been seen by viewers across the globe and in the United States, has had an enormous impact on improvisers on a local scale. Because of the exposure of improvisation on a national and global scale in a different medium than theatre, improvisation on a local level has grown enormously. For example, as of 2007, *Fuzzyco.com The New Improv Page* Web site lists links to over 700 national and local improv groups in nearly every state of the United States, with just over that many links to other groups across the globe (*Fuzzyco.com*). Local groups build on audiences familiar with *Whose Line*, who then become hooked on the live format and the spontaneity of short form. Such was the case with River City Improv, to be discussed shortly,

which can point to the short form style used by *Whose Line* to quickly explain their approach to improvisation to new audiences.

Live performances, while benefiting from the popularity of short form spurred by *Whose Line*, can also suffer from the overwhelming exposure of specific games in the short form format. Even though Theatresports or Second City may have been doing a game for years, it can become old hat after achieving "hit" status on the program. West explains:

> A drag about *Whose Line?* is that certain games become so associated with the show that we can't do it on the stage, even though we could do it better. Because it is like we are doing someone else's bit. I mean, I wouldn't do an old episode of *Happy Days* on TV, so I won't do Superheroes or, God forbid, Hoe-down on stage. (personal interview)

Even for the performers on *Whose Line*, the repetitive line up of games can be wearing, as observed by one audience member:

> "I went to see a couple of the tapings when I was in Los Angeles and the funniest part is whenever they announce Hoe-down or something like that, it's just all four of them going [rolls eyes and sighs]. So they do a lot of retakes at the end of those guys going 'Hoe-down, great!'" (Bernard 2)

But despite some shortcomings, *Whose Line* has served a very important function in the improvisational community—it has interested and encouraged new players and, more importantly, a growing audience for improv groups across the country.

Interestingly, *Whose Line Is It Anyway* has spawned more short form television programs, such as *Thank God You're Here* broadcast by NBC. The show, an elaborate version of a "pimp game" is also an import, with previous version in Australia and the United Kingdom. Like *Whose Line*, it maintains the quasi-competitive format, as one judge declares a winner from the four guest stars at the end of the episode. Here, a cast of regular actors surprise a guest star with the line "Thank God you're here" as that guest walks into a room. The controlled actor has no idea what the scene will entail before entering the stage, but the regular actors follow a fairly tight script predetermined before the show, complete with a detailed set. The fun ensues as the guest is put on the spot and must dig his or her way out of the situation while guided by the skilled and highly trained cast. No surprise, the cast includes actors from some of the best improv companies in the United States, including Marybeth Monroe and Nyima Funk of The Second City, Chris Tallman of Comedysportz, and Brian Palermo of The Groundlings.

NONCOMPETITIVE TEAM FORMAT:
RIVER CITY IMPROV—LOCAL IMPROV

Short form troupe River City Improv has been working in Grand Rapids, Michigan, since 1993, a city with no other live, "name brand" improv groups within a three-hour drive. Troupes like River City Improv based in smaller cities have brought improvisation to smaller theatrical markets and thereby provided more improvisers the opportunity to perform outside the large market of major cities while cashing in on the nationwide audience built by *Whose Line.*

In its earliest stages, River City began more as a performance outlet for college friends who enjoyed doing improvisational short form and less as an audience-centered venue. The first members were all recent grads of Calvin College in Grand Rapids, Michigan, who convinced the college alumni office to allow them to have use of a room for weekly rehearsals. The team began with several different names, shifting meeting times, and even a few changes in members, until a set weekly rehearsal schedule with a twice a month performance schedule emerged. In the first year or two, River City charged nothing or sometimes only a dollar for admission. Finding an audience beyond friends and family became the goal, and using the connection with their alma mater became a mutually beneficial tool. The situation worked especially well for the team when it first began, as they had little money in their coffers to fund advertising. In the early 1990s the college was especially interested in expanding their role in the community—and together, both groups achieved their goals. The group's ties to the college remain strong as Calvin College continues to provided the group with rehearsal space and in return the group performs for the college a few times a year. From this humble beginning, the troupe has grown. As of 2007, River City performs over 50 performances a year, some for general audiences, and many for private groups. The team also has expanded to include nonalumni performers, drawing on a growing number of community members to join their ranks. Several previous members have gone on to do improvisation full time as actors or entrepreneurs in other venues; these folks sometimes join the team for a show when they are back in town. But at River City's core remain a few long-time members who continue to perform improvisation as part time improvisers—as performers who have other full time professions but who perform improv for the sheer joy of performance. Nance, who has been on the team for several years, explains:

> Most of us are happy, I think, with what we do during the day. We like our
> career choices that we made. And improv is a really exciting thing to do
> outside of our work to keep our minds tight and to keep our intellect strong.
> To be witty, to be intelligent—to carry that over. This is an extra way to keep

your mind sharp, [...] and a lot of us are working in our field. Someone like Michele [Dyskatra] has specifically worked her whole life to do the job that she's working right now... [as] a speech pathologist. And I don't think she'd give that up to be a full time improviser. Or Tracey [Kooy] as a teacher, or Rick [Treur] as a campaign manager. We've made a career choice and this is like the little cherry on top of the ice cream sundae of life. (RCI personal interview)

The long success of a short form team is quite unusual according to McEvoy, who mentions in a 2001 article that nine months is about the average life of a local improv group (Three 1). When asked how River City has endured as long as it has when other short form improv teams come and go, members cite the friendships developed on the team, strong leadership, and clear goals as the main force behind their success. But as River City member Todd Herring explains, more than just friendship holds the team together:

> The friendship part is great. There are so many teams that fail, but even so, every time they get together they're like, "Oh, this is so fun; this is great." The format they choose is great and they love each other and everything; but they still fail.
>
> One reason we've had success: we're organized. The fact that I know that I'm going to River City rehearsal and I'm going to get a little sheet of paper that tells me what's going on, this week and next week, pretty much for River City I can put it on the back burner because I know that Rick Treur is holding it up, which makes me go and perform much better because I don't have to worry about these things. That's the one part of the longevity of it.
>
> The other point is that we don't get lost in the fact that we are a talented group. Because so many groups go, "Oh this is so great, we need to take it to the next level." And I've wanted to do that, and a lot of people on this team have wanted to do that at different points. We could branch it off and it could be full time for some people. But River City is really not a place for that... a big point of River City's longevity is the fact that it hasn't been minded to that idea of going "to the next level." River City has achieved a goal, and we're going to continue to achieve *that* goal year after year. (RCI personal interview)

That goal for River City has been multifaceted: to do short form improvisation on a local level, to increase their audience base in the community, to improve improvisational skills among the group, and to have fun while doing all those things. As Treur puts it, "The fun has to be there. Otherwise, it isn't worth it for me; it just becomes stress" (RCI personal interview). Beyond the fun, River City also strives to be a forum where a true ensemble is built. The team has weathered various controversies that tear at the notion of ensemble; for example leadership issues, personal problems, lack

of trust, lack of equal commitment, and "star minded" individuals. Still, the team holds together because, as Treur puts it, they are consistently striving to improve not only their improv skills, but also their team skills. He lists those skills as "people working together, supporting each other, trusting each other, making each other look good. Helping others who fall down. Looking to see what needs to be done and doing it without needing to be asked" (RCI personal interview).

RIVER CITY IMPROV IN PERFORMANCE

River City performs short form devoid of any competitive formalities on the stage. The concept of judges or points has been eliminated, creating a simpler format. In *Impro for Storytellers*, Keith Johnstone actually mentions a version of improv similar to what River City does, naming it Bar Pro because of the small, bar-like spaces in which it is performed. But Johnstone's take on it is less than complementary, citing the lack of props as one of the major nontheatrical elements of the form (5). River City, while using a smaller space at times, does use costumes and props whenever they are handy and facilitate the action, but in general, a performance is a string of games that can be performed without much in the way of technical back up.

Rather than use competition in the performance, River City uses variety in the schedule of games to get the audience excited about the performance. Members alternate in creating the line up of games for a performance and follow a certain format in fashioning the list. Treur explains:

> One of the other things that I do when I am making the schedule is that at the beginning of the show I want to have a game that is going to be pretty high energy, pretty engaging. And if it's an audience that is not real familiar with us, I'll try to think of a game that it wouldn't be difficult to give a suggestion for. So the audience can get more warmed up and more comfortable with giving suggestions. Like maybe ESPN, you need one quick suggestion. It's high energy. It's a lot of fun. And that can get things going. To end the show I try to have a group game so we can also end it together on a high note. (RCI personal interview)

In ESPN, a common household chore is turned into an Olympic-style championship, all based on one suggestion. When asked for a chore, the audience might suggest vacuuming, and suddenly the scene starts at the "Hoover World Cup Championship," being played at a location geared to the particular audience. An "athlete," perhaps portrayed as America's sweetheart of this particular event, goes through all the pregame interviews, chats with commentators in the booth, and the competition to win or lose depending on the improvised performance. So, rather than create a competition between

teams of improvisers, this particular game allows competition to creep onto the stage through the games themselves. While this one game uses a sports motif, there are many more that do not. Overall, the emphasis is on the execution of the improvised games, rather than theatricalities provided by emcees or judges between the games. Games are introduced by members of the team—sometimes they perform in the game they introduce, and sometimes they do not. But even without the sport motif of Theatresports, the noncompetitive short form style still needs to get the audience excited and interacting. River City tries to achieve this connection with the audience without using a referee character, and instead uses many of the same techniques as the "emcee" in Theatresports to get the crowd involved.

While this might lack some of the pizzazz of Theatresports, it does create a more simplified performance vehicle, capable of performing nearly anywhere. During the academic year, the sponsoring college provides a rehearsal space, but a performance space can be difficult to secure. Consequently, River City has floated between several different theatres in Grand Rapids as a home base to wandering as a troupe from time to time; however, the lack of a permanent theatre in which to perform, while at times frustrating, has not affected their ability to perform. In fact, the flexibility in performing at a variety of stages has made it easier for the team to take on private shows where the facilities vary greatly. Now that the team has grown in popularity, some facilities court the group, giving the team options not previously afforded them in terms of venue.

While flexible in staging, River City Improv still has an optimal set of standards for a performance. The ideal needs are not large—sound system, light board, decent stage, and a small to medium house with some acoustical integrity. At times, that ideal isn't met in a performance space—the house might be too big or small, there might be no sound system available, the acoustics may be poor—but the performance continues anyway. Anywhere from 4 to 12 players can be at a specific performance, with a predetermined list of games and game assignments scheduled prior to the show. Like Theatresports, River City does their best to keep their shows family-oriented, free from bad language, and overtly smutty behavior. This desire to create entertainment suitable for the whole family also created, as Tracey Kooy explains, a beneficial side-effect:

> I think another thing that keeps me going and keeps us together is our commitment to cleanliness and to not stoop to use crass language or things that are inappropriate. And while that's funny the first time, I think it gets very old and prevents you from exploring if you go right away into the gutter, (which we do at rehearsal). But if you go there on stage, you're done! That's as far as you can go. There is no place to go; you're in the hole with walls all

around. So I think exploring a pomegranate rather than a penis just is more fun. (RCI personal interview)

OTHER SHORT FORM VARIATIONS

As the theatre tree in the improv forest grows, so do the formats that short form follows. New variants on short form are always being created. Indeed, even within a well-established format of Theatresports there are endless variants. Wacky examples exist like Gorilla Theatre where one player dresses like a gorilla and is the prize given to the best player, and a version called Micetro (pronounced Maestro) where action is directed by the Micetro in a series of games that result in the weakest player being eliminated at the end of each round (Tollenaere 1–2). Tom Tollenaere describes a format called Impro Match TM, which is popular in French-speaking countries, including the Congo. This style reportedly follows that of an ice hockey match in the number of players as well as the fast pace of the action. Also, each audience member receives a slipper that can be thrown into the ring whenever an audience member dislikes a scene. The slipper can also be thrown at the referee should the ref make a disputable call (Tollenaere 4–5). Some formats of Theatresports involve individual players instead of teams; however, the format used in the original Theatresports at the Loose Moose in Calgary was a team competition, and many Theatresports organizations continue to follow this format. Theatresports has a number of official, registered troupes across the globe, and the name "Theatresports" is a registered trademark. Just as consumers often call any brand of facial tissue a "Kleenex," the term Theatresports has come to stand for many formats and, with ComedySportz, serves as a general name for competitive team improvisation in improvisational circles. The International Theatresports Institute licenses the official Theatresports format developed by Keith Johnstone, as well as Gorilla Theatre and Micetro. Other forms, like Impro Match TM are not licensed by The International Theatresports Institute.

As quickly as a new format can be recorded, it can change slightly and evolve into something else. Still, all short forms of improv involve short games with strong audience participation played in either team competition, individual competition, or noncompetitive formats. Therefore each new short form variation can be linked to one of three short form style branches— team competition, individual competition, and noncompetitive—on the short form limb of the improv tree.

REHEARSAL AND RISK

While short form is the most accessible and widely seen improv form with games that are quick to learn and likewise quick to get a laugh, all forms

of improvisation need rehearsal time. As there is no script, improvisational rehearsals are not the same as straight play rehearsal. Rehearsals build the confidence and ability in a performer to take a risk on stage. While some risks in a live venue are important as we have seen, most risks are taken during rehearsals as team members build trust and familiarity with each other. This team spirit is perhaps the most important aspect of rehearsal, but groups also practice new formats of short form games and brush up on older ones.

Rehearsals also create a safe place to fail. A performer can misunderstand a game or format and completely ruin it in rehearsal with no real consequences, but such an error on stage would be devastating. Risks on stage need to be positive, such as creating a new character on the spot, or initiating a scene between two one-celled organisms, and hoping your scene partner will "yes and" your unconventional choice. Not all risks are positive, however. If the object of a short form improv performance is to be entertaining, performances are not the time to quickly *learn* a new game. Doing untried games or putting performers in games they do not know does not create a positive risk, as it does not forward the comic spirit of the performance (Pierse 61–62). Performers need to feel comfortable with the rules of the game before they can embrace the creativity it takes to perform it in front of a live audience. Certainly, an advanced player who is performing with a group he knows and trusts might have success jumping into a game he doesn't know all that well. And once an improviser knows many games, the games do follow a pattern that can be fairly simple to follow if the actor has played enough of them. But, like any art form, practice with the craft is an important element of success. Understanding the formats and what to expect from the other players helps build confidence in performers creating a more likely recipe for success than not.

EXAMINATION OF SHORT FORM PERFORMANCE FORMATS

In the noncompetitive format of short form, where there is no competition even implied, the focus of the audience is solely on entertainment. With entertainment as the emphasis, the idea of theatre as a competitive sport does not exist in this style of performance. Furthermore, it is true that lack of a team in the individual competition erases the link between competitive team sport and theatre, somewhat taking the competitive edge off the performance, and hence out of the audience's experience. The team competitive format will give the audience the chance to cheer for a particular team as well as be entertained by the evening's events. In the individual competition format, the competition can be so downplayed that the audience

participates only in the entertainment, not the sporting event. However, in the more individual competitions of Theatresports such as Micetro and Gorilla Theatre, the competition can be honed by the company to make the individual competition more heightened and important than in the style of *Whose Line.*

While both formats can be described as only marginally competitive because of the collaboration all competitors must employ to practice improv, just as in pro-wrestling as Johnstone noted, the audience accepts the competition if the performers present a show in this format. So the real difference here lies in the experience of the audience. The audience experience, in turn, is dictated by the goals of the particular troupe. Theatresports, Gorilla Theatre, and Micetro troupes have a goal to create a sport-like environment where competition is important to the experience of the audience. *Whose Line Is It Anyway?* does not share that goal; consequently, the competition is downplayed by those performers.

Beyond the level of competitiveness each short form team chooses, other differences emerge that stem from the goals of the team and the number of risks allowed to be taken. *Whose Line Is It Anyway?* has a more polished, more technically fast-paced style because they aim for a more polished, perfected, and marketable product. In troupes like River City Improv and Theatresports, the goal can be to serve the immediate community by honing spontaneity while having fun, resulting in a different experience for the audience.

Because having fun is a goal of these troupes and both companies perform live, a situation where more risks can be taken on stage is created. Johnstone's Theatresports encourages risk taking with an emphasis on the competitive spirit. River City Improv also encourages risk taking with an emphasis on the creative spirit. If a short form game fails for some reason in these live venues, the time spent on the failed scene is relatively short, and a new scene with a chance of being better is quickly begun. *Whose Line,* with its TV format, does not allow for risks to be shown in the finished product. And even though the studio audience might see some very different and difficult scenes than the viewing audience at home, the final product lacks that sense of risk created with the live audience that has seen a troupe fail as well as succeed.

PRINCIPLES OF SHORT FORM

Whatever format short form takes and no matter who performs it, short form has some specific principles that apply to all styles. These characteristics, or rules, apply to this form of improvisation in addition to the four basic categories of rules discussed in chapter 1. These categories again are: 1) why: focus and goals, 2) do's: yes and, 3) don'ts: blocking, and

4) how: justification. Short form *builds* on these four categories of rules, growing a unique style of "play" that marks it *as* short form.

First and foremost, the aim of short form is to **entertain comically**. While some short form games may take a turn for the serious, one of the elements that separates short form from the other forms of improvisational theatre is the fact that short form ultimately goes for the laugh. In *Impro for Storytellers*, Johnstone explains why Theatresports is a comic form:

> Another reason why public improvisation tends to be comic is that an evening of serious scenes would be like seeing a series of car crashes in which we empathized with the victims. Classical tragedy packages a tragic episode that may last only fifteen minutes, and Shakespearean tragedy uses poetry and clowning so that the misery won't exhaust us. (22)

He maintains that improv audiences are ready to laugh because they love the spontaneity of the event that has the energy of a sporting event (22). While short form aims to entertain, the truthfulness of a scene must still be intact. Theatresports player Helen Vikstvedt of Norway found this to be true when analyzing her team: "I think what we are doing [in Norwegian Theatresports] is going for the laughter—making funny characters and it is never truthful" (Foreman 124). As Vkstvedt shows, only going for the "funny" of a scene does not go far enough. Short form can still be truthful without a complicated scene. While the truth and integrity of a scene must be intact, Margaret Edwartowski (nee Exner), veteran of Second City Detroit and cofounder of Planet Ant Improv Colony finds that short form is a good place for beginning improvisers to find success in front of an audience because "short form is easier in the sense that you don't *have* to know scenic structure to make it work" (personal interview). In a sense, short form aims to entertain by going for the laugh, being truthful, and creating a bond with the audience when things go well.

This brings us to the next principle: **audience participation must be high throughout the show**. In short form, the audience is continually consulted for more information on which to build the scenes. A game is played, then a player asks the audience for another suggestion on which to build a scene. The constant contact with the audience makes for the most interactive form of theatrical improv in performance. While interaction is important, the audience does not control the actors like marionettes, rather the improvisers need to become skilled at obtaining suggestions that can build a scene. Sometimes an audience member will give suggestions meant to make the rest of the house laugh, but these suggestions are not usually things that will really help build a scene. Johnstone agrees: "A suggestion may get a laugh, but don't assume that anyone wants to see a scene based on it. In

general, the funnier the suggestion, the less use it's likely to be" (*Storytellers* 30). Therefore, keeping the performance highly interactive, but with the control on the side of the performers, is another important aspect of this principle of short form.

The third principle of short form is the **fast paced, energetic, and quick-witted style of performance.** This does not mean, by contrast, that other forms of improvisation are slow and dull. Rather, short form rarely deviates from the fast, high-energy style; serious character-driven scenes that need time to develop do not neatly fit into time constraints and the rules of the short form games. "Short form improv is all about speed," says Clifton Highfield of Detroit's improv duo "Men in Shirts" (personal interview). The games themselves are not only fast paced, but the structure of a short form performance is also segmented by the quick changes of games. Short form improvisers must be adept at quickly surmising the situation at hand and finding the most comic results in the shortest amount of time.

VandenHuevel cites using the structure of the game to accomplish this as an important element:

> Here are the principles of short form—live and die by the game. You have to follow the rules of the game otherwise it doesn't work. Trust the game to provide your funny. Focus on creating a scene within those restrictions. And those restrictions will provide the funny automatically. The audience delights in not your wit, which is where I think people get on their high horse about improv. How you create monsters is when people think the funny of that scene comes out of the wit of those people. The funny of the scene comes out of the restriction of the game, and the people maneuvering through those restrictions to create the scene. (personal interview)

This brings up an often overlooked principle of short form: to **focus on the creation of a scene *within* the rules of the game.** Actors in a beginning acting class spend a lot of time talking about scene work and analyzing their character's intentions. While there are millions of approaches to acting, most acting methodologies include the pursuit of a goal or objective of some kind. As in life, the goals can be blocked by obstacles and complications of some sort, and the actor must use various tactics and strategies to overcome these obstacles. Often, but not always, the partner in the scene is part of the obstacle or needs to be convinced to try a specific tactic to achieve the goal.

In short form improvisation, while the restrictions of the specific games create the comedy, an uncomplicated series of related events (otherwise known as the scene) give structure to the games. To that, players cannot be working independently to get a laugh—they have to work together to create a believable scenario in which the rules of the game can operate. It is this

combination of the rules of the game operating in a mutually agreed-upon situation that creates solid and interesting short form.

Ron West, who in addition to his work with *Whose Line* and Second City, began as an improvisational performer, agrees:

> I think people forget that the game is there to help the improvisers create a scene. So whatever device there is in the game, it is best that you not play *that* so hard. (By device, I mean the game's primary rule. Examples: you freeze, adopt the physical position, and start a new and unrelated scene. Or you have to touch someone else to talk. Or you speak in questions only.) I don't like games when performers are saying, "Look how funny the GAG of this game is!" Rules of a game are like rhymes of a poem; the rhyme helps you focus on what you want to say. It's not enough to *say* if you are just rhyming. (personal interview)

While creating a meaningful scene within the constraints of the game is indeed one of the principles of short form in performance, it is not the easiest thing to accomplish, as the rules of improvisation in general, as well as the specific principles of short form need to be followed for successful short form improv. Highfield agrees:

> The comedy is built into the games so if you play them right, you will do fine. By playing them right I mean all of the basics. Don't deny your partner's reality. Refrain from asking questions, and establish your relationship early in the bit. I love short form...but it really isn't as easy as it seems; too often early improvisers find themselves playing to the audience's laughter instead of playing to the scene. Unfortunately, this is easier hidden in short form than it is in long form, that's why a lot of early improvisers struggle with long form. (personal interview)

Improvisers may struggle with the challenge of creating a scene in short form but the fact remains that the first principle of short form is its comic nature. At times scenes rich with characters and plot are quickly sacrificed for a laugh and a faster paced show. This does not mean that all short form performers are incapable of creating more in-depth work, rather the style dictates those occasionally be sacrificed for the amusement of the audience should the need arise. As an improviser who works in many styles, Chuck Charbeneau of *Men in Shirts* expands this idea:

> Short form is about the game. In most short form oriented scenes, you have a predefined hook and you play it to the amusement of the audience. The characters' relationship to each other is less the goal than finding the humor in the situation. The end result is a series of funny moments meant to amuse the audience, but not usually asking them to relate to what they are seeing. Fun for fun's sake. (personal interview)

SHORT FORM GAMES AS A FRAMEWORK
FOR ALL IMPROVISATION

While short form has been defined here in the context of games, some improvisers feel the idea of a game is the basis for improvisation in any form. Two people in a live, unrehearsed, nonscripted scene work together to find parameters on which they can agree. That agreement, then, becomes the game. River City improviser Todd Herring described this concept during a group interview, which forced the participants to increase their volume so the tape player would record their voices:

> I think a game happens even in just basic conversation, and it could be an improv game. And a perfect example is a game that we're playing right now is the talk loud game. When you are in the middle of long form, let's say, a game happens, like the "no" game, when someone decides to say no to everyone else. A game happens once two people agree to progress the scene in a certain way. (RCI personal interview)

Herring's example of the tape player points to the games of wit or wordplay that individuals play in life on a daily basis, with no knowledge of improvisation or the rules of short form at all. If one person in a group surrounding a tape recorder chooses to talk a little louder than the last person, and the next person who talks decides to speak just a little louder than the person before him—and others follow suit—a game is created. While this particular game was not performed for anyone other than those in the room making the recording, these kinds of "games" without specific rules can arise organically in any form of performance improvisation, and, indeed, looking for the previously unestablished "game" in other forms of improvisation becomes a key element of performance, especially in long form improvisation.

Antoine McKay, award-winning actor at The Second City, sees an element of the short form games in every form of improv, including the sketch work done at Second City. "In order for a scene or any long form to work, you've got to have a good game. It just has to have a good game" (personal interview). These games become the framework on which to hang the scene work. McKay explains any of the improv games created by the likes of Spolin and Johnstone qualify, though some of them were not initially intended for performance:

> Some don't have a name because they're created so well. Prime example is this scene called Christmas Tree that Mary Jane Pories and Mark Warzecha wrote. It has the game of questions, which is a game where you ask questions and that's all you do. [...] I was just blown away because it was written so

well I didn't notice it. Finally I was like, wait a minute, this is questions. And it's hysterical, it's so built in and so well written in. And I think you need that strong basis where every scene, every long form improv, short form improv has got to have a good solid game. (personal interview)

While the idea of a game in theatre can mean different things to different improvisers, West theorizes that "game" holds essentially four classifications, at least one of which is applicable to each form of improvisation in performance:

> A **game** is (A) an improvised performance piece. The rules of the game are explained to the audience before it is performed. Often, the audience role is explained to them. Sometimes, however, the rules of the game are so simple that you can get the audience to participate in exactly the manner you want without explaining directly. (B) The thing the audience catches onto in a written scene that allows them to laugh and understand what is happening. In *The Sunshine Boys*, the game is that they undo each other, climaxing in the scene where they make (or try to make) the set in Willie's apartment. (C) The thing that improvisers decided to play when they beat out a scene that they DON'T explain to the audience and that the audience might not ever know. For example, "Let's see what happens if we only talk when we create a new object." (D) The thing that CHANGES in the midst of an improvisation that no one planned that is like discovering gold. (personal interview)

CONCLUDING SHORT FORM

Short form improvisation in contemporary performance can be divided into three very basic performance styles: team competition, individual competition, and noncompetitive. Regardless of the performance style of short form and the numerous variations within those categories, short form shares a number of principles beyond the four basic categories of rules shared by all improvisation. The short form principles are: 1) to entertain comically, 2) to keep audience participation high throughout the show, 3) to maintain a fast-paced, energetic and quick-witted style of performance, and 4) to focus on the creation of the scene *within* the rules of the game.

To some, short form improvisation appears simple, but it is deceptively so. The games used by short form performers appear throughout all forms of theatrical performance. And, as short form games hold the keys to other forms of improvisation, mastering them becomes a prerequisite for actors in the other forms of improvisation. That's not to say that in order to do other styles of improvisation, an actor will need to spend a certain amount of time performing *only* short form. But if that actor has not performed short form

prior to jumping into long form improv, games may be learned on the fly—but they will be learned, as they are foundational in performing long form. Likewise, short form is often referenced in improv-based sketch writing, so a working knowledge of short form games creates groundwork for all improvisation in performance.

CHAPTER 3

LONG FORM IMPROV— CELEBRATION OF THE FORM

WHILE MANY MORE INDIVIDUALS ARE FAMILIAR WITH SHORT FORM DUE to the popularity of the televised *Whose Line Is It Anyway?* and a large portion of the population is familiar with the sketch comedy format often used by venues like The Second City and *Saturday Night Live*, long form has remained the more elusive form of the three branches of performance improv. When trying to describe long form to an audience member unfamiliar with the term, experienced improvisers find themselves boiling down this hybrid art form. Improviser Nancy Hayden, who has worked at Second City in both Chicago and Detroit and is a founding member of Detroit's Planet Ant Improv Colony explains it this way: "If I couldn't use any improv terms to describe long form, just pulling from their [the general public's] reference level and what I think they'd know, I'd probably say that it's a play that we improvise. It's like a short little play; a 30-minute play that we improvise" (personal interview).

Long form is indeed a play. Sometimes it is a story with a beginning, middle and end, and sometimes it is a collection of scenes tied together with a theme. Either way, long form is performed on stage by improvisers who have no idea what the final story or "collage of scenes" will be when they start. While it is accurate to describe long form as an improvised play, Hayden's definition is simplistic by design, as it skips over the complexity of this form. Yet the intriguing aspect of long form is that, despite how complex the form can become for the improvisers, when it goes well, it *is* simply an improvised play from the point of view of the audience.

Long form can be problematic to define because there are so many variant types of long form. In a nutshell, a long form improv performance generally

lasts 30 to 45 minutes, though some forms can vary, lasting anywhere from 20 minutes to over an hour. Generally, long form is a collection of improvised scenes presented in a predetermined format known to the players—but it can even be one long scene. It is either primarily narrative and therefore tells a story, or it is primarily thematic, and makes connections and patterns from the material performed throughout the show. Often, a long form improvisation can be both of these things, that is, narrative *and* thematic. It is not, however, the fast-paced, punch line packed comedy of short form improv. This is not to say that it is humorless, rather long form does not put its emphasis on a quick laugh produced by the constraints of the game, but on the more powerful statement built on the through-line of scenes.

While the masses of theatre goers might be the least familiar with this form, it is nothing new to the performers of improv. A hybrid of the improvisational performance styles, to the uninformed audience member, it might at first seem slightly less accessible. Chicago City Limits improviser Victor Varnado recounts in an online article an experience he had at a recent long form show: He took a friend to see a long form Harold show. His friend was confused and made it difficult to enjoy the show by asking questions about what was going on. Varnado explained the actors running across the stage were editing, and that a new scene had started so actors had taken the stage as different characters than they had played before. Reoccurring scenes bookended by games made the event confusing for his guest and Varnado found a high learning curve for his friend in a long form game, but when he took him to a short form show, no questions were asked and the friend had a great time (2).

To the uninitiated, long form can seem intimidating, as it is molded by rules known to the performers but generally left unexplained to the audience. Even the names of certain formats of long form, like Harold, imply an insider's knowledge of a performance. In fact, the name Harold was supposedly given to the original long form after inventor Del Close could not think of a name upon its creation with the West Coast improv group, The Committee. Inspired by the Beatles' response to the name of their shaggy hairstyles, Committee member Bill Mathieu gave the name Harold to that long form style, and it stuck (Kozlowski 28). Some long forms like the "Armando Diaz" were actually titled after the person who invented it. But despite the insider's names and terms, long form grows naturally from short form and sketch-based improv, making it far more accessible than it might appear at first glance.

METAPHORICAL LONG FORM

Long form on stage easily fits with the metaphor of intertwining branches of a tree, particularly the uppermost branches of the canopy. A tree's canopy

consists of many smaller branches overlapping to create shade, and so it is with long form, which generally uses several shorter scenes that eventually interconnect to tell a story or to create a collage, much like a canopy of leaves create shade. Individually, one leaf does not provide shade, but many leaves together fulfill that purpose.

When trying to describe this complicated form to those who have never seen it, analogies and metaphors abound in the journals, classes, and conversations of improvisers. To this point, improviser Kiff VandenHeuvel uses this parallel:

> My interpretation of long form is...to give you a metaphor, it's like a pea pod. Each scene is a pea inside of a pod and long form improvisation is not only a delivery device but also a collection of those scenes that all share a relation, whether that's organic or not. Even if they don't appear related, the fact that they are juxtaposed together creates a relationship. It's been motivated. They spawn from one place or one point, and their interrelation...is like a film in a way. A film is comprised as a series of scenes. And that's a linear way of thinking about it, but I don't think it's that linear. (personal interview)

VandenHeuvel points out that long form is not as linear as most traditional films, but the analogy of the episodic nature of some film is often applied to long form. Films like *Pulp Fiction, Traffic*, and *Crash* more accurately reflect the style of long form where the film as a whole is deconstructed and scenes are rearranged so that either the plot, connection between characters, or the meaning becomes clear only at the completion of the film. Whether or not these films were influenced by improvisational long form is a point that is difficult to prove; yet the mass appeal of these episodic films correlates to the boom of long form as an improvisational style. Long form began to take root in the improv community in the early 1980s, steadily gaining recognition and popularity throughout the decade until the early 1990s when the 1994 release of *Pulp Fiction* coincided with the 1994 publication of *Truth in Comedy*, the manual of improvisation with a long form focus written by the founders of ImprovOlympic.

The episodic nature of long form does not always tell a clear linear story, however. Sometimes the scenes held together by a theme might seem to wander from one topic to another, much like a conversation with a group of friends, or as Second City Detroit alumnae Cheri Johnson puts it:

> Long form to me is like getting drunk at a party. You'd have these huge house parties and a bottle of wine and you are just going to get drunk. And in the course of the evening, 85 million different funny things happen. You're here and you're doing "this" and then you're off talking to Craig about the "thing," and then the lamp falls off the table because Craig is drunk and knocked it

over, and you're thinking, "Oh God" and you go away and do something else.
[...] And then by the end of the party, you realize you had a really good time,
but you don't know exactly what you did. But you know you did a bunch of
different things. (personal interview)

While the concept of comparing long form to getting drunk at a party might
not fit every improviser's idea of a long form performance, there is a sense
of letting go in order to perform well in the form. While each individual
player must always be in control, ultimately performers must let go of their
preconceived notions of individually building a scene and submit their ideas
to the will of the group mind created by the ensemble. Senses are heightened
as one must both give to a scene as well as accept and build on everything
that has been established in the preceding performance that can include
approximately 30 to 45 minutes of material. The idea of wandering from
room to room at a party neatly describes the scenic nature of many long
forms, as the scenes all take place in the same performance and the events in
the rooms are all connected by occurring at the same party.

When long form first hit the stage in Chicago at ImprovOlympic in the
early 1980s, it was a competitive event with two teams performing one long
form each and the audience choosing a winner. That competitive element of
performance has since faded into ImprovOlympic history. Performers still
do work in teams but do not perform in a competitive format. Now the
storytelling of long form mingles with the sense of sport and game first
established with short form, but the purpose of the game has changed.
Charna Halpern, cofounder of the ImprovOlympic and codeveloper of long
form explains:

> Long form is a "Meta-game" where everything we've ever leaned about improv
> is used. It's a half-hour performance filled with games and monologues that
> weave together to tell a story. It's about the group working as one mind—the
> group mind—where ideas are constantly brought back in the course of the
> performance. When those ideas come back, they often have a greater mean-
> ing and importance. In long form, statements are being made throughout the
> improv. We are improvising and then constantly reconnecting and recycling
> the material to create something more. (personal interview)

The benefits of playing long form are slightly different for each individual
player. Some revel in the sense of ensemble, the development of a group
mind, or the unique storytelling ability of the form. But the liquid format
of long form remains one of its distinguishing characteristics, as it has the
ability to change and mutate to the needs of the performers and the story
or theme being told. The format itself is ultimately less important than the
function it serves—to get both the players and audience to think while

being simultaneously entertained. Perhaps improviser Keegan-Michael Key best described long form as "a celebration of the form," as it is the very fluidity of the style and the creativity that it allows, which creates the excitement of performing and watching long form (personal interview).

While an evening of short form games can *add up* to hours of entertainment, long form aims to create an interconnected performance that ultimately sticks to a particular theme or story line. Joe Janes, improv director, teacher, and producer, explains that long form weaves improvised scenes together, tying them in an intricate tapestry that might not seem related if looking at the individual threads. It is only when the work is done that the picture created in the tapestry becomes clear (personal interview). Such is the experience of a long form that continually celebrates the creation of new long forms through an explosion of new styles of play, with almost as many new long "forms" as short form games.

LONG FORM'S DEVELOPMENT:
THE HAROLD AT IMPROVOLYMPIC

ImprovOlympic, birthplace of the long form known as the Harold, was started by Charna Halpern and David Shepherd in 1981. It began as a short form venue, doing a version of team competition short form games and was quite successful with that style. Despite the success with audiences, Halpern felt the short form games did not challenge her abilities. "I got bored with it, so I sought out Del [Close], who was looking for new forms, too. All we had done was short form, and people loved it, they ate it up. But I wanted something more" (personal interview).

At the time in the early 1980s, there were few places to perform improv in Chicago outside of The Second City. Del Close, who had worked as both a performer and director for The Second City, had returned to Chicago after working with comedy troupe The Committee for a few years in Los Angeles. Feeling that improv held more potential for storytelling than its current forms could provide, Close attempted to entice Bernie Salins, owner of The Second City, to try some new ways of using improv. Halpern explains:

> I was bored with games, and Del wanted to experiment with improv. He'd been working with Bernie Salins, the owner of Second City who was making millions and didn't want to experiment with the form, thank you very much. So Del and I got together, we talked and he said, 'well I've got this form that is un-teachable and un-playable,' but we closed the theatre for a few weeks and worked on it. With his form and my invention of the time dash, we put together the Harold. (personal interview)

The "unteachable" and "unplayable" form was the work Close had started in Los Angeles, but it wasn't until he joined forces with Halpern (after the departure of David Shepherd) that an audience-ready, performable long form developed. Close had the idea of three scenes, each divided into three sections that play out in the course of the evening. Halpern brought in the idea of a time dash, where a scene will start in one time, and then skip in time while telling the story of the same characters. As Ron West explains, "Say there is a divorce scene. The first part is a couple having a fight, and then the next scene shows the couple at the lawyer's. There is a time dash between those scenes. In the third scene, they meet 20 years later" (personal interview).

The end result of this collaboration was the form known as The Harold. First a team of approximately 6–12 players enters the stage and asks for suggestions from the audience. As with short form, while some improvisers feel the first suggestion heard should be the suggestion taken, others feel it is better to solicit several from the audience and take a suggestion with the most thematic/story telling potential. For example, "divorce" might hold more potential than "jellybeans" or the ever-popular suggestion of "proctologist." Still, either approach is acceptable, as it is sometimes the unlikely suggestion that yields the most interesting results.

After one suggestion is taken, an opening game is played using this suggestion. The games of long form do not go for the punch line like a short form game, rather they serve to generate ideas for the team on which to later build scenes. An example of a long form game would be the Monologue where every member of the team gives a brief monologue based on an association with the suggestion. However, *Truth in Comedy* warns, "A monologue in a Harold is an opportunity to remember and then share a past experience. Players must remember, not invent" (*Truth* 136). Team members do not discuss their ideas; they simply play the game. In the case of the Monologue game, they would perform their brief monologues, which can vary in number and length depending on the number of players on the stage.

Following the opening game, players perform three scenes based on something related to the suggestion or the information given in the first game. This first round of scenes, known as Round One (1A, 1B, 1C), are performed as short scenes that generally do not connect to each other at this point, but rather connect to the opening game. Following Round One, another game is played to stimulate more ideas and to create an atmosphere that allows the players to build on ideas created in the scenes. Suggestions are not usually taken for this game, nor is the game predetermined before the performance. The choice of the game evolves organically from the material previously performed and from the "group mind" developing among the

players. The second game, like all long form games, can be anything from more monologues to a different long form game known to all the players, to a new "game" created in that moment by the players (and previously known to none of them) inspired by the first round of scenes. Any player can initiate this game when the last scene (1C) appears over.

The move to end a scene and start a new scene or game is called an edit, and essentially makes all the players into editors of the story. There are several ways to edit a scene. A player in a scene can choose to make a "scene ending" move like walking off stage or dropping dead (Kozlowski 153). Players not in the scene can start a scene that overlaps the current running scene, signaling to the actors in that old scene that they should now finish their scene quickly as the new one gains momentum. A popular version of editing is the Whoosh edit, where a player not in the scene runs in front of the action as if flying while making a "whoosh" sound (Kozlowski 39). It works well as the actors in the edited scene do not fail to see the person editing them, and therefore mistakenly continue with the scene. As actors in a Harold do not have the ability to turn off the lights on a scene, the Whoosh edit serves as a type of aural "blackout" with an accompanying visual cue of an actor "sweeping" the stage with the whoosh.

After the second game is played, which ideally includes the whole team, Round Two (2A, 2B, 2C) is performed. In this round, connections between Round One scenes and Round Two scenes begin to form as the characters' situations or relationships begin to interweave.

The cycle repeats and a third game precedes Round Three, where the scenes by this time should have woven together to create a piece of theatrically improvised art that is not only based on the suggestion given by the audience, but also woven together by the group mind of the ensemble performing it.

A description is shared here to best illustrate the Harold. Here the Harold grows from the theme of "trophy" given by audience suggestion. The group opens with a pattern game, a word association where each member of the team says a word and, without missing a beat, the next person in line says what comes to mind. The pattern continues until, after a few minutes, connections are made and the game comes to a natural close. Based on "trophy" the team comes up with the following pattern:

High school... prom... sister... loser... jock... beating... crying... basketball... winning... losing... home schooled... home made... home ec... over achiever... brown noser... total hoser... slacker... aspiration... college... books... Bunsen burner... chemistry... romance... heartbreak... achy breaky heart... dance... sister... date... limo... prom... condom... birth control... health class... useless... high school.

The connection between the first phrase "high school" and the suggestion of "trophy" might not be clear to everyone in the audience, but the person who starts the round makes some connection to a high school memory and the word "trophy." How that connection is made is less important than the connections that follow it in the round. While each player connects with the last word immediately said, the whole body of words that come before are built upon, sometimes revisited and then moved in a different direction to make a new connection.

Following the pattern game, which was played instead of a monologue game, the players begin their first round of scenes:

1A: Two girls, Katie and Joanne are out shopping for prom dresses. They are excited because it is their first prom. One of them, Katie, has been asked out by the popular and super smart basketball captain. Joanne doesn't have a date yet, but is hoping someone will ask her. As the scene progresses, it is clear the girls were good friends in junior high, but now Katie is moving into a new social level, and keeps asking her dateless friend to duck into dressing rooms so other popular girls won't see them together. The dateless Joanne decides she is going to make her dress in home ec class and hope for the best.

1B: A deeply nerdy man is taking dance lessons from a country western dance instructor. He is hoping that he will be able to gain more confidence by taking the class. The instructor, Luella, shares that she knows how he feels, as she used to be very shy. Having been home schooled she didn't have many friends growing up, but now she has found her muse in country western line dancing. As he looks deeply into her eyes, he tells her maybe she was lucky to have been home schooled.

1C: Two young, smart guys are eager to make a difference for the better in the world. They want to find a way to make salt water into fresh water so the whole world will have water. Their plan is to make homemade water distillers with modified Bunsen burners.

Connections from the pattern game are beginning to be established, as performers use elements from the opening game to begin a scene. At this point, the main connection is between the pattern game and the individual scenes. As the next rounds begin, more connections to the first game are formed, but the scenes themselves start to tie into each other.

As the second round begins, players kick it off with a spontaneous game. A player will initiate an idea and hope that her fellow teammates will follow and build on it. In this case, players perform a game called Beatnick Poetry. Here, members of the team gather for an evening of beatnik poetry at a local coffee house. The actor playing the barista declares a theme for the evening's poetry, as members of the team step up to the microphone one by one. In this case, the theme is loneliness. Some actors take on the persona of a

beatnik and do spontaneous haikus or interpretive dances, another plays the proud mother of a beatnik who is so moved by her son's poetry she shares a little rhyme. Yet another actor plays a person who just came in for coffee and finds himself at the microphone sharing his personal loneliness.

Tying the poems to the scenes already performed, the characters share poems about loneliness in high school, being different, and being outcast. The man who just stepped in for coffee shares a poem he calls "lonely road of capitalism and the 'so called' American Dream" in which he explains that working hard to be successful at his job has deprived him of family, friends, and a full life.

Following this game, round two begins—now with a round and two games on which to build ideas. In the second round, the same basic scene ideas are revisited, but now the audience learns a little more about where they are in the story that each scene in the first round has began to tell. In long form it is not unusual for some stories to start in the middle, some at the beginning, and some to work backward, starting at the end. Audience members also have a chance to see the time dash used in the second round of the Harold. The time dash is frequently used to further the story and skip exposition, getting straight to the meat of a story. Round two unfolds as such:

2A: The two girls are meeting for coffee. Katie, who had a hot date at the prom is now married with a child in tow. She and the basketball captain got married when they found out they were pregnant after the prom. He's in college while she supports them by working at a local coffee shop and taking care of the baby. Joanne is also in college and excited about her course of study—she's studying nursing, but is really interested in the science classes, as there are lots of cute guys to "study."

2B: The nerdy man and the country western dance instructor are married now and have opened a dance studio together. The man says he is glad he quit his job as a high school chemistry teacher, but his dancer wife tells him she knows he has to follow his own muse, and for him, chemistry will always be a part of his soul. He vows to keep working on his experiments when not at the studio.

2C: Two men are working hard on a scientific discovery in a posh lab. They are excited about their work, though one feels guilty because he has been putting in such long hours and hasn't seen his family much. The other admits his divorce was the best thing to happen to him because he has more time to work on his own projects. Still, they both agree if they win the Noble prize, it will all be worth the long hours.

Now, three seemingly unrelated scenes—about girlfriends, dancing lessons, and scientific inventions—begin to tie together with the references to chemistry, aspirations, high school, a word that appeared twice in the first pattern game. The science the boys experiment with in the first scene—homemade

Bunsen burners—has grown into a fancy laboratory. The depressed feelings of the man from scene 1B are suddenly explained while simultaneously connecting to the material covered in the 1C with the science experiments and the 1 and 2 A with high school.

The next group game between Rounds Two and Three becomes a narration game called History Of. Here, a player initiates the game and becomes the narrator or host of the history of something, which is told in its entirety in a few moments. Players present the history of basketball, starting with caveman days, then a Middle Ages version, than a 1970s version, then the future of basketball. In the game a host explains the frozen vignettes provided by the other players. The group manages to tie into the idea of super jocks and loser slackers into the vignettes throughout time as well as the future. Even when a familiar game is initiated, the game itself can, and should, vary according to the needs of the current Harold by finding the best way to make connections to the preceding scenes.

The final round makes the connections to all the work that previously happened on stage and finishes the story. Here, the scenes interconnect while answering final ambiguities left hanging in the earlier work. Round Three of this Harold unfolds in the following manner:

> 3A: Joanne is a doctor at a clinic and Katie is the next patient. Katie says she and Joe got a divorce four years ago, but she's been very happy working at Starbucks because now she has healthcare coverage for her and her daughter. Katie tells Joanne she was lucky her brother took her to the prom after all.

> 3B: The nerdy man is accepting the Nobel prize for turning salt water into freshwater. He is giving all the credit to his lovely wife and their three children, who encouraged him to pursue his passion. While lots of scientists have been working on this project, the water line dancer, inspired by his wife's dance moves, gave him the idea for the inexpensive device that will change the world.

> 3C: The two scientists are packing up their lab, both have been fired. They are bitter that their old chemistry teacher, Mr. Bunsen, was working on the same project. They talk about shooting some hoops when they are done. The married man, Don, says he can't because he's got to get back to his wife, Joanne, whom he promised to pick up from her job at the hospital. Joe is left alone on the stage and mutters, "I never should have divorced Katie...such heartbreak."

There are several ways to end a Harold. Music can be used as part of the final scene or as an ending "game" where the whole team sings an improvised song. Monologues can be used, as players come forward to tie together lose threads from previous scenes. But scenes can end in any order, even if it is different from how they begin. The final round can break the action

into whatever seems best for the story that has unfolded. Furthermore, a natural ending often materializes as the final round comes to a close. Such was the case for this Harold with Joe's final line. While not all the ideas that develop in the first introductory game must be used, pulling in one last unused phrase from the first pattern game creates a perfect circle of ideas in the performance.

This example neatly illustrates the ensemble work needed to perform a long form Harold, as well as the need for players to hear, remember, and recycle material already mentioned while continuing to *build* on ideas and themes, moving those themes in new directions not at all preconceived when the game began.

While Harold players use humor throughout their performance, going for the quick laugh is not the focus of the form. Making connections improvisationally by tapping into the group mind of the performers while they create scenes outweighs the desire for quick laughs. The connection about Mr. Bunsen being a former chemistry teacher becomes all the more funny because the audience watches the connections form and then experiences the feeling of being part of an "in" joke at the end. Yet, the goal of a Harold is not to aim for a joke at the end. Rather a Harold aims to entertain as well as challenge an audience to think about issues raised in the performance. The topics do not need to be funny, as demonstrated by the focus of loneliness, divorce, healthcare, and heartbreak in the preceding example.

This kind of interweaving of connections—between the scenes themselves and to the larger world as a whole—constitute an ideal Harold. While this example clearly shows that connectedness, it is important to remember that performances are completely improvised. In this example, actors are portrayed as performing well, remembering all the ideas put forward, and then, more importantly, finding a coherent way to weave them into a story. When a performance comes together in such a tight, cohesive way, some ImprovOlympic improvisers talk of "seeing Harold" to describe the intense connections between the scenes, between performers and audience, and between stories and themes. The real goal, then, becomes to "see Harold," or to get to the point where the connections can be made in a seamless manner.

Beginning improvisers rarely "see Harold." Not that it is impossible, but it requires the experience of skill on stage, knowledge of all the rules of improv, and a profound sense of trust among teammates, which can be best established over time. Even when a veteran group of improvisers perform a Harold, things can still go quickly awry, as they can in any improvised situation. Long form improv performer/director Hayden explains:

> I think Harolds can be the hardest things in the world. If they go well, they are the greatest things in the world. It depends on whether they go well or

not. If it goes well you feel so lucky because you've got this natural road map and you do it and you get done. And you say "That was so easy! It was spelled out for us. I think we cheated the audience!" Or if it goes poorly it feels like a prison you're stuck in. So a Harold can feel like the greatest thing in the world, a savoir and a road map, or it can feel like this horrible restriction so you just want to crawl under a rock and die. And when they are bad they are the worst, the worst! And it's so hard to watch people die [on stage], but it's a thousand times worse to be up there. (personal interview)

While some improvisers have felt both the freedom and the strain of the Harold as a form of improvisation, it was never intended to become a prison where performers are chained to the format, unable to deviate from the structure. Long form is less about format and more about relating themes and telling stories, consequently long form at the ImprovOlympic has spawned many new structures designed to help tell a story created in the moment. While the Harold remains a popular format for many improvisers, partly because the rules of play have been neatly laid out in the book *Truth in Comedy*, long form improvisers are free to create their own new forms and "celebrate the form" in the storytelling process. In fact, Halpern encouraged her students to go beyond the format of the Harold:

I blasted the players to go beyond the form. The Harold is just training wheels for long form. Long form is all about reincorporating new things. You don't have to follow the form of a Harold to do that. Once they got that message, there was no turning back. People started upping me, and then I would up them, and new forms were happening all the time. (personal interview)

IMPROVOLYMPIC: BUILDING
ON SUCCESS

ImprovOlympic (IO) has had many challenges in its history, not the least of which is a bizarre dispute over its name. Due to a legal battle with the U.S. Olympic Committee, ImprovOlympic has been legally known as IO as of 2002. Despite the legal name change, ImprovOlympic has grown into an institution of improvisation in Chicago with two stages in their theatre located almost within batting range of Wrigley Field. The current space holds performances nearly every night, including an alumni show on Mondays for improvisers from IO who are working in theatres across Chicago and might have Mondays free when other venues are dark. While most Monday night performers are from the Chicago area, many improvisers have gone on to other cities and gained fame and fortune, yet occasionally come back to Chicago to do a show with the ImprovOlympic. ImprovOlympic claims many well-known actors and comedians including

Mike Myers, Andy Dick, Tina Fey, Rachel Dratch, Tim Meadows, Andy Richter, and the late Chris Farley as part of their improv family.

In addition to being a performance venue, ImprovOlympic offers a series of classes that constantly generates new talent as well as new forms of long form. As ImprovOlympic has grown in popularity, the number of classes has grown to meet the demand of willing students eager to learn long form. Classes begin at an entry level and build on skills through five levels, with the fifth level split into two consecutive classes. And the fifth level class continues to create new long forms as part of their curriculum, performing it in a final class performance. Each new form has the potential to become a style that sticks, entering the rotation of ever-changing shows performed nightly at the ImprovOlympic.

The ImprovOlympic training center has also influenced the improv community simply by the sheer number of alumni working in the entertainment industry. ImprovOlympic has become a launch pad for many performers and has served as a training ground for actors who move on to The Second City in Chicago, *Saturday Night Live*, and numerous television sitcoms. ImprovOlympic performers have also gone on to write for a variety of programs such as *Late Night with Conan O'Brien* and *Saturday Night Live*.

Due to the large number of ImprovOlympic alumni who moved to Los Angeles to further their acting careers, ImprovOlympic opened in Los Angeles in 1998. The L.A. theatre provides an opportunity for some Chicago IO alumni to gain exposure in the larger market of Los Angeles, and for West Coast improvisers to practice long form with the group that began long form's popularity. The Los Angeles IO theatre also has a training center, creating more devotees of the form in the city with the biggest entertainment industry in the world.

ImprovOlympic shows no signs of slowing down. In 2001, ImprovOlympic in Chicago celebrated its 20th anniversary in Chicago with a gala anniversary show including a match between actors who went on to *Saturday Night Live* and others who went on to *Late Night with Conan O'Brien*. In Los Angeles, the smaller, rented theatre has been replaced by a new facility, complete with a full bar, mezzanine, and other amenities unknown to the older facility in Chicago. The organization continues to grow and spread across the theatre community as IO fields calls from as far away as Denmark and Japan as, according to Halpern, short form performers yearn to move on to the next level:

> Everyone wants to learn the Harold because they're bored. I had a call from ComedySportz, they had a problem where they would hire new performers but they would get bored and quit. I said, yes, that's a problem. My problem is nobody leaves here! I've got more people than I know what to do with. But it's

such a challenge to get good at this. Monday nights we still have our alumni show and everyone wants to be in it. I had to open the L.A. theatre because lots of alumni were out there [...] and needed a place to play. (personal interview)

ImprovOlympic has moved beyond a national venue into a global one, with international troupes performing long form across the globe. As noted in *Truth in Comedy*, "Life is a slow Harold" (146), and something that started small in a Chicago theatre as an experiment with improv has snowballed into a powerhouse of creative improvisation in performance. ImprovOlympic reinvents forms and ideas to continually build on the story of their success.

OTHER LONG FORMS:
THE CELEBRATION GROWS

The Harold was just the beginning of long form at ImprovOlympic, and in fact was not the only form invented by Del Close and Charna Halpern. In his book, *The Art of Chicago Improv*, Rob Kozlowski explains that there are "so many variations on long form [...] that it would be impossible to put them all down in this one volume, unless one wants to carry around a fifty-pound improv book" (70). A number of these variations come from small changes made in a Harold, which then earns a new form "name" though it may essentially remain a Harold in spirit. Kozlowski noted an example of this in a long form where the suggestion for the evening is taken from a phone book. Whatever random page number is suggested by the audience becomes the groundwork for a Harold—but as Kozlowski notes, it isn't exactly a new and groundbreaking change to simply alter how the suggestion is gathered form the audience (70). Changing the Harold is nothing new either, as Kozlowski explains:

> Del Close himself created dozens of forms at ImprovOlympic, first as exercises in class and then for performances. He created variations on the Harold itself in a show called Night of the Mutant Harolds in 1995 utilizing the house team Missing Fersons. They performed three variations on the Harold. The first was Monologue Harold, in which scenes were created improvisation-ally through monologues. No direct interaction between characters occurred, even when there were more than one person in a certain location. It's as if scenes are composed entirely of asides. The Dream Harold did not receive a suggestion from the audience at all, the opening scene consisting of one player describing a dream she recently had. The Solo Harold was one player performing a Harold with multiple characters all by himself or herself, some-thing that was later adapted unknowingly by Andy Eninger, who developed a form called Sybil.

Late in his life, Close taught a performance class at ImprovOlympic (also known as Level Five B) in which students who completed the last level of classes there would create their own forms and perform it for a limited run in the Del Close Theatre. (70–71)

Eventually, some new forms became more popular than others, and certain improv teams became known for doing a specific variation of long form. For example, the ImprovOlympic team Baby Wants Candy specialized in musical long forms, using the twists and turns of a Broadway musical for inspiration. While the Harold is the original long form at IO, it is one of the more complex forms. A more generic form, according to Kozlowski, is the Montage (86). Here, improvisers get a suggestion from the audience, and then a series of scenes follow based on this suggestion. No group games are played, and the build of scenic rounds as in the Harold is absent. In this simple form, connections and patterns arise from the first suggestion and from material in previous scenes. Actors simply edit scenes and start a new one, perhaps riffing on a topic that surfaced in the previous scene, or perhaps creating a character that might have some relationship to the characters in the previous scene. Perhaps the connection will not be clear to the audience at all, and might emerge only at the end of the performance. Even with this simple format, the temporal nature of improv dictates that variations will arise, and such is the case with Montage. Another way of playing Montage is described by Hayden: "...you can continue coming to the audience and have that theme sort of grow in a free association way. People in Chicago called it Continuous Montage. We [in Detroit] used to call it Advanced Montage—an Advanced Montage because we would advance the theme" (personal interview). In a regular Montage, one suggestion is taken and a number of scenes are done from that suggestion. In a Continuous or Advanced Montage, a new suggestion is taken from the audience before each scene. The hope here is that the audience will start to see thematic patterns and supply suggestions accordingly, or provide the improvisers with a chance to connect seemingly unrelated suggestions into their scene work.

Other forms emerged that gained popularity on stage, partly because they used a formula quite different than the Harold, and partly because they were easy for other long form improv teams to pick up and perform. La Ronde, which began as a classroom exercise by Del Close, is such an example. The title is based on Max Ophuls' film of a sexual daisy chain, *La Ronde*, which was based on Arthur Schnitzler's 1921 play—adapted for the stage in 1999 by David Hare as *The Blue Room*. As long form, it begins with two characters in a scene. The first scene will play for a while then another actor will freeze the action with an edit and switch out one of the actors. The remaining actor will keep the same character played in scene one, but now

will begin scene two with a new scene partner in a new location. The daisy chain of characters continues, until the first character that was tagged out returns to the stage in the final scene, creating a complete circle of characters and relationships. So, for example, scene one might start with a fast food employee and the manager of the fast food establishment. As scene one ends, another actor takes the stage, removes the fast food employee and becomes manager's wife at home having dinner. Something in scene two will inspire another performer to create scene three, and this time we see the manager's wife at her job as a busy ER nurse, talking with another nurse about the insufferable working conditions for nurses at the hospital. In scene four, we see the second nurse at night school, trying to study to become a doctor as she struggles with an exam given by the chemistry professor. In a five-scene version of La Ronde, we might see in the last scene the chemistry professor going to the fast food restaurant from the first scene and seeing his former student, the same fast food employee, taking orders at the counter.

La Ronde is not limited to any number of scenes, as actors can be recycled by returning to the stage as a new character, but eventually a whole community emerges linked by the themes created in the individual scenes. Kozlowski interviewed Kevin Mullaney who worked with the La Ronde in Chicago. The form was too short to create a complete show, so a new idea developed:

> "It couldn't be a whole form in itself," says Mullaney, "and it's always kind of felt to me like a beginning, like it was a way to set something up. So that's what we started working on, this idea that we're going to use La Ronde to set up a community of characters and then when La Ronde was complete, we would see a lot of other scenes.
>
> In a sense, we would be deconstructing La Ronde, which would be a very large opening, where we would set up all these characters and then we come back and continue to do those kinds of moves." For example, the Character A referred to earlier will end up doing a scene with Character C, and then Character C may do a scene with Character E, and so on. (78)

Consequently, in Mullaney's version of a La Ronde performance, the La Ronde became a way to develop characters in a community, and after the La Ronde is finished, the community of characters reappears in scenes, but is no longer tied to the daisy chain format. La Ronde becomes an excellent game to focus on the improvisational rule of justification. In a short form game, the justification focuses on working in the structure of a game. In La Ronde, the actors justify character development, which takes longer to build and is not based on quick jokes or fast action. In the Mullaney version, a whole community of characters emerge who are all justified by the connections made in the improvisational scenes of the daisy chain.

Other forms have a looser structure than the Harold or La Ronde. In Detroit, Margaret Edwartowski of Planet Ant Improv invented a game call Go which, like many long forms, sprang from a classroom exercise. Here, actors form a line and get a suggestion from the audience. The suggestion can be for virtually anything. Players then do a word association, much as in the example of the Harold, where actors simply say one word based on the words that have come before. At any time in the word association, any player can say, "Go." When this happens, the actor who last spoke in the word association must come forward and give a brief, one-minute monologue on the word he or she just said. Edwartowski gives an example: "You have a back line, you get one word. And down the back line you'll do word associations. So 'camp,' 'tent,' 'hole,' 'flag,' blah blah blah. And everybody says a word, till *anybody* tells the person who just spoke to 'go.' So if go lands on flag, then I have to go down and do a monologue about flags" (personal interview). Because long form highlights truth and being honest on stage, the monologues give actors a chance to explain why that word popped into their head in the word association, or to simply say what association they have with that word. After the brief monologue, the actor returns to the line and the next person in line picks up a word from the monologue—any word that stood out to him or her—and continues with the word association.

This pattern of word association, monologue, word association, monologue, continues until it seems "done," which is usually after every player has had a chance to do at least one monologue. However, there is no set rule to this. If the team is quite large, not everyone might do one. If the word associations and monologues are quite interesting, perhaps they will continue a bit longer. When the moment comes to finish the word association/monologue pattern, anyone on the team can initiate a scene. Other improvisers will retreat to the upstage corners of the stage to watch and remember material, while a scene emerges that is based on the material that came up during the word associations and monologues. The scene can be on a specific word that came up in the associations, or based on people mentioned in a monologue, or on any connection to the previous work on stage. Scenes follow scenes, and are edited by other team members who begin a new scene that can now incorporate material from the word associations, monologues, and previous scenes. This loose structure of long form allows for a theme to easily arise, but it can be difficult to create a story with a beginning, middle, and end without a more stringent structure like the Harold.

Planet Ant Improv Colony has another long form format in their repertoire that is held together in a very loose structure. In a form they call Ant Jam, one player gathers suggestions from the audience in different categories. Generally four categories are used, and may include headers like "Things you hear Oprah say" or "Scientific facts" or "Things that have the initials

G.B." Audience members call out suggestions for the respective categories. Each category is presented to the audience one at a time and as suggestions are gathered, they are written on a huge pad of paper that has been divided into the four categories. When the team feels they have enough suggestions, usually about 10 to 12, they will begin doing scenes. Here, a player in a scene will go to the pad and cross off a suggestion that will be used to create their scene. Once this scene is finished, the next performer picks a suggestion from the pad, crosses it off, and does another scene, and so it continues. Much like Advanced Montage, Ant Jam becomes a series of scenes based on suggestions that are gathered at the top of the show, but used throughout.

A simpler, story-like long form played by Planet Ant and other long form companies is Soap Opera. Here, individual actors ask the audience for a stereotypical soap opera character (i.e., young doctor, jilted lover, the lawyer, etc.) as well as a fictitious title of the soap opera. The goal of the form is to mimic a daytime soap and tell a narrative story through several scenes, which are initiated by the actors. Scenes are changed in a similar way to Harold edits, with actors beginning new scenes and introducing new characters throughout the night. Since typical soap operas usually have several story lines and many characters, this form satirizes a popular form of entertainment while providing opportunities for actors to connect scenes by using the call back technique. Some companies have had Soap Operas that continue for several weeks or months, with the same group of actors continuing the story lines in much the same was as conventional soap operas, but this time in front of a live audience.

Not all long form is associated with the Harold's origins at ImprovOlympic. The long form troupe Shelia's Instant Odyssey, which performed from the early 1990s until 2001, started at the University of Chicago by a group of students who began a narrative, two-act format of long form. They used a simplified version of Joseph Campbell's 12-step mythological "Hero's Journey," boiled down in *The Writers Journey* by Christopher Vogler and intended for script writing. By utilizing the 12-step structure in a rough format, suggestions from the audience could be plugged into a generic scenario of the mythic steps. Since all the performers were familiar with the twelve steps, the formula became like beats of a Harold, giving structure and form to an improvised show. This particular format allowed them to create a full-length two-act improvisational performance, something that is difficult to achieve with most Harold-based forms (Kozlowski 102–105).

THE RUBRIC OF LONG FORM:
STRUCTURE AND CONTENT

While long forms might have many names for essentially the same form, all long form formats can be placed in a rubric of structure and content.

According to Kozlowski, "Some long form improvisation attempts to create an evening's worth of comedy using one arc. The arc may be thematic or narrative" (121). So the thematic and narrative categories take one side of the rubric: content.

Margaret Edwartowski of Planet Ant Improv Colony has taught improv since 1997 to Detroiters and has devised a different categorization of long form formats to help new students understand the many different forms. While some forms have been well established, other are constantly changing and evolving, building on previously established forms. Says Edwartowski, "I eventually made up two terms in my class: 'fluid long form' and 'segmented long form.' Fluid is Montage or 'Soap Opera,' anything where you don't break the reality to go to the audience and get more suggestions" (personal interview). As shown in figure 2, segmented long form returns to the audience for suggestions, yet unlike short form, a theme is maintained throughout the performance and new suggestions are not plugged into quick "game" scenarios.

Within the rubric, fluid and segmented forms do not mix. Either a suggestion is taken more than once, or it is not. In some cases, as with the Dream Harold, the suggestion does not even come from the audience. And with Ant Jam, all the suggestions are gathered at the start of the performance but are used throughout the performance, making it segmented.

The content side of the rubric, however, has degrees within the categories of the thematic and narrative forms. Some forms of long form strive to create a performance situation where themes and a narrative story convene in a tightly spun performance piece. Here, the line between narrative and thematic blurs slightly. Consequently, a long form that might be primarily thematic but strives to create a narrative within this theme would be placed in the thematic category, but closer to the narrative line in that row on the rubric. A continuum of long forms emerge that shows certain forms more apt to mix the narrative and theme than others.

Long Form Rubric		Structure: Fluid	Structure: Segmented
Content: Thematic	Unmixed \| Mixed		
Content: Narrative	Mixed \| Unmixed		

Figure 2 Long Form Rubric Template

In Soap Opera, the format does not return to the audience for suggestions and is consequently fluid in structure. It also aims to tell the highly dramatic story of a soap opera, making it narrative. Depending on how the form is played, themes can arise, which might be tied to a character or even the title given by the audience. Yet, because the objective is to focus on the story and a theme is not vital to move the action forward, Soap Opera is in the narrative fluid category but should be placed near to the line between thematic and narrative content. The aforementioned Harold uses one suggestion and concentrates on tying things together thematically. Yet, as we saw with the example, narrative story lines that connect to the theme can emerge. It would therefore be categorized in a fluid structure with a thematic content that is very close to the narrative line.

In Montage, a narrative story is not as important as relating the scenes to the suggestion. Consequently, this form would be a fluid structure with a thematic content, and would be placed far from the narrative line in the thematic area. However, in Advanced or Continuous Montage, where the audience is continually consulted for new suggestions, the content remains thematic, but the structure changes to segmented on the rubric.

By placing the long forms previously discussed into the rubric of figure 3, we see in this small sample of long forms that it can be difficult to perform a narrative story when the audience is consulted more than once. This can be partly explained by the fact that narrative long form relies heavily on the group mind establishing a story line. If the audience is consulted frequently, the potential to change the story line with new suggestions can derail the work of the ensemble group mind.

However, new forms evolve at lightening speed in long form. For example, with Shelia's Instant Odyssey Mythic Hero performance, there is nothing stopping a new company from using the 12 mythic hero steps that also incorporates new suggestions. Bits of information that can further the

Long Form Rubric		Structure: Fluid	Structure: Segmented
Content: Thematic	Unmixed ┃ Mixed	Montage, Go Harold, Monologue, Dream and Solo Harold	Advance Montage, Ant Jam
Content: Narrative	Mixed ┃ Unmixed	Soap Opera, La Ronde Shelia's Instant Odyssey's Mythic Hero	

Figure 3 Sample Long Form Rubric with Formats

story—like locations or objects or anything involved in the work already established—can be gathered from the audience at the top of each "step." A segmented form of Shelia's Instant Odyssey's work would then emerge. The rubric does not take into account the vastly different outcomes that a live performance can create. While the example Harold in this chapter was a blend of the thematic and narrative, many Harold performances turn out to be purely thematic. Likewise, the form Go might be a difficult vehicle with which to create a narrative story, but that does not mean it cannot be achieved on stage. And a mythological hero story as told by Shelia's Instant Odyssey might well have developed themes as it unfolded. Because all of these long forms are improv, they are difficult to categorize simply because they can change slightly with every performance. So in essence, the individual performance of a game is what can be placed into the rubric with certainty, not the form itself as it can vary from performance to performance.

To many improvisation performers, a rubric of any kind is a hair-splitting tool of classification and disconnected to the business of performance. As longtime improviser and founder of the Annoyance Theatre Mick Naiper notes:

> [Form is] so derivative to me. Improvisation is human beings standing on stage having no previous information about what they were going to say and making it up. [...] Good improvisation is good improvisation, no matter what form you attach to it. The best form with the worst improvisers, I'm still gonna be fucking reaching for my Game Boy. (Kozlowski 124)

It is important to understand that while performing, the categories of the rubric do not matter—the rubric is a tool to describe long form improvisation after the fact. Once a long form has been established, the categories can help define it and explain it to other improvisers and potential audience members, but categories play little or no part in the creation process of long form improvisation. Just as an arborist does not need to know the Latin names of his trees to make them grow, for those who have been doing long form improvisation for many years, the different classifications the rubric provides might be of little use. After all, the form itself is less important than the product when in performance. But for those new to the complicated art of long form improvisation, classifications can be a way of sorting the many formats, many grown from the seed planted by the Harold.

BEYOND IMPROVOLYMPIC: ADVANCEMENT OF THE FORM

Practitioners of long form owe a great deal of debt to the ImprovOlympic in Chicago. Now that ImprovOlympic has taken such root in the city, other

theatres in Chicago and across the nation have begun doing long form. Some are short form venues adding an occasional long form to their repertoire, like Theatresports in Los Angeles that touted the blend of forms on their Web page. Their long running show *Carnal Peaks* used the Soap Opera format to create an improvised show that continues week after week, just like a daytime soap—but audiences could still see short form most nights of the week (Los Angeles Theatresports). Other groups specifically focus on long form, building on work done by IO and other theatres. In Chicago, where improvisation is an important part of the theatre scene and audiences are familiar with the form, new long form theatre companies do not need much explanation. Generally, performers who want more stage time than they can get after completing the training at ImprovOlympic, or want to do something specifically different, branch off to start their own group. Some improvisers belong to an IO team as well as an independent improv group. Other groups developed in Chicago created their own style of long form. For example the Annoyance Theatre, founded in 1987 by Napier, often presents edgier shows such as the long running "Coed Prison Sluts," which helped launch the theatre. The improv troupe WNEP performed a show in 2001 called "Postmortem," where an obituary was selected from the newspaper and a show was then improvised around the life and the minimal facts found in the memorial.

While many long form improvisers in Chicago have connections to IO, some groups have grown without the ImprovOlympic connection. Shelia's Instant Odyssey, which performed in the University of Chicago area, is a good example. This group began at the University of Chicago under the tutelage of Bernie Sahlins, the producer of The Second City at the time (Kozlowski 102). However, even though Shelia's Instant Odyssey grew without the direct influence of ImprovOlympic, the improv-ready audience that IO helped create in Chicago cannot be denied, and benefits non-IO groups as well.

Chicago is, in fact, the home to a weeklong yearly improvisational festival begun in 1998 by Jonathan Pitts and Frances Callier. In the short number of years of its existence, this improv festival has grown to include improvisers and teams from around the globe doing long form as well as short form, sketch, solo, and duo performances. There are a variety of stages around Chicago during the festival, and the number of attendees keeps growing. In 2003, the festival hosted over 100 performances at nine different stages in Chicago over four days. Once again, the success of the festival is due in part to the ready-made audience in Chicago (Kozlowski 129).

While audiences in Chicago might be more in tune with variations of long form, communities outside of Chicago are just getting their first taste of long form in a show format. While some groups have been around

for a while, it has taken time to build an audience that appreciates and understands the form, especially if there is not much improvised theatre at other venues in the community. While *Whose Line Is It Anyway?* has helped spur the popularity of short form, long form has not had a major network television program promoting the form.

Despite that, growth has been steady for long form outside of Chicago. New York and Los Angeles have had long form companies for years. The Groundlings in Los Angeles, which has been doing improvisation since 1974, has a Wednesday night long form performance. Likewise, in New York, former IO improvisers helped found the successful Upright Citizens Brigade, where the Harold and other long forms are not only performed but also taught at their training center. However, other cities where the theatre industry as a whole is not so prevalent have taken a bit longer to find their long form audience. A good example of the growing interest in long form in a city without a huge entertainment industry base is Detroit, Michigan.

REGIONAL LONG FORM: THE MOTOWN EXAMPLE

In the Metro area of Detroit, Michigan, long form has finally found a regular home. The Planet Ant Improv Colony operates out of the Planet Ant Theatre, a converted row house/candy store in the blue-collar town of Hamtramck—neatly tucked into the boundaries of the city of Detroit. Planet Ant began as a coffee house complete with poetry readings and grunge bands in 1993, but by 1996 the space had developed into a black box theatre. The small space creates an intimate setting for plays, and the theatre company has gained a reputation for edgier theatre, sometimes presenting original works and sometimes putting a contemporary spin on classics. The intimate setting is also ideal for the audience/performer relationship needed for improvisational performances.

But the road to long form improv in Detroit hasn't been easy. After graduating from The American Academy of Dramatic Arts in Los Angeles, Nancy Hayden moved to Chicago to begin a theatrical acting career. Not long after that, and with every intention of returning to Chicago, she accepted a job at the Flint Art institute in Flint, Michigan, to make some extra money and to be near her family. As the job was coming to a close, her brother convinced her to audition for the new Second City that was just opening in downtown Detroit. She did, was cast, and stayed with the company from 1994 until 1996. Following this, she moved back to Chicago where she worked with The Second City Chicago for almost a year. But Hayden eventually made it back to Motown where she joined forces with Second City Detroit Alumnai Angela Shelton to open a long form based improv theatre in Detroit in 1996. The Underground Improv Works laid the groundwork for future long form venues,

but according to Hayden, "It was just too soon" (personal interview). While Second City Detroit had introduced audiences to sketch-based improv, and *Whose Line* was beginning to become more popular on American television, the idea of long form was new in the city and a large enough audience base had not yet grown. For nearly two years the Underground Improv Works persisted in doing improv shows before closing in 1997.

Meanwhile, Detroiter Margaret Edwartowski joined the Second City Detroit cast, performed on the main stage, and taught classes there from 1997 to 1999. Choosing to end her contract with Second City in Detroit, Edwartowski recognized the time was right for a long form theatre in Metro Detroit. Opting to stay in Detroit, Edwartowski joined forces with Hayden to revive the Underground Improv Works in a new home. Despite the fact that needs for an improv theatre are small, "because you don't need anything to do an improv show, other than a stage, maybe some lights, and a bunch of people," a theatre ultimately became the biggest challenge "because the hardest thing in this industry is to have a space—in this improv thing—is to have a place to play" (personal interview).

Working with theatre owner Hal Soper, Edwartowski and Hayden carved out a system based on the defunct Underground Improv Works that worked around the full season of regular drama at Planet Ant. The Planet Ant Improv Colony began in 2000, with a performance schedule similar to the ImprovOlympic Monday night alumni show. Mondays were chosen for Planet Ant Improv Colony partly because the theatre can be easily scheduled around the regular theatre season, and partly because the main thrust of the theatre's audience are improv performers and theatre people in the Metro area who are working in their own shows on the weekends. As at IO, a Monday performance ensures that most other theatres will be dark, creating an opportunity for busy theatre people to perform and see each other's work.

Each Monday, the Planet Ant home team performs with an opening guest improv troupe. The Ant, as it is known in Detroit theatre circles, invites teams from around the Metro area to open for them, giving new teams a half hour to 45 minutes to perform. The home team follows with another 45 minutes to an hour of long form improv, followed by an Ant Jam performance. The system is mutually beneficial. The visiting team gains an opportunity to make a name for itself in the improv community, and the home team draws a larger audience with the friends and family that attend the visiting team's performance. The hope is that those visiting supporters of the away team will have an enjoyable time and return—and, according to Edwartowski, they often do:

> This started off as a very insider's project, but has just grown from then. What started to happen is that people's friends started coming, and telling

people, and now people who aren't involved at all come. One of the best marketing tools we ever invented without even knowing it was to have the home team follow a guest team at every show. So the guest team that is visiting brings a whole market with them. And *those* people bring their friends. (personal interview)

The passage of only a few years made all the difference in the success of an improvisational long form company in Detroit. Much of this had to do with the existence of Detroit Second City. While Second City performs a completely different style of improvisational theatre, their training center taught hundreds of interested Detroiters the basics of improv who then formed teams of their own. Edwartowski points out "All these people were graduating from the training center and had nowhere to perform" (personal interview). Furthermore, these graduates of the training center had few options to see improv outside Second City Detroit without driving for several hours to cities like Chicago or Toronto. Consequently, a new audience grew in Detroit that better understood the form after performing short form and sketch-based improv as taught in the training center. And, most importantly, the general public began to see improv as something other than stand-up. As Edwartowski points out, "With Second City around, now the public knows what improv *is* at least a little bit more" (personal interview). Planet Ant now has improv offerings three nights a week: Monday, late night Thursday, and a fully improvised romantic comedy on Sundays called "Uncoupled."

Improvisational offerings in Detroit are rounded out by long form at Planet Ant Improv Colony for those who want to keep learning, either by doing or watching. Classes are offered at several levels in long form. But in addition to this, at the Ant on Monday a visiting team might perform, and the next week that team is at the theatre watching a different troupe; so much of the audience rotates between the stage and the seats on a weekly basis. Furthermore, the home team sits in the audience for the opening act, then takes the stage after intermission, so the line between audience and performer is further diminished, creating (as with IO) a community of long form devotees both in the seats and on the stage.

DIFFERENCES IN DETROIT'S AND CHICAGO'S LONG FORMS

While Planet Ant Improv Colony has done their share of long forms developed in Chicago, like many improv companies, the Detroit long form troupe continues to put their own stamp on the imported forms. Because all improvisation draws from the experiences of the performers, improvisers

based in Detroit are logically going to have a different set of experiences on which to draw than their counterparts in Chicago. The differences are subtle, as the goal to create innovative improvisational shows remains the same regardless of location, but the different cultural elements of any city are reflected on stage. As Edwartowski and Hayden work to build a community of improvisation in Detroit, they build on the improvisational work imported from Chicago but let it evolve to reflect the culture of the city and the suburbs of Detroit.

Subject matter is perhaps the easiest element of change to spot, as local humor will change from city to city, but the forms themselves can mutate into new versions of a long form that may have originated in Chicago. A team member of Planet Ant might see a form done in Chicago and bring it back to try, but in the transition small changes are made in the rules of play or the order of scenes, ultimately creating a new long form loosely based on a previous one. While some groups in Detroit do intentionally base their work on Chicago long form, Edwartowski sees long form as something inherently changing due to the nature of the form. She explains:

> *Truth in Comedy* is great, but it addresses long form in its embryonic stage. The Harold came out if it, which was ground breaking long form. But once people played with that, they started creating new forms. I mean, making up new forms is relatively easy. At Planet Improv [another Detroit improvisational theatre] in their *Wonderground Magic Show* they do Chicago Style Improv. No one knows exactly what that means, but for the most part it means to them that they go to Second City Chicago and ImprovOlympic for workshops and what have you, and then come back to Detroit and try to develop those same techniques here. And that's great. But more so, Chicago style improv is a term that is like a stamp of authenticity. Workshops are great, but I get a lot students who say "I was told never to do '*blank*.'" What I am trying do with long form is to continue to develop it, because something based out of imagination should be limitless. (personal interview)

Perhaps because of this limitless imagination, new long forms can be developed almost simultaneously and consequently can be called different things in different regions of the country. The Planet Ant discovered this when they began playing Ant Jam. At the same time, Second City Detroit players and students were using it but called it Commando. And the Planet Ant member who created it, John Edwardtowski called it John's Game. So within the same city, one game had three different names.

In addition to using imports from Chicago or converting them to the strengths of the Detroit players, Planet Ant has created many of their own games. The game Go described earlier, for example, is a Detroit game, though as with all improv games, another group anywhere in the world

might be playing a very similar game with a different name. Ultimately, in long form improv circles the variations in long form do not matter so long as the players involved understand the tenets of the form they are using. In fact, the name of the form does not need to be shared with the audience and often is omitted from the performance. Long form improv is perhaps the most temporal of performance improvs. Sketch-based improv can be transcribed and a script can ultimately emerge. In short form, the rules of the short form games themselves provide some record of what was done. While the particulars can vary wildly within a game, there are only so many outcomes of a game like ESPN or Super Heroes, so a record of the games played at a short form performance provides some reference level as to what occurred. But long form has more variables and more players than short form, and no script like sketch-based improv. Consequently, new things happen on stage every night—even if the same form, like a Harold, is used. The structured forms of long form, then, become simply tools to help create an organic theatrical experience between the audience and the performers. That connection between audience and players is more important than the forms themselves to long form players. And any form, be it new, old, or mutantly recycled that can create that thematic/narrative experience without a script is original long form when it goes on stage before an audience. Hence, rather than be trapped by forms, long form celebrates the freedom to improvise and create via the forms.

PRINCIPLES OF LONG FORM

Because it is a more advanced form of improvisation, long form has a glossary of terms and rules beyond those shared by all forms of improvisation discussed in chapter 1. Terms previously discusses like "edits" and the "time dash" have helped mold long form into a distinct variety and have empowered players with a working vocabulary that has allowed them to be "on the same page" as they create connected scenes. But those characteristics alone do not compose the principles of long form.

The first principle of long form is that the themes and the stories within long form **take time to develop**; they need to simmer and stir on stage for a while before the performance is done. Short form games take very little time to develop in performance, as the emphasis is on a much faster paced show. Consequently, long form performances vary from about 20 minutes to a full two-hour performance. However, the median length is about a half hour to 45 minutes. A typical evening of a long form performance might equal the two hours of a full length play, but may be comprised of only one to four different long forms. A two-hour short form performance could have up to 20 different games performed. While length is an

easy way to distinguish between short and long form improvisation, the length itself is not the essence of the distinguishing factor here, rather it is symptomatic of this goal, which is to take the time to let ideas develop improvisationally.

In the *Art of Chicago Improv*, the fact that length plays into the principles of any improvisation is annoying to the founder of the Annoyance Theatre, Mick Napier: "It's embarrassing that this is an art form that is designated by its length. It's either short…or it's long. It's an embarrassing concept to me. 'Short book, long book.' 'Small art, big art'"(Kozlowski 116–117). Kozlowski agrees: "From what I can tell from people, it should more be split into 'game' improv and 'scenic' improv" (Langguth 3). But however you dissect it, a long form like the Harold or Soap Opera will likely last longer than a short form game like Foreign Film or Props because long form aims to take the time to develop more complex and interwoven ideas.

The second principle of long form, as we have seen, is that it aims to **entertain thematically or narratively**. While short form aims for comedy with a fast paced, energetic style, long form aims to establish connections between scenes and characters that might be comic, but do not have to be in order to be successful with the audience. Often a more ironic sense of humor develops—but long form certainly does not have to be serious and ironic. Rather, the content of the scenes dictates the humor level of the show as it organically grows in front of an audience. As *Truth in Comedy* puts it, "Real humor does not come from sacrificing the reality of the moment in order to crack a cheap joke, but in finding the joke in the reality of the moment. Simply put, in comedy, honesty is the best policy" (16).

Inherently tied to that thematic or narrative principle is the third principle: **focus on truth**. The very title of Halpern, Close, and Johnson's book *Truth in Comedy* is a testament to this principle. And while all theatrical improvisational forms aim to avoid "stand-up joke" style comedy, long form allows for scenes to dig deeper than shorter forms, make connections and possibly even send a truthful and thought-provoking message to the audience. While many long form improvisations might fail to achieve this difficult goal, short form rarely if ever *aims* to send a specific thought-provoking message to the audience. And while the performers might not know what was going to be the message when the evening began, the form can become a medium of expression for whatever is on the "group mind."

The idea of the **group mind** is the next principle of long form. All improvisation, indeed all good acting, is ensemble work. However long form pushes the idea of ensemble, as a team performing a long form set must truly be "in tune" with each other. Letting go of all preconceived notions and being willing to let a performance go where it goes takes practice and training on the part of the performers. And while there is technique involved

for the individual performer, in group mind work it is also an inherent part of what makes long form function. But it can be complicated to explain due to the noncollaborative nature of much of our society. Halpern, Close, and Johnson explain:

> In the world outside of improv, the more minds that are involved in an undertaking, the lower the intelligence of the group—just look at the government (any government), or most TV and films that are created by committee! Too many cooks definitely spoil the broth.
>
> The situation is very different with improvisation. We already know that people have incredible individual capabilities. Unlike the real world, however, when a number of players are on stage, their intelligence is actually *increased*. The group intelligence is much more than the sum of its parts.
>
> When a team of improvisers pays close attention to each other, hearing and remembering everything, and respecting all that they hear, a group mind forms. The goal of this phenomenon is to connect the information created out of group ideas—and it's easily capable of brilliance. (*Truth* 92)

There are some elements of modern culture that utilize the group mind, whether they call it that or not. Sports teams are a good example of a group working toward a common goal. But even if a team is united in that goal, at times they still lose a game. And on stage, while all players might be united in the goal to perform a Harold, despite the improvisers' best efforts, the performance still might fail. It can be very difficult to let go of a preconceived direction for a scene and to truly listen both on and off stage, remembering everything. It is much easier to revert to the funny "bit" that got a laugh last time, or for a performer to push a scene in a direction that will allow him to shine. But if these pitfalls are avoided, the group mind can emerge. Halpern, Close, and Johnson note that a strong group mind experience involves a team that will "always accept the ideas of the other players without judging them to be 'good' or 'bad,' always thinking, 'This is now *our* idea'" (*Truth* 93). The group mind does not wipe out individual creativity in some strange New Age collective thinking formula. Rather, the idea of the group mind is about eliminating the concept of mistakes on stage. If everyone is paying attention and actively thinking of ways to tie material together, something said that might make no sense at the time might later become an idea on which a scene is built or a character is based. In good long form, every idea brought to the stage is used to create a mosaic-like performance. Small bits are put together to create a pattern or picture that takes on beauty and shape as it nears completion. Without the group mind, the talents of the individuals would be a messy pile of "bits"; the group mind gives form and meaning to the individual ideas, providing a medium to create a piece of art collectively.

All improvisation uses the concept of group mind to some degree, which stems from solid ensemble work. But because of the nature of long form, where ideas need to be incorporated and performers need to stay focused on the work of the group for a longer period of time than in a short form game, the group mind becomes a distinguishing factor of long form. Short form can still succeed if performers do not pay a great deal of attention to the group mind throughout the entire performance and focus only on an individual game as an ensemble. As a long form performance is all connected, the group mind is an essential goal of the performance.

Because the group mind has so much to accomplish during the performance, the audience is not as involved in an evening of long form as it would be in a short form show. Consequently, the fact that **audience participation is intermediate** becomes the next principle of long form. All live theatre performances are interactive to some degree, but improvisation in any form feeds more from the audience than a rehearsed traditional play. In short form, the audience is constantly consulted for new suggestions for games, and the interaction is a part of the evening's performance itself. In long form the audience might provide a suggestion or two, but the scenes themselves take time to develop on stage and the need to "check back" with the audience for more suggestions is outweighed by the need to create a truthful thematic or narrative performance. So the process of performing long form makes it less interactive than short form.

Segmented long form becomes the gray area in this principle as the audience is consulted more than once for suggestions during the performance of the form. With games like Advanced Montage or Ant Jam, suggestions from the audience are used throughout the show. But unlike a short form show where the audience is consulted at the top of each new game, here the suggestions from the audience feed one particular form and are tied together thematically. The audience may supply more than one suggestion, but is still less involved than the constant back and forth audience consultation of short form. Furthermore, the emphasis in long form is on improvising scenes that are tied thematically and not on playing a short form formula game into which the new suggestion is plugged.

And while, compared to short form, the audience involvement is medium to minimal, compared to a regular theatrical performance, a long form show will still feel wildly interactive with a cabaret-type quality. Because performers are making up material on the spot, they cannot rely on weeks of rehearsals to carry them through if the audience is not responding well, as actors in a regular play can. The audience's mood, therefore, greatly impacts the long form performance. An audience that is quick to laugh, or responds verbally, or exclaims a quiet "ah" of appreciation when all the pieces come together will have a huge impact on how the performers are feeling, and

therefore what the show will ultimately turn out to be. A long form audience is involved, but involved more by being eyewitness to the creation of a completely improvised show (and also part of the "in-jokes" that come with it) than by shouting out suggestions.

Finally, while in a short form performance players are encouraged to focus on the creation of a scene within the rules of the game, in long form, players are encouraged to **find a game within the creation of a scene.** Short form players know what game they will play, but the game works better if they have some sort of established and mildly believable scene work developing throughout the game. In long form, with its emphasis on scene work, making up a scene on the spot is the challenge. Consequently, little games can be used to give form to a scene. Unlike short form, these long form games don't always have a name or a specific set of rules. Long form games emerge as players agree to a set of circumstances. The "one up each other" game layered onto a scene can involve, for example, two competitive neighbors who "one up" each other with the power tools in their garages as they prepare to do some weekend home repairs. Many of the games in long form stem from the competitive nature of our culture. There are endless ways we try to "one up" each other at work, at play, at school, and so on. Cashing in on this cultural phenomenon and calling attention to it in the context of a scene then becomes a game that gives the performers a map as they create dialogue on the spot. Furthermore, a game like this, based on the one-upping with material goods, could then lead to a multitude of themes: the evils of materialism, environmentalism, corporate greed, American consumerism's impact on third world countries, and the like. Games in long form are not played to *be* the entertainment, but rather serve as a conduit for stories and ideas within the context of performance.

To review, there are six principles that all long form performances share. Long form 1) takes time to develop, 2) aims to entertain thematically or narratively, 3) focuses on truth, 4) utilizes the group mind to a greater extent than other forms of improvisation, 5) has intermediate audience participation, and 6) finds the game within the creation of a scene.

LONG FORM: THE IMPROVISERS' IMPROV

Long form offers players more complexity and a greater challenge due to the lack of a simple "game" structure or rehearsals that are found in other forms of improvisation. While games can certainly be challenging, there is a sense that short form is more accessible to the public because it involves the audience more and is far more interactive. Sketch-based improv is likewise accessible because it has the polish of a play. Long form, on the other hand, is the improvisers' improv. There is a certain "insiders" quality to a long

form show, perhaps attributed to the callbacks, the often lack of an explanation of play at performance and forms named after individuals unknown to the audience. If short form at its best is fast and witty, long form at its best is clever and intellectual. Both forms can be comic, but long form has the potential to let both audience members and players alike wrestle with issues in a completely spontaneous performance. Above all, long form improvisation requires a long form sensibility by all the players to be successful. A long form format can take on the sensibility of a short form performance if improvisers are going for quick jokes rather than scene development.

And in some ways, there is a certain appropriateness that the newest form of improvisation, long form, harkens back to the roots of improvisation in Chicago. Sketch-based improv that later developed into The Second City brand of improvisation began at the University of Chicago—the home of the atomic bomb—in 1950s, the heyday of the University's bohemian radicalism. The founders of the Compass, which later gave birth to The Second City, began by performing plays of Brecht and classics heavy with modern relevance and ideas. Long form brings this idea full circle as it ultimately aims to entertain, but to do so in a way that is thought provoking, connected, and relevant.

CHAPTER 4

SKETCH-BASED IMPROV—THE SCENE'S THE THING

SKETCH-BASED IMPROV IS NOTHING NEW TO THE WORLD OF IMPROVISATION or, indeed, the world of theatre. Simply put, sketch-based improvisation is a series of short scenes compiled together to create an evening of entertainment. The scenes are created from improvised ideas, then refined and polished in a rehearsal process before performance. The rehearsal process itself is what separates this form from the short and long forms of performance improvisation where the *process* of improvisation is the entertainment. In sketch-based improv, the rehearsal allows the faults to be worked out of a scene before it is performed for an audience—putting the product before the process. But the process of creation is still improvised for sketch-based improv, making it part of the improvisation in performance trio.

As we have seen in other forms of improvisation, not all participants agree on a name for this style of improvisation. Most practitioners of the form say they do "scene work," and indeed, ultimately that is what the process leads. As improv director Mick Napier notes, skits would be what cub scouts do—serious improvisers create scenes. (Napier journal). The process, however, is rooted in something more akin to developing an outline or a thumbnail sketch of a scene, and using improvisation to flesh out that sketch. Consequently, while scenes are performed, sketches are where the work is rooted. Therefore, "sketch-based," and all the work-in-progress, loose and unfinished qualities that the term implies, is more accurate to describe the improvisational creation process.

In traditional playwrighting a playwright alone creates the dialogue and often provides notes on the stage business and directions for a production before turning the work over to the collaborative nature of the theatrical

process. In sketch improv, the playwright is eliminated and the process is reversed. Here the actors, often with a director, perform an improvised scene, work with it by tweaking lines and adding bits. Only after the creation of a scene can it be transcribed as a matter of record, then perhaps tweaked further in performances—being written down after it has been acted.

In some sketch-based improv the material is never written down. Coming up with a sketch outline and then improvising around that scenario hails back to Greek and Roman theatre, and more notably to the *Commedia dell' arte* of the Italian renaissance. In the sketchy records of early Greek and Roman farce a few character types and scenario descriptions survive, but few scripts (Bieber 36–37). Likewise, the early *Commedia dell' arte* scenes have a surviving "script" in the outlines of scenes and bits or *lazzi*. However, the imaginations and the talents of the actors creating a performance supplemented much of the material on paper, so simply reading the material that survives is only a shallow record of the performance itself (Duchartre 50). These scripts either do not survive or survive in a sketchy format because logically, they did not serve the actor. The creators of the material knew the gist of the lines and did not need to memorize what had already been performed. A written outline of the scene might serve the actor if a scene partner needed to be replaced or if a memory needed to be jogged, but a word-for-word script had little value for this type of improvised theatricality. And for most of Western theatre history, this type of script would have been an unneeded expense for a performing company.

Transcription of contemporary sketch-based improv can serve a purpose beyond the actors' performance. It might serve as a record of the show, or as a script for an actor replacing another in a scene, or as a tool for the troupe to perfect lines in an "after the fact" editing process. But writing down all the lines is not imperative for a sketch performance. Essentially, sketch-based improvisation is collective playwrighting, with the writing being the last step. Improvisers skip right to the *doing* part of acting, and may or may not write the lines and actions later. Sketch-based improvisation then, skirts a fine line between pure improvisation and scene writing. Actors can come in with a scene idea—but then use improvisation to take an idea and "riff" with it before getting it in shape for a performance.

Sketch improv is also different in creation from a performance comprised of scenes or sketches—such as television's classic *Your Show of Shows*, David Ives' play *All in the Timing*, or other compilations of shorter pieces. Sketch improv shares much with these types of performances in the outcome, but the process of creation is different than a single writer or group of writers working on material that is later handed to actors who generally do not improvise with it. Perhaps the actors in these types of formats might improvise a line or a physical bit of business at the most, but they do not create

the core of the material in the rehearsal process, rather they work from a prewritten script. In sketch-based improv, there are no traditional writers—performers create their own material as they go—so once again it is the process, not always the product that delineates this art form from other sketch-type work.

In this process of shaping a performance from improvisation, sketch-based improv has a chance to polish the creation before it is seen by the public at large, creating something more refined, and perhaps more mainstream than other forms of performance improv. An audience might not understand the difference between how a traditional play is written and how a sketch improv performance is created. So long as the performances are solid and entertaining, the audience might well not care. Because many audiences see sketch-based improv as mainstream theatrical entertainment, and they might not be aware of the improvised quality that led to the performance, the basis of comparison for sketch-based improv is somewhat different than it is for other forms of improvisation. In a short form or long form show, the audience is aware that what they are seeing is being created for them before their very eyes. No one has seen this before, and it is quite possible that no one ever will again. That insider's knowledge of being part of the creative process influences the experience of the audience. In a sketch-based improv performance, the audience has expectations that are closer to the experience of a play—while live, and often lively, traditional theatre is polished, rehearsed, and little is left to chance. Audience members attending a sketch-based show might expect some of the elements of the show to be improvised, but they are also expecting greater polish than audiences at other improv styles. Consequently, it is not so much the experience of the audience that makes this improvisation, but the process of creating the work that is improvisational.

SKETCH IN THE FOREST

In the improvisation forest, the branch of sketch-based improvisation takes on a topiary quality. It is pruned and sheered into shape, and while quite beautiful, it might lack the wild, organic quality of the other branches. However, it is still part of the same tree in the same wild improv forest. And while the pruning and the shaping might give it a different look than the short form and long form branches, they all share the same wild roots. Sketch-based is simply a more refined version of the form—at least by the time the audience gets to see it.

There are many groups that use improvisation as a basis of sketch or scenic shows. For example, The Annoyance Theatre in Chicago takes improvised material and uses it to formulate new ideas for their stage (Seham 152–153),

as do many improvisational groups across the country. An online search of "sketch improv" will list (minimally) hundreds of improv groups that incorporate sketch improv in their performances, or perform sketch improv entirely. There are quite a number of famous sketch-based improv companies across the nation, including the Brave New Workshop in Minneapolis, Minnesota, and the Groundlings in Los Angeles. But the best known sketch improv company is The Second City, based in Chicago since 1959 with performing stages in Chicago, Toronto, Metro-Detroit, Las Vegas and training centers in New York and Los Angeles.

ORIGINS OF THE SECOND CITY

The Second City is the dominant force in sketch-based improv, partly due to its longevity, but more so to the string of successful actors and entertainers who are counted among its alumni. Gilda Radner, Bill Murray, John Belushi, Tina Fey, and Mike Myers, to name only a few, all performed on the Second City Stage before moving on to national fame first on *Saturday Night Live*, then to film careers. Other members of Second City, like Steve Carell, Stephen Colbert, Alan Arkin, and Amy Sedaris have achieved great success without the stop at *Saturday Night Live*. Second City became known as a star maker, attracting new performers and audience members alike. However, it is important to remember, Second City did not invent the form and the style they use; rather they picked up on something used and refined in the 1950s in Chicago by The Compass Players.

Janet Coleman's book, *The Compass*, neatly outlines the history of the company that laid the groundwork for The Second City. According to Coleman, The Second City had one particular "liberal arts" minded president at The University of Chicago to thank for planting the seeds of the company, Robert Hutchins. Concerned that students in higher education were being pushed into vocational training too soon in their development, Hutchins, who served as college president from 1929–1951, created a plan to focus students on the acquisition of knowledge (Coleman 4). This process included an intense program for undergrads who were focused on reading the great works of literature and knowledge in Western civilization. The program enticed brilliant students as well as brilliant faculty to the University of Chicago. Faculty member Enrico Fermi, whom Hutchins helped escape from fascist Italy, first demonstrated nuclear fission under the grand stand of the defunct football field—Hutchins having disbanded the football team at the University of Chicago (Coleman 5). Despite the fact that the workload was more than challenging, students could work at their own pace after scoring well on placement exams. Hutchinson did not adhere to age limits for entrance into the college—anyone who could pass the entrance exams

could be admitted. Coleman explains:

> An unusual and elite student population was attracted to the Hutchins Plan. They were young (Marvin Peisner '51 entered at fourteen), serious (Omar Shapli '53 came to study Egyptology), and daring (Eve Leoff '59 came from a mill town in Methuen, Massachusetts, because "my grandmother told me everyone there was a Communist and everybody slept with everybody. So I took steps to go there. And it was true. Everybody *was* a Communist and everybody *was* sleeping with everybody. I signed up for every club that had the world 'socialist' in it"). (5–6)

Having set the stage for a bohemian atmosphere, it is no surprise that bohemian students arrived in great numbers. Paul Sills, son of the great improviser Viola Spolin, had moved to California with his family but made his way back to Chicago, first to finish high school, then after World War II, to enter the University of Chicago on the GI Bill. Sills was attracted to the theatre and began working with a group of students who performed plays at the University. A young intellectual named David Shepherd also was attracted to Chicago. Having inherited a good deal of money, he spent time traveling abroad. In his travels he was impressed with the work of Bertolt Brecht, and more so by Brecht's idea that the theatre was for the public—and therefore populist. Shepherd maintained, "If you're going to have a popular theatre, you have to let people come and go and smoke and drink—be comfortable and not think of theatre as something holy and untouchable" (Sweet 5). More so, Shepherd embraced the social agenda of Brecht, which maintained that theatre should be a place of social change— that the audience, comprised of blue-collar workers, would be challenged to think about social issues rather than simply be entertained. Shepherd held to the idea that a small cabaret theatre was a grassroots way to make an impact in the world, starting with the Hyde Park community around the University of Chicago. Eventually Sills and Shepherd met and began working together in 1955.

After directing Brecht's *The Caucasian Chalk Circle* and meeting with a great deal of success, Sills knew it was time to leave the University scene and begin his own theatre. When Sills and the cash-heavy Shepherd met, they soon began working on the Playwrights Theatre Club, a place where new and edgy plays could be performed by and for the public. The idea fulfilled Sills needs as a director and Shepherd's desire to instill social change. But despite some success, the theatre quickly began to drift into the more safe area of Shakespearian classics performed without an edgy new interpretation and the work soon became less exciting. Dissatisfied with the lack of appropriate scripts for his mission, Shepherd wanted something that would speak more directly to his target audience and began to experiment with

the idea of scenario plays as "an improvisational workers' theatre presenting plays in the workers' own language that reflected their lives" (Coleman 86). From this idea, Sills' mother, Viola Spolin, was asked to work with the company at Playwrights with her improvisational games—and soon following, The Compass was born.

Originally, The Compass's goal was to perform a new full-length scenario improvised every weekend, and then do some purely improvisational material after the performance at night. That schedule soon became too grueling, as the pressure of creating a new, full-length scenario with meaning as well as entertainment value became too demanding. Eventually, the actors stockpiled characters and bits from improvised games played after the performance, and began doing a review of those pieces they knew "worked" in front of an audience but were born in improvisation. The Compass was very successful for a while, but frustrations over Shepherd's idealistic approach to the social revolution that he believed scenarios could achieve ran into trouble with the entertainment value provided by the new reviews. While social issues were still being covered in the scenarios, the comedy was more popular.

Eventually, The Compass disbanded. Sills teamed up with Howard Alk and with Bernie Sahlins—who had joined the group back in their Playwrights Theatre days and who had access to enough capital for a new investment. After finding a location and putting together a cast primarily of Compass alumni, The Second City was born. The name comes from a satirical piece in *The New Yorker* by A.J. Liebling as to why Chicago was inferior to New York. In a kind of satirical backlash, the group chose this name for their company. On December 16, 1959, The Second City opened with Barbara Harris, Severn Darden, Mina Kolb, Eugene Troobnik, Andrew Duncan, Roger Bowen, and Howard Alk. The company, as was the practice in The Compass, performed material they created themselves. Building on material stockpiled from Compass improvisations as well as the improv set done after the sketch-based performance, new material was always emerging.

The Second City became a hit in Chicago—so much so that talent scouts offered to bring The Second City to New York. This was fine with the cast, who did a limited run in a big theatre in New York that lacked the intimacy of the space in Chicago. The change in performance space effected the production, but more so, the talent was cannibalized from the move to New York. Several of the cast members left to gain fame and fortune on stage, notably Barbara Harris, who began a successful and award-winning Broadway then film career.

Bernard Sahlins was eventually left alone in Chicago to produce when Paul Sills remained in New York to direct. It was at this time that Sahlins saw the need for Chicago to be the home base of The Second City and not to use The Second City only as a vehicle to get their theatre to New York.

He explains his experience in 1964 after seeing some of his Second City actors in plays on Broadway:

> It was then that I began to appreciate an aspect of the Chicago theatre scene that had never occurred to me before. In New York or California, in the centers of "show business," if one does get a chance to work it's a high-stake and often one-shot venture. Strike out and there is seldom a second chance. In Chicago, we in the theatre are granted a magnificent right not accorded our coastal colleagues: the right to fail. Here an actor or director or playwright can present the work without paying the price of oblivion for not succeeding. Here one can try, fail, pick oneself up, and try again with little penalty. And while in Chicago ambition is always there, it can be safely stowed in the margins of your mind. It does not inform the work on a minute-to-minute basis. And there is no "scene" in Chicago, no big TV series around the corner, no Broadway stage, no movie industry. So the work can be done for its own sake rather than for where it might get you. This means better work. (Sahlins 61)

But the choice to leave the institution of The Second City headquartered in Chicago does not mean that the talented performers all stayed in Chicago. Many notable performers have gone on to fame and fortune in *Saturday Night Live*, other television programs, and films. A list of Second City alumni reads like a who's who list of comedy, partly because The Second City discovered a way to train their performers to write and perform comic material using the risk-taking (and sometimes failure-creating) tools improvisation demands. Those who have moved on from Second City with great success are not just performers; they are writers, directors, and even producers. Many Second City performers have moved on to become writers for the television and film industries because the work at Second City trains individuals to understand scenic structure.

And while The Second City remains based in Chicago, other Second Cities have sprung up throughout the years. Second City has had theatres in Cleveland, Ohio, in Edmonton as well as Alberta and in London, Ontario, and a satellite group on the northwest side of Chicago. In 1973, The Second City began in Toronto, and produced some of the most notable talent in their history, including Martin Short, Gilda Radner, John Candy, and Dan Ackroyd. The Toronto theatre continues to go strong, as do The Second Cities in Detroit and Las Vegas. The Canadian Second City not only produced great stage talent, it also paved the way for Andrew Alexander to gain experience as a producer in Toronto. In 1988, Bernie Sahlins retired as artistic director of The Second City, and the reins were passed to the next generation headed by Alexander. The Second City continues to strengthen the improv community with training centers, two Chicago stages (including

the main stage company and The Second City e.t.c. stage), as well as several touring companies performing archived material. With the reputation of The Second City in the improv community as a step toward national recognition, as well as the sheer number of people who have taken classes at their training center, The Second City has greatly contributed to the popularity of improv. While some audience members might not know or care that the material they are seeing at Second City was developed improvisationally, many performers and hopefuls flock to the theatre to learn the time-proven and successful formula of sketch-based improv, Second City style.

SKETCH-BASED PERFORMANCES

Unlike short form games and long form formats, sketch-based improv is centered on scene work. While the same basic principles of improvisation from Chapter 1 apply to sketch as short form and long form, sketch-based improv does not use a specific format to create their material. While long form uses a format to connect different, often segmented, scenes into an evening of entertainment, and short form uses a series of fast-paced games to accomplish the same thing, sketch-based improv uses improv as a tool to create a final product. This tool is different, however, than the other branches of our improvisation tree. Unlike applying improvisation to scene work as Stanislavski did or using Spolin games in a play's rehearsal, sketch-based improvisation does not use improvisation as a tool to rehearse a traditional script. Rather, sketch-based improv uses any kind of improvisation—scenes with a long form format, games, Harolds, scenes based on newspaper articles, current events, popular culture, and so on—as tools to create their sketches. And unlike a traditional play or sketch, the ideas for these sketches can come from the minds of the entire cast, as opposed to a single playwright who might come into a rehearsal with a finished script and then assigns roles to various people. Sketch-based improv emerges from the body of improvisation work done by an ensemble cast. For example, a cast can be working on some simple warm-up exercises, never meant for an audience to see—and a cast member can create a new character in that process, which then can become the basis for a scenario that is worked out in rehearsal. Or, during an improv set, a particular improv might go extremely well—this one scene or game could then be transcribed and tweaked by the cast in a rehearsal and later could emerge as a scene in performance. Even if a cast member comes to a rehearsal with a very strong idea for a scene that might at first glance seem akin to playwrighting, the scene will be worked on in rehearsal and critiqued by the ensemble, regardless of whose idea it was.

When Second City improvisers get together to rehearse, they are gathering ideas from a variety of sources. Individual actors bring in ideas, and the

director might have some specific material for the actors to use, but current events remain a mainstay in sketch-based improvisation, with many scene ideas stemming from topical social issues. When Viola Spolin began working with improvisation in the 1930s, she employed a technique called The Living Newspaper, where an article from a daily newspaper would be read and an idea would be improvised about it. This could be an article about a pressing local issue or a one line item about fashion. On the Second City stages in Chicago, even the titles of the shows take a satirical look at the headlines. The 2002–2003 show *Curious George Goes to War* puns on the popular children's books about Curious George, but here, the "George" is George W. Bush engaging in the war on terrorism. The idea of Bush being compared to a curious but troublesome monkey is in keeping with the satirical look at politics that The Second City has made throughout the years. Still, while the title of the show may reflect the satirical nature of a show, it is often one of the last things added, and might actually have little to do specifically with the review other than to highlight the fact that the review is comic because of the comic nature of the title.

Inserting one or two sketches into a primarily improvised show is quite a different thing than creating an entire review. For example, the short form practitioners of River City Improv discussed in Chapter 2 often write a sketch for the opening of their shows that might satirize a particular local issue or poke fun at movie genre or television show. Generally, in the RCI case, a formula is followed where music is involved in the opener and the entire cast must be used somehow in this opening scene. The scene is then discussed and rehearsed a few times before being performed for the audience. But creating one sketch for an opener is a much easier thing than creating a whole review of sketches, as a single sketch does not need to be balanced in the show with other types of sketches, topics, and genres since it is the only sketch in an evening of games. In a short form venue, if the sketch goes well, then the rest of the show goes merrily along. But if the sketch does not go well, the rest of the evening will still continue with the same kind of energy that an audience at a short form improvised performance has come to expect. If one bit is bad, chances are the next one will be better. A sketch-based improvisational performance has different expectations from the audience, who usually see these performances as more mainstream comedy theatre and are not likely to be as forgiving. Consequently a review of sketch-based improvisation often goes through a lengthy rehearsal process, which at Second City can be divided into three rough stages: early development, trial and modification, and performance.

After a new show has been running for a while, it becomes time to work on the next show, and the early development phase of the process begins. The time length for this will vary quite a bit depending on the location of

the theatre. In Chicago, because of a large theatre audience base, tourism, and an established name in the city, one show can run for a year. This isn't the same at every Second City stage. In Detroit, for example, the theatre scene and tourism market is smaller, creating the need for new shows to be created more often. Nancy Hayden explains:

> [In Detroit the audiences] come back and see a new show and they know they are going to get quality entertainment. There is a large enough group to do that, to sustain the run of a show for four or five months. [...] Chicago can run a year if it's great. They have. They ran *Piñata* for a year. Then within that year they can spend four months writing the next great show. (personal interview)

Regardless of where a Second City stage is located, the basic formula of the cycle remains the same. After a new show opens, actors do not rehearse in the day for a while, but do perform some improvised material after the performance at night. If two shows are performed in one night, as is the case with most Fridays and Saturdays where there will be an early and a late performance, the set of improvised material only follows the last show. This set is a bonus to the performance for which the audience has paid, and begins after a break where some of the audience invariably leaves the theatre, but many stay. The policy at The Second City has been that this performance is open to the public, so a few people may join the audience. The set isn't usually long, maybe 20 minutes or so, but it can vary depending on the response of the audience and the material being performed. At this stage in the process, ensemble players have an opportunity to play, take risks, and try new ideas. They might do some improv short form games, they might try a series of scenes based on audience suggestions, and they might try a long form set of improvisation. From this work, where the audience members now have the expectations of improvisation in performance rather than a polished review of comedy, risks can be more freely taken by the performers—as this set is a bonus to the ticket price, the audience has already got what they paid for, so the need to be polished and perfect no longer applies. While it might seem like a little extra fun, this process is an important one for performers on the Second City stage. The performers are afforded the opportunity to "riff" with their ensemble cast, in the space they normally use, and in front of an audience. New characters are created, new ideas for scenes are formed—and these seeds of potential scenes are stored in the minds of the performers for the next rehearsal process.

 When the process of creating a new show officially begins, the actors, director, and musical director now come to the theatre in the day to begin working with the material with which they have been playing in the sets at

night. Maybe a character was successful, or an idea for a location of a scene, or a conflict, situation, or even a topic. These ideas are fleshed out in the daytime rehearsals. The sets after the show begin to change as well. Rather than being a free form time to play, they are a platform to try out material from the rehearsal process in front of an audience. The seeds of ideas that are created in early sets and grow a bit in rehearsal are watered in these later sets to see if they will take root with an audience or not. The input from the sets is noted by the performers and the director and then revisited in rehearsal. Depending on the focus, length, and cadence of a scene, it might be tweaked, it might be completely revamped, or it might be dropped altogether. It is here that scenes might finally be transcribed after they are performed in a set for closer examination at rehearsal.

As the early development segment of the process comes to a close and the trial and modification period begins, the director's job changes from encouraging creativity and pushing new ideas to further development, to that of an editor, where scenes are selected, tried, modified, and omitted (Janes personal interview). Napier, whose work at Second City overlaps with his work as the founder and producer of The Annoyance Theatre in Chicago, self-published a series of online journals while directing at The Second City in Chicago. Here, he explains that the process is akin to editing a film. The director needs to think about pace, lighting, transitions, and cuts. Napier wanted to use lighting in the same manner as a film switches from scene to scene. In the rehearsal process for this particular show, *Paradigm Lost*, the group had 16 different elements including blackouts, scenes, monologues, and more; the show was running too long. The finished product actually increased the number of elements to over 35 items but actually ran much shorter due to the constant pruning of the material (Napier journal).

The second part of the process is replacing scenes of the currently running show with new scenes. Once a scene has been previewed in the set and worked enough where an ensemble and director are fairly certain it will appear in the next review, some segment of the current show will be replaced with a new one. This actually works quite well to keep shows in step with current events, as scenes that have the most "old-news" references are often the best candidates for replacement, especially in a show with a long run.

This process continues until the old show is completely replaced, and the new show is, for the most part, running on stage. This gives the director a chance to work on things that cannot be easily assessed in rehearsal, for example, the effectiveness of the running order of scenes in front of a live audience. When a new show finally opens, the old show has been completely replaced, bit-by-bit, but the new show has been previewed in one form or another many times—first in the sets, then as part of the old show under that show's title. In his online journal describing the experience of directing

the show that eventually became *Paradigm Lost* at the Second City's Chicago main stage, Napier explains in his journal that Second City shows don't exactly close, they "cross-fade."

After a show officially opens at The Second City, the actors then run the show, no longer rehearse in the day, and continue the cycle of doing sets after the last main stage show of the night—and another cross-fade begins.

CONTENT AND BALANCE

While the process of putting together a show in the cross-fade cycle has remained fairly consistent over the years at The Second City, the content of the shows has shifted to reflect the views and politics of the day. The core of the audience, according to Sahlins, has remained fairly young, giving a new edge to each decade of performance (93). The bohemian intellects of the University of Chicago beginnings, where a scene about Chekhov or *The Iliad* would have been greatly appreciated, were replaced with the more physical comedy of Second City actors like John Belushi and Chris Farley. Likewise, more pop culture references have made their way to the stage to appeal to the ever-changing landscape of our culture.

Still, within that current context, certain elements have arisen for the components and structures of a Second City review. Variety is essential, and that variety works on two major planes in the creation of a show: content of the scenes and type of scene. Logically, content—as well as the actors playing in a scene—need to be varied. Audiences do not want to see the same type of scene over and over again, and the same two actors in scene after scene about similar topics would lack the review pace and quality that Second City values. The type of scenes used at The Second City has, to a large degree, made the review format work for the theatre, despite the changing subject matter and youth culture. In the second part of his book *Days and Nights at the Second City*, entitled "Notes on Staging Review Theatre," Sahlins expands on this idea: "The ground of our work is irony, and its basic unit is the scene. These are the types of scenes that constitute a review: blackouts, parodies, songs, relating scenes, satires, and improvised games" (120).

The **blackout** is a Second City hallmark consisting of a short joke, which very quickly goes to "black" with the lights as soon as the punch line is told. On a practical level, the blackout is a great way to create a little breathing room for an actor who has a quick costume change between two longer scenes, while keeping the pace of the show quick and sharp. For example, a famous early blackout consisted of Joan Rivers and Bill Alton discussing the horrible evening out they just experienced. After a short bit of dialogue where Rivers complains of the dreadful behavior and boorish quality of their company for the evening, she declares that she never wants to go out with

them again. Alton replies, "But honey, they're our children!" (Klein 4). The lights immediately go to black as soon as the punch line is told. This format, while seen often in comedy reviews, is in fact present in some of David Mamet's early work, particularly *Sexual Perversity in Chicago*. The short, shifting scenes that quickly went to blackout are speculated by Sheldon Patinkin to have been influenced by Mamet's high school job as a bus boy for The Second City (Patinkin 34).

Parody, according to Sahlins, is the most difficult form to master because both the skill level and the content must be in sync with each other. Sahlins defines parody as "a scene that takes off on some existing form" (122). The subject and form must be appropriate as well, and the parody must make a broader social statement than to simply lampoon the *form* of the parody. Sahlins recalls, "The Second City did a parody about *The Pirates of Penzance* about the Chicago City Council, with the mayor as pirate chief and the aldermen as his pirates. The parody form was Gilbert and Sullivan, the subject was the attempt by the aldermen (pirates) to take over political power—an appropriate marriage of subject and form" (122–123). Here, the scene was more than just a parody about Gilbert and Sullivan; it also had a political message. Sahlins also recounts a parody of the ballet *Swan Lake*, entitled *Swine Lake*, which commented on the 1968 Democratic convention riots in Chicago. For this, the actors took ballet lessons so that they could achieve a skill level that matched the content; otherwise the point of fun becomes the lack of skill of the actors rather than the message of the scene (125).

Relating scenes, also called **behavior scenes**, are character scenes acted with an air of reality and believability. The characters, whether they are everyday people or famous figures, must be acted as if they were ordinary people doing believable things in the context of the scene. These scenes usually have two or three actors and focus on providing a truthful comment about society wrapped in a comic, yet believable package. A good example of this is the scene "Wicked" from Second City's *Paradigm Lost*. In it, a mother and angst-ridden teenage daughter (Tina Fey and Rachel Dratch respectively) shop in the Merry-Go-Round clothing store at a mall for jeans while maneuvering though the challenges of being products of both pop culture and their own dysfunctional family. The many references to television shows, mall chain stores, and fast food franchises all add to the issues of a young girl growing up in today's society. As the daughter struggles with body image, boys, parties, and relating to her mother, the characters (with heavy Chicago dialects) are so well drawn and believable that they are entertaining in and of themselves. Without the extra layer of specific pop references attached to it, the scene would be about a mother and daughter struggling through the tough teenage years. With that pop reference layer the scene becomes

multifaceted, adding another message of the scene—that today's families lack refinement and culture as a result of the highly commercialized mall and TV culture in which both the mother and daughter dwell. This message culminates in the last moments of the scene. The daughter, after being confronted about her romance with a young man in his car parked in a Kentucky Fried Chicken lot, says, "You're causing me serious psychological trauma, alright? You're like one of them mothers on *Sally Jessie.*" The mother quickly and dramatically exclaims, "God forbid, we are not white trash!" to which the daughter retorts, "We are *damn* close!" (Klein 11).

While "Wicked" is highly comical, some behavior scenes might be more bittersweet and more reflective than other styles of comedy. Reviews then, according to Sahlins, shouldn't have more than two or three behavior scenes, as the intensity and involvement is too large to sustain over the evening entertainment (128).

Music and song are also a mainstay of the review that are guided often by the talents of a musical director. The music director at The Second City performs every night and, like the cast, also attends rehearsals to develop both ideas for songs as well as the underscoring of certain scenes. Songs can be entirely original or parodies of more famous songs or styles; but either way, for a song to be successful in a review, it must highlight a point or truth in a comic way. Such is the case with the opening number in the 2003 Chicago e.t.c. show *Curious George Goes to War.* In the scene, a corporation is trying to think of a new song that will highlight the patriotic feel of the country for the entertainment at their annual corporate meeting. A version is sung borrowing lines from the pledge of allegiance. Objections are raised to the mention of "God," so a new version is sung with a more vague replacement for God with a general sense of spirituality. Further objections are raised until a final version of the song, with all objectionable material erased or watered down in an effort to please everyone, now pleases no one, as the new version ultimately highlights corporate greed and the negative effects of war on the country. Technically, the song is well sung by the actors and very entertaining to watch, but the comedy of the song lies in the message, not just the musicality.

Scenes of **satire** are different from behavior scenes in that some element of irony plays heavily into the scene. Here, the comedy does not stem from the behavior of the characters so much as the often-ironic ideas that are proposed. For example, in the scene called "Sportz" from the fortieth anniversary Second City Chicago review, a sports reporter interviews a winning athlete after a game. The reporter asks how the football player can account for the great turnaround in the game. In a very predictable fashion, the athlete cites his team members' group effort and the skills they all have, and also thanks the Lord for their victory today. The reporter follows up; "Now you're

coming off two tough losses at home—you personally went three games with zero receptions. Tell me why, during this dark time, did God abandon you?" (Klein 15). The athlete continues as best he can in the language of postgame platitudes, but the reporter continues his questions with the slant that the outcome of the sports world is the will of God almighty, even asking the athlete why God hates the team they beat. Here, satire is expertly handled in the ordinary situation of a winning athlete taking a moment in the spotlight to assert his faith with an extraordinary idea of a reporter taking that idea to a logical yet absurdly ironic conclusion, one that the athlete in the scene clearly did not intend with his benign and familiar comment.

Finally **games and improvisation** play a role in the making of a review. Short form games can be inserted into a review with ease, so long as the audience knows they are now going to see a game and then modifies its expectation to appreciate the creation of the scene as opposed to the product of the scene. Sahlins is not a fan of using too many games in a review, if any. But they are popular with audiences, and so long as they don't become a "mere display of technical virtuosity" (135) they can be played with some exciting results. Yet, Sahlins has reservations:

> Still, games are essentially presentational and showing off. For these reasons I feel it is a bit of a cop-out to use them in the show. But sometimes they are an easy way to get a nice energy boost, a change of pace. Sometimes a game may give an actor who is light in the show something to do. Sometimes you are stuck for a scene and everyone has run out of inspiration. Sometimes the director is lazy. (135)

Different directors, of course, had different views about how to build a review, as well as the value of games. Some felt the variety of the actors was more important than the variety of content or scenes. In *The Second City, Backstage at the World's Greatest Comedy Theater*, Sheldon Patinkin mentions other priorities in putting together a review for the directors:

> Putting the scenes into a running order has always been the hardest task for the director. When Paul Sills made a running order for the first act of our early shows, one of his main concerns was to make certain that the audience got familiar with all the performers and their individual personalities. The second act would have some scenes that allowed the performers to be seen in completely different ways from what the audience had come to expect. At the same time, Paul, like every director after him, was also concerned with keeping the momentum going in each act. That part was a bit easier in the early days, since the shows then had a different and more leisurely pace and flow, with longer and fewer scenes and less concern with constant laughs.

Paul Sill's concept of a running order, based as much as possible on the credentials of the actors, changed over the years. Bernie, for instance, when he took over as director, had come to believe that you should put a lot of your best and smartest and, if possible, most politically relevant stuff up front to establish the credentials of the show more than the actors. Now we do a little of both. (165)

The six elements of sketch-based review work—black outs, parody, behavior scenes, music and song, satire, and improvisational games—remain a mainstay of The Second City repertoire even as the way in which these elements are presented has changed over the years.

NEW DIRECTIONS FOR REVIEWS

With these foundational elements to build a review, The Second City thrived and built a solid reputation for itself. The tried and true mix of scene types seemed to work despite the changing content as the mood of the nation evolved over time. Still, critics began to see Second City's reviews as formulaic and predictable (Patinkin 164). It wasn't until Tom Gianas directed *Piñata Full of Bees* that the formula changed radically.

The eightieth review performed in 1995 at The Second City Chicago departed boldly from the format established by Sahlins' generation. By 1995, the various players of improvisation in Chicago were working with more than one format in more than one venue. Improvisational actors would receive training at both ImprovOlympic and the Second City training center—which created a unique blend of formats. Form-wise, Gianas broke out of the mold created by The Second City while still using the basic principles of parody, satire, music, and improv in the review scenes. Patinkin explains the connection:

> *Piñata* was, to a large extent, a two-act variation on Del's "Harold" using the form, but rehearsed and set rather than improvised on the spot. The results were a show that not only looked different than any Second City review in history, but also had an anarchist political edge that hadn't been seen on the main stage since the late 1960s or early '70s, from its opener in which Uncle Sam is put on trial by figures with flashlights and gas masks, to its closer, "Passion," about a man on a quest to get Americans to understand the lies our corporate and consumer culture had perpetrated on them. The scene ended with the cast asking audience members to surrender their Blockbuster Video cards because of the company's censorship practices and monopoly of the industry. The cards that were given up—and many were each night—were then cut up in small pieces and thrown over the audience's heads from a simulated water tower built above the entrance from the theatre to the back bar. (169–170)

Patinkin goes on to describe a parody of *Forrest Gump* where "Adam [McKay] played a low-level human resource director who, in the course of a standard company-wide psychological exam, learns that the company's vice president (Scott Adist) is legally retarded" (170). An improv game was cleverly employed when performer Rachel Dratch tossed a ball to a member of the audience while assuming the role of a young girl. She would then ask them questions as if they were one of her parents. The conversation would grow to other members of this contemporary "family" including the father's mistress or the girl's new stepfather.

What was ground breakingly different for Second City was not so much the politically charged content as the ability to split up scenes and revisit them using the callbacks and time dashes employed in long form. Hayden explains the impact:

> It was the first long form show *ever* at Second City. I mean they opened in 1958, so until 1995—you know that's a lot of damn years—Tom Gianas breaks away. It had been the same formula for essential 40 years. Lights up, lights down—characters, you see them once. Maybe there's a call back later in the show, but not where everything ties together and all the stories interweave. That had never ever been done. It was always scenes, song, cast scene, game; it was a formula. And *this* was, essentially, no lights down, ever. (personal interview)

By changing the form, Hayden points out the fact that the formula was altered, and by not taking the lights down in a show, the quick "black-outs" of Second City needed to be reinvented. Rather than telling a quick joke and then going to black with the lights, a joke could end a moment in a scene that is revisited later in the evening. The lights would go to "blue" instead of black as a new scene was quickly set up in the transition—making the performance almost seamless. This type of resifting of the scene order created a new challenge for directors and performers at The Second City. Tom Gianas left for *Saturday Night Live* not long after the opening of *Piñata Full of Bees,* and the next director of The Second City main stage, Mick Napier, continued the scene shifting, long form–inspired style review. Napier directed the next two shows, beginning with *Citizen Gates* in time for the 1996 election, creating a show that featured much political satire. The next show, *Paradigm Lost,* established Napier's impact in the new style of a Second City review as he took the new way of arranging scenes to a new level. He explains in his journal that while the new transitions were better on many levels, the transitions themselves should not be the "new form." For *Paradigm Lost,* Napier set the scenes in the mind of a character in a coma, creating a context for the juxtaposition of scenes that layered meaning into the transitions. While setting the show in the mind of a coma

patient is a dark, seemingly noncomic choice, the show created an irreverent frame of reference, which in turn heightened the comic moments (Napier mainstage journal).

The show was very well received, winning four Jeffrey awards (the Chicago equivalent of a Tony) for the show, the director, and two actors, neatly dispelling any critics who claimed The Second City had become predictable and formulaic. The change was inevitable as the improv community began to grow. However, it took some time for this meshing of the forms to evolve, as Del Close and Bernie Sahlins, two patriarchs of improvisation, saw the function of improvisation to be vastly different and initially helped create theatres that furthered their viewpoints.

IMPROV: FORM VERSUS FUNCTION

In Chicago, two major forces of improvisation evolved to spearhead two different approaches to the art form. On one hand, Del Close established the long form approach that eventually led to the creation of ImprovOlympic. On the other, we have Bernie Sahlins whose work with sketch-based improv to develop scenes helped establish The Second City. In its early days, Close's long form, while highly creative and freewheeling, was not polished enough for some practitioners of sketch-based scenes. A debate ensued in improvisation circles about form versus content:

> Del directed Second City from 1972 until 1983. [...] In this, his last and most legendary tenure [at Second City] Del Close and Second City owner Bernie Sahlins began the legendary argument that would last for over a decade: is improvisation merely a tool to be used in workshops and rehearsals to bring about written material? Or is it an art form in itself, to be presented theatrically in front of a paying audience all by itself? Sahlins believed strongly in the form. Close believed that in order for the Second City to evolve past its tried-and-true tradition, it needed to accept the idea that improv could be performed in front of an audience. After all, Close had taught the Harold for almost fifteen years and seen it succeed in workshops and in front of audiences. Long-form improvisation would work, and people would be willing to pay to see it.
>
> The disagreement became heated enough that Close and Sahlins could no longer work together and Close was fired from Second City in 1983, leaving Sahlins as the sole director until 1988. (Kozlowski 29–30)

The early practitioners of sketch-based improv, trained with Spolin's improv games, well understood the division between performance improvisation and rehearsal games not meant for audience consumption. Theodore J. Flicker, interviewed in Sweet's *Something Wonderful Right Away* describes

his experiences of working with the Compass and Second City in its early days of creation:

> First, we divided improvisation into two categories: Private and public improvisation. Private improvisation is classroom improvisation, which is what actors use to tune their personal instruments. With private improvisation, no one gives a rat's ass if you bore each other to death because the purpose is not to entertain the class but to sensitize yourself to your inner creative force. The problem was that too much of what had been happening on our stage was that kind of private improvisation that bored the piss out of an audience. So we decided that public improvisation first of all had to entertain. At that time we were very Brechtian, so it also had to edify, and perhaps at times even frighten, all of which came under the heading of entertainment for us. (160–161)

Before Close's group began to add structure to the more private forms, evolving them into something more public, mistrust of new forms that appeared to be more focused on the act of creating improvisation cropped up among sketch-based practitioners, as reflected in the 1978 interview conducted by Jeffery Sweet with Robert Bowen in *Something Wonderful Right Away*; here they discuss the nature of short form games, or "spot improvs":

> *Q:* I get the impression that the spot improvs are like sports events. That the audience watches a spot improv differently than a regular scene or a planned improv. They're watching the spot improv to see if you can do it, and part of the interest is that suspense element.
>
> *Bowen:* It's a game. It's a virtuoso feat we perform for the audience. We love it. When it works, the audience loves it. It's not been my experience that during any of these anyone has sent a pipeline through to infinity, you know, and real truth has come out. On the contrary, it seems to me that in content it is the most superficial of the things we do. Certainly a whole evening of complete improvisation wouldn't add up to anything. [...] I never had much interest in improvisation for its own sake. For me, the only value of improvisation is that it creates a show. It's one of several different ways of creating a show. It's like a carpenter and his tools. He doesn't fall in love with a hammer and forget about the chisel. It's just one of his tools. But what you have now with some of the people is...well, I believe there was a scholar who defined decadence as a tendency of means to swallow ends. And Nietzsche said, "A fanatic is a person who, when he forgets his purposes, redoubles his effort." These thoughts cross my mind when I see the cult of improvisation. (37–38)

What may have begun as a "cult" of improvisation to Bowen grew into the respected styles of short form and long form. And while few practitioners

of performance-based improv would disagree that the goal of improv in performance is to entertain, exactly what was regarded, as "entertainment" has been the subject of debate. Furthermore, what some improvisers would consider "private," others would consider "public." Sahlins, however, had strong views on what was worthy of being public, and that included only those scenes that met with success. He explains:

> I have a running argument with devotees of improvisation (I passionately dislike the word "improv") about its visibility and value as a presentational form. It is highly limited—momentarily interesting as a game but scarcely sustainable night after night. For one, most of the time it fails as a coherent theatre piece. When it does succeed its virtue most often lies not in its concise expression, nor in relevant content or balance of scenic structure, but in its game aspect. The audience watches it as a display of skills, like juggling, pantomime, or stage combat. They know the rules, and they are interested in how the actors achieve their goals. As an "entertainment" it is often fun to watch. But the deeper value of any expression does not depend on how it is achieved but what is expressed. Whether it is made up on the spot, found under a stone, or written down is finally not important. It is the scene itself that matters, its artistic quality and not its origins. How much better a scene can speak if it is worked on, shaped, edited, with its prolixities curbed, its self-indulgences excised. Worst of all to me, presenting pure improvisation inevitably results in the evaluation of form over content and the player of the play.
>
> I know that many actors believe they can improvise in front of an audience better scenes than anyone can write for them, and that what results is unique and can be achieved in no other way. To them I ask, why does it fail so often, and why should I forgive that? They frequently reply that it is a new form and takes time to develop. But this is not true. It is older than writing. And even the masters—the dell'arte people—codified their work and narrowed it to specific characters and comic turns that they used over and over again. Some very wise heads claim a unique, an almost metaphysical virtue in pure improvisation with an audience present. I admit to seeing some wonderful things happen in that situation. But I have also seen enough terrible things—and that is most of the time—to want to polish and prune. I just do not believe it is viable for audiences or actors to successfully improvise night after night on a regular schedule. (Sahlins 136)

For all Sahlins' arguments, Del Close disagreed. He felt he'd found a way to tap into that private inner creative force and create improvisational entertainment at the same time, as Seham explains: "Humor in a Harold is meant to come not from jokes but from the pleasure an audience takes in seeing the performers call back, or remember, justify and weave together elements of earlier scenes to create profundity out of banality" (53).

Eventually, as the 1990s dawned, Sahlins and Close became less involved in the theatres they established, and the lines between "pure" improvisation and sketch-based improvisation that led to the creation of scenes began to blur in the Chicago improv scene:

> The absence of a controlling figure as powerful as cofounder and former producer Bernie Sahlins opened the door to other innovations. Many beginning improvisers began to study at more than one place—at Second City, ImprovOlympic, Comedysportz, and other, smaller companies simultaneously. This multiple affiliation encouraged some developing improvisers to compare philosophies and techniques, to use one approach to critique another, and to feel entitled to construct their own approaches to improvisation rather than to follow any one method religiously. (Seham 114)

As The Second City offers improvisers in Chicago a rare chance for fulltime acting work with an Equity contract, the business of theatre led gifted improvisers from the ImprovOlympic to accept work at The Second City. This, coupled with various fringe improv venues—that allowed improvisers from any training background to gather and create a night of improv—led to the cross-pollination of ideas about improvisation. Like the natural evolution of a forest, where the strongest limbs of the strongest trees reach the goal of receiving light, the best improvisational ideas reached the goal of favorable audience reaction. If the audience enjoyed it, it didn't much matter from what "form" an evening of improv was derived.

Furthermore, as more audiences became familiar with improvisation, more kinds of improvisation were accepted. One does not expect the same kind of evening from a musical as a Greek Tragedy, but both can be satisfying. Audiences did not expect the same kind of evening in the ImprovOlympic as they did at Second City, just as patrons of an art museum would not expect the same kind of experience in the gallery of old masters as they would in the gallery of modern art. Form and function are united in improvisation, and both have a role to play in the enjoyment of the audience.

IMPROV FRANCHISE—SECOND CITY IMPACTS
ON THE IMPROV COMMUNITY

In her 2001 book, *Whose Improv is it Anyway? Beyond Second City*, Amy E. Seham devotes some of her work to exploring the impact Second City has had on the Chicago improv scene, and the improv companies it has helped support by its long run, training centers, and steady work. The Second City in Chicago now supports many opportunities for actors to perform, as well as gain experience. Second City supports a business theatre named BizCo that creates programs specifically to suit the needs of a corporation

that hires them. They also have three touring companies, named RedCo, BlueCo, and GreenCo, which provide talented new improvisers a chance to perform archived material and improvisation on their main stage on some weeknights, as well as travel to locations where in demand. In Chicago, the popular Second City e.t.c. stage has been in operation since 1982. This stage creates new shows in much the same way as the Chicago main stage, and in fact offers talented improvisers a place of gainful employment while creating more seats for the Second City audiences to fill.

As mentioned earlier, The Second City has a number of other stages across the country, most of which are part of the Second City organization. Only one, the Detroit branch, actually began as an official franchise bought by the Illich family, owners of Little Caesar's Pizza, the Detroit Red Wings, and a number of other Detroit based enterprises. That contract has since ended, and The Second City has opened a new theatre in Novi in the suburbs of Detroit. While Second City has created stages in places where the theatrical and improvisational talent pool has been quite saturated, such as Toronto, Northwest Chicago, and Las Vegas, Detroit remains quite an anomaly as improvisation as performance in the Detroit Metro area was just getting started when the theatre opened in 1993. Having been bought as a franchise and transplanted into a city with only a very small improvisational community made it more of a challenge to get started, as director and performer Ron West describes: "Chicago is significantly different from Detroit. In many ways, I would rather work here [in Detroit] than anywhere else. In Chicago, the director's job is easier because the talent is greater. His job is more difficult *for the same reason*. There is no getting around the fact that the people here [in Detroit] are less experienced" (personal interview).

While the actors in Detroit have not had the benefit of many improvisational companies with which to train, the impact that company has made on the theatre community cannot be underestimated, as noted earlier by Nancy Hayden with the creation of Planet Ant. What has happened on a large scale in Chicago—where Second City's training centers created a huge pool of alumni improvisers who then created new performance venues across the city—has happened on a smaller scale in Detroit. As the Detroit Second City has only been open since 1993, the number of theatres its alumni have created is considerably smaller, but is growing. In addition to Planet Ant Improv in Detroit, the state of Michigan boasts a growing number of improvisation groups formed in part by Detroit Second City alumni. Fishladder, Inc. in Grand Rapids, Michigan, was founded by Detroit Second City and River City Improv alumna Mary Jane Pories and uses improvisation to train, educate, and entertain in the workplace. And in Detroit, as in Chicago, performers at the Second City might do improvisation with a smaller troupe at a local stage on a night when the Second City stage is dark. According to

Second City Detroit producer Joe Janes, this growth has been nothing but beneficial for the improvisation community as a whole:

> I think what happened is...when Second City initially got here [to Detroit] there was this—I don't know how spoken or unspoken it was—but it was like, "this is the only game in town, if you're not doing this, you shouldn't be doing anything improv-wise." And I think one thing we were able to turn around, probably at the training center level, was starting to encourage people to go do that—go start your own group. Go get more experience because that is only going to help us in the long run. It's great that you made it through level five of our training center, but that doesn't mean that you're quite ready yet for the touring company. Go play; go do some more stuff and we'll keep tabs on you. (personal interview)

PRINCIPLES OF SKETCH-BASED IMPROVISATION

Because the bulk of sketch-based improv work is in the process and not the product, this type of improvisation has a set of qualities that reflect the unique nature of the product more than the form itself.

First, in comparison to other forms of improvisation in performance, **audience participation is minimal**. In a sketch-based review, the same show is performed night after night, and relies very minimally on audience suggestions and input to create the show before the eyes of the audience.

This is not to say that the audience is unnecessary, and the show will play as a movie does, whether anyone is in the house or not. The energy of the audience and the reactions of the audience certainly impact the overall show, but it is more akin to a **cabaret-style theatre** where the audience is occasionally addressed directly. Unlike a short form show or a long form show where a suggestion previously unknown to the performers creates the entertainment value of the performance, here it is not the challenge of the suggestions but the reactions of the audience on the polished material that fuel the performers.

As mentioned earlier by Bernie Sahlins, occasionally a review will include a game or a scene that uses an audience suggestion; but more often than not, in a polished review these suggestions will be plugged into a formula where the suggestion matters little, and a scene is already in place that only needs the missing "subject" supplied by the audience to create the improvisation. A good example of this would be "NPR" from the Second City show *Paradigm Lost*. In it, the audience is asked for a household object from which a day of programming at National Public Radio is improvised. The "game" was highly structured, however, and parodied the highbrow intellectual style of National Public Radio talk shows. One player would, for example, play the author of a book recently published on the topic supplied

by the audience. While the improvisational talents of the players cannot be faulted as it takes a great deal of skill to talk about a topic on the spot, the real thrust of the sketch came from lampooning the structure of NPR, and how the most mundane topics can be treated with a highbrow culture in the highly stylized NPR format.

This example leads to the third quality of sketch-based improvisation, **polish**. Unlike short form or long form improvisation, sketch-based improv is the only improv format that takes time to polish scenes begun in improvisation. It can be argued that short form and long form players can return to a situation or character they have played before and "polish" something that has already played in front of an audience. This is not, however, the goal of these styles of improvisation. In fact, this type of repeating of scenes or scenarios can cause problems for players of short and long forms, and the fresh and fast quality can be missing from a scene that has become a "stock" set for a player. Sketch-based, on the other hand, aims to present something practiced and smooth to its audiences. A character that appears in a rehearsal might appear again and again in the improvisational set in hopes of refining and perfecting the comedy of the character.

Tied to a polished performance, the goal of sketch-based improvisation is to be **entertaining more in content than in form**. As Bernie Sahlins mentioned, the content and the "play" that is created is paramount, not the form itself. The format of a review is simply a tool to communicate the scenes. If this format borrows from long form, deconstructionist influences, expressionistic influences, or all of the above, the emphasis is still more on what is being said and less on how it is being said. In long form and short form, the balance is slightly in the other direction, where how a message is being said is often as entertaining, if not more so, than what is being communicated.

Because the review is concerned more with content and message over form of performance, sketch-based improvisation tends to aim more for a mainstream audience than short form or long form improvisation. The polish of rehearsal, the quality of the content, and results that do not vary wildly from night to night, all cater to an audience that has been fed on a more cinematic audience experience. Additionally, for most theatre audiences, the experience at an improvisational review based on sketch improv will be more akin to that of a traditional play, where the audience does not need to participate heavily to enjoy the show. While short form aims to enliven audiences with participation, and long form aims to engage the minds of the audience to focus on the form itself as a structure of meaning, sketch-based improvisation lets the audience be the most passive and conventional, and therefore, the most mainstream.

Finally, **sketch-based improvisation aims to achieve balance between issues and comedy**. Reviews can be funny, but for them to be successful,

they need to have a bit of satirical edge to them. This, of course, can happen in short form or long form, but a message is definitely harder to achieve without rehearsal than it is in a format that allows for ideas born in improvisation to be fleshed out and manipulated into achieving a theme or a message of some kind. In long form or short form, when issues are presented in a comic fashion, it happens accidentally. In sketch-based improvisation this balance is a key ingredient to a full performance and carefully planned as the show is being formatted—it is always a goal of a show, not a happy byproduct of chance.

With minimal audience participation, cabaret-style theatre, polish in performance, entertaining content over form, and a balance between issues and comedy, sketch-based improvisation becomes the most mainstream of the improvisational forms of performance, as it is most akin to a traditional theatrical experience. Even as this branch of the improvisational tree may lean to a traditional theatre experience, it is still firmly rooted in improvisation and in fact has the longest history as improvisation in performance.

SKETCH-BASED IMPROV—THE OLDEST BRANCH, THE DEEPEST ROOTS

The cross-pollination of forms happens when the genre of improvisation as a whole grows, and players move easily from one company to the next. Because the most basic principles of improvisation are the same regardless of the form ("yes and," "don't block," etc.) the players of improvisation are not locked into one format, and bring with them, as they move from one theatre to the next, new ideas and ways of thinking that further the form.

As other forms of improvisation have sprung from the old *Commedia dell' arte* scenarios of the renaissance and have evolved in our more modern age as short form and long form, all forms can be traced back to this single branch, this arm of improvisation with the deepest root. Variants have sprung from its branches, and while some critics have denied the improvisational quality of something that is polished and pruned, time has proven that this form has a universal appeal that transcends the ages. While new forms add to the entertainment value of improvisation, it cannot be denied that sketch-based improvisation has the distinction of the longest life, the most time-tested and proven methods, and therefore, the most success.

THE GROWING FOREST

As SHOWN, improvisation in performance exists in three basic forms, yet continues to grow and evolve. Like trees in a forest, seeds of new improvisation forms take root in the fertile soil provided by the work that has gone before. Branches intertwine and sometimes appear to graft together to make the boundaries of various forms less clear. Furthermore, as seen in the case of Chicago, one improvisational company, The Second City, has helped to sow the seeds for other improvisational companies and forms to flourish. Likewise, Johnstone's short form phenomenon Theatresports has planted new companies across the globe, starting with Canadian cities and quickly spreading to the United States, Europe, and throughout of the world. And long form cultivated by ImprovOlympic, which feeds partly on the roots provided by the sketch-based work of Second City, has now grown into sketch-based work as long form has changed the way sketch-based improvisers think of the presentation of that form. These "trunk" companies provide the two necessary ingredients for new companies to form: actors trained in the craft of improvisation, and an audience that understands and appreciates each specific art form. Like a forest, these companies may have started small, but have grown in density and reach.

Newer companies are also taking on "trunk" qualities, acting as an anchor in their communities for other improvisational organizations to emerge. Detroit Second City, which owes its existence to The Second City of Chicago, now serves as a place for Detroit Metro improvisers to learn the art of improvisation and continue their work at places like Planet Ant Improv Colony. River City Improv has also benefited from the increased audience awareness of improvisation—not only by the live theatre companies in Chicago and Detroit, but also with the popularity of *Whose Line Is It Anyway?*, creating an "instant audience" familiar with the short form

games they perform. Other improvisational groups have formed in Western Michigan, due in part to the groundwork laid by River City.

THE AMBIGUITY OF INVENTION AND ORIGINS

The idea that improvisation is akin to the natural world is a good metaphor to describe its origins. Here, the three major formats of performance improvisation have been examined, each with at least one major company that feeds the growth for a particular form or style. But being a proponent of a form is not the same as inventing a form. In fact, is it possible for any single person to invent a new *form* of improvisation? Does that person invent or simply nurture a form—a branch that was already growing organically from the tree? Maybe that person waters it, protects and helps it grow, but can we credit them with the act of invention? Even long form, which has evolved into a form in its own right, began as a complicated game of sorts and sprung from work done in short form and sketch-based improv. Was it invented, exactly, or was it the product of a natural evolution of improvisation, a tweak to fill a need for more thought-provoking improvisation?

Certainly, new variations within a format can be developed. New games of short form and new types of long form are invented all the time, with the latter occasionally given the name of the inventor. Like a rose in a garden, someone can breed a new hybrid, maybe a large rose with a peach blush to it, or a small white rose that is particularly fragrant. Those gardeners are certainly entitled to name their new variety of rose (and they do, from the Peace Rose, to the John Wayne Rose). Those gardeners might even be able to hold a patent for their particular hybrid of rose. Yet, no one credits that gardener with inventing the rose itself.

The improvisation directors and teachers examined in this study are master improv gardeners. Their willingness to take risks fuels their ability to take elements from this game and that form and to try things in new combinations. From these experiments new variations emerge and grow. The variations themselves might blur the line between forms—for example, Tom Gianas' *Piñata Full of Bees* took long form elements and blended them into a sketch-based show. But Gianas did not invent a new form of improvisation. In fact, he was not the first to experiment with long form elements in a sketch-based review; he was simply the first one to do it with great success. Bits of long form appeared when Del Close worked as a director at the Second City in 1989 on the show *The Gods Must Be Lazy*. Second City's Sheldon Patinkin explains:

> *The Gods Must Be Lazy* wasn't universally admired; like Del himself, it was pretty dark, often misogynistic, and occasionally confusing to many in

our audiences. It seemed unfinished, and actually it was; Del pronounced the show ready to open two weeks prior to opening night, all but blowing off the final two weeks of preview and rehearsal. And Bernie Sahlins wasn't around anymore to finish it for him.

But the show was a harbinger of things to come. It had an edge that many who'd been criticizing us felt had been missing for too long. For the "formula" at least wasn't as apparent as it had been recently. Furthermore, part of what was occasionally confusing to our more traditional and formerly content audiences was that not everything was as neatly plotted out as they were expecting; the scenes weren't always the traditional beginning-middle-end ones they were used to. Along with his personal worldview, Del had also brought a little of the more fragmented structure of his improvisational "Harold" to the show, the long form (about an hour) he'd invented at The Committee in San Francisco and taught at the ImprovOlympic in Chicago. (161)

And even though Patinkin credits Close with inventing the long form Harold, the idea of a long form improvisation is a classification that arose well after the Harold itself in order to help audience members and improvisers distinguish the sensibility of play required for each type of performance. Contemporary practitioners are not limited primarily to one form or another, further blurring the boundaries of the origins of a form. Del Close may have started work on the Harold in a sketch-based context, but it didn't work until he collaborated with then short form practitioner Charna Halpern. Even in the 1994 book, *Truth in Comedy*, the first publication to describe a Harold in great detail, the term "long form" is not used; rather the Harold itself is used to describe the long form sensibility needed to do this type of improvisation. And it is important to remember that in this early type of long form, the Harold included both scenes and games, but scenes organized in a new way and games played without being chosen before the show began. So even this newest form has it roots in something already in existence: short form games and sketch-based improv scenes.

Throughout this study, emphasis has been placed on the *Commedia dell' arte* as a forefather of sketch-based comedy. This is so because outlines of their sketches actually exist. But even with these older forms, we cannot credit the *Commedia* players as the inventors of sketch-based improvisation. Most scholars point to the Romans and Greeks whose records are a bit less well preserved and are more inferred from descriptions by other writers and artists. We might credit the Greeks with the invention of improvisation— and why not? They are credited with inventing much of Western civilization already. But in reality, it will never be known exactly how improvisation as a performance began. As legend has it, Thespis, the first recognized actor of Greek theatre, invented the job of actor when he responded to the chorus. Was this planned? Did Thespis respond to the chorus on the spur of the moment,

moved by the rites and the ceremony of the religious observance? Did he feel from his previous performance experience that stepping away from the chorus would work in that moment, even if it was a risk? It is intriguing to consider that Thespis not only invented the first actor, he may have also invented the first improviser in performance. In fact, not all scholars agree that Thespis *was* the first actor, so the deepest root—the exact origins—remain unknown. And while this study does not aim to unearth the origins of improvisation in Greek theatre, parallels can be drawn to the ambiguity surrounding the "the first actor" and the case with the modern innovations of improvisational forms in performance. While one improvisation director or teacher may promote a form, there is no concrete evidence of invention of a form itself. Rather, the directors are caretakers and advocates of the shifting and evolving forms.

BRAVE NEW WORKSHOP, THE HYBRID

Improvisation grows organically to fulfill a goal, and while we have looked at a number of companies that specialize in one type of a performance style over another, some companies embrace all the styles. Such is the case with Brave New Workshop in Minneapolis, one of the country's oldest improvisational companies. Established in 1958 by Dudley Riggs, the company settled in Minneapolis, Minnesota. The goal of Riggs' theatre was entertainment, stemming from his own work in the family business, the circus (Johnson 63–69). Over the years, Dudley Riggs' Brave New Workshop became well known for its satirical sketches, as well as its improvisational sets (Johnson 70–77). The company was bought in 1997 by husband and wife team John Sweeney and Jenni Lilledahl, who, though they still honor Riggs as founder, have dropped his name since Riggs' retirement, and now use Brave New Workshop as their company's title. Together they have continued the tradition of performing sketch-based improvisation followed by an improvisational set. And while there are some similarities to what Brave New Workshop and The Second City do on stage, particularly since both perform sketch-based improvisation, Sweeney explains some differences between Brave New Workshop and The Second City. Brave New Workshop performs five original shows a year. They also have a specific writing process where the originator of an idea must defend the satirical element and the comedy in each piece. And the culture in Minnesota is quite different from Chicago, creating a different dynamic for their work (Dinneen 2). Another large difference is the function of the improvisational set after the original show. Unlike Second City, the improvisational set does not become a cross fading tool to create the new show. It is a popular portion of their performances following the scripted show, utilizing short or long form styles. It

is not seen as an optional "bonus" piece to the entertainment but as an important element of the performance in its own right.

As early as 1989 in the improvisational set, Brave New Workshop was doing something called a "herald" where one suggestion was taken from the audience and a series of scenes was built around this suggestion. In her thesis research on Dudley Riggs' Brave New Workshop as a tool for pedagogy, Corrine Sue Johnson describes a "herald" in her list of most often-used structures for the improvisation set:

> *Herald.* This consists of an entire series of scenes based on *one* audience suggestion that is used as a theme for all of the scenes. Each scene is not ended; one scene merely takes stage after the other. There are normally 6 to 10 scenes per herald. The final scene is established by a blackout and is determined by the technical director. (85–86)

From the above description it is clear that a Harold and a herald are not exactly the same: the former has games and a very specific structure, the latter is described simply as a series of scenes. How the Brave New Workshop started using a structure similar in name and style to the long form Harold Del Close nurtured and furthered typifies the spread of variations of any form of improvisation. According to Sweeney, the Brave New Workshop herald ended the improvisation set and would typically last about 12 minutes. The herald came to Brave New Workshop sometime in the 1980s when its creative director Mark Bergan and a group of performers went to California to participate in the Southern Comfort Comedy competition. Sweeney explains the experience:

> There were a couple of Chicago groups and San Francisco groups there. And they [the Brave New Workshop performers] thought the Harold meant not a game, but just a scene. So they came home and developed their own herald which was one suggestion and then all the scenes were inspired by that suggestion—kind of like a hub and spoke model. The center of the hub would be that suggestion and all the scenes had to have something to do with that. That's how I was taught the herald in 1993. (personal interview)

While Close may have fostered a thing called the Harold, the players from Brave New Workshop, having seen a performance of Close's version, promptly devised a similar yet new interpretation of what a Harold was—and even chose a different phonetic spelling of their version. While the Harold may have hit the improv stages first, the respective companies of the Harold/herald developed each version further in a simultaneous time period of the late 1980s and early 1990s to suit the needs and goals of the companies—to try new things, to expand in creativity, and to entertain the audience.

For Minnesota, Brave New Workshop functions as an improv trunk company, creating audience members and players versed in improvisation while creating opportunities for other companies to branch out and grow in the community. In 2007, improv webzine *Yesand.com* cited 13 improv companies in addition to Brave New Workshop groups in Minneapolis alone ("Yesand").

In some ways, Brave New Workshop represents the best of improvisation in that they do whatever style suits the desires of the performers and the audience and embrace the nature of creativity that improvisation holds, while aiming for the goal to entertain comically. And like most performers actually working in improvisation, they are not overly concerned with forms and origins. When asked in a *Performink* interview what Brave New Workshop owner John Sweeney would change if Brave New Workshop ruled the world, Sweeney replied:

> First, that no one would have to be convinced that they could improvise. Everyone would believe they could. Second, that people would live their lives "improvisationally." Finally, that no one person or organization would claim responsibility for inventing improvisation and everyone would accept it for the pure, ever changing art that it is. (Dinneen 3)

Sweeney's comment makes it clear that he sees improvisation as an art that cannot be invented, and also alludes to the idea that it is possible to live one's life improvisationally, an idea that has taken root in the improvisational community among some performers.

IMPROV FOR LIFE

If, as Shakespeare wrote in *As You Like It*, "All the world's a stage," then we are all improvising. The character Jaques may have given us seven scenes, but no script exists for them (2.7). For many players of improvisation in performance, improvisation becomes a way of life, both on stage and off. Johnstone used improvisation as a way to connect to the "common man" in his community—the ones who were attracted to sporting events and not the highbrow theatre scene. Close, on the other hand, connected to the community on a more spiritual level with his experiments in improvisation. One example of this is cited in the book, *Truth in Comedy*, where an invocation exercise practiced by Close is described. In it the group creates a god or demon; improvisers begin by first describing the god, then talking directly to it and then worshiping the god. The invocation is described as an exercise that could be easily modified to become the opening game of a Harold (108–112). The idea, however, that a group improvising together creates

something that is (even in play) worshiped tips its hand to the religious origins of theatre itself. The improvisation ritualizes the steps of creation and provides a shared mystical experience for those in attendance. In fact, it was these very invocations that further led to Close's dismissal at Second City, as he insisted on performing invocations at Second City workshops that clashed with the more mainstream improvisation sensibility of Sahlins (Kozlowski 30).

While Close may have played with the idea of tying improvisation and religious ideas together, other improvisers have seen a very real set of values for life grow from improvisational roots. The basic rules of improvisation create a philosophy by which some players choose to live their lives. The idea that you must trust the ensemble with which you play and that you must be able to read your fellow players by simply looking at them creates a sense of fellowship for some players of improvisation that have shifted into their personal lives. Improvisational rules shared by all types of performance improvisation, when applied to life, create a positive community. By accepting the situation, making your partner look good, accepting and building (yes and), and not creating blocks for your partner, a code of "life instructions" beyond improvisation emerge. As one Chicago improvisers said at a long form workshop: "The rules of improvisation have become a way of life for me. You're not there to be funny, you're there to be brave, to have courage. That applies to everyday life." The success of the recent book, *Improv Wisdom: Don't Prepare, Just Show Up*, is a testament to this kind of thinking. Written by longtime improviser, Patricia Ryan Madson, the book is divided into thirteen maxims infused with improvisation, Eastern philosophies, common sense, and human kindness. Madson neatly takes the rules of improvisation and creates a guide for better living. John Sweeney takes a similar approach in his book *Innovation at the Speed of Laughter*, this time applying the rules of improvisation to the business world to help companies increase productivity by fostering creative thinking. No surprise, better living and increased productivity both are inspired by respecting other's ideas, saying yes, and working to make your partner look good. But it can be argued that applying the rules of improvisation to life in general is nothing new, as the simple act of living is the biggest performance improvisation of all.

At the Brave New Workshop Sweeney and Lilledahl have made the philosophy of improvisation the centerpiece of their training center, Sweeney explains:

> Our defining narrative is that really all we want to do is create an environment which allows people to occasionally find what we call the white light. As we travel toward the white light as improvisers, it's that place which your head doesn't control what you do anymore. It's the place where you're

not concerned with the outcome because you're too busy with the moment. It's that place in which you just feel light and things will go as they will and you'll be okay with that. That's a rare thing, to be able to find that white lightness in improvisation. It's kind of a Buddhist quality of "got to be in the right place at the right time and got to be quiet enough to get there." It's a wonderful, wonderful thing to aspire to, and what we believe is that everyone's path towards their own white light is different. Again, it's back to the things you learn in improvising. For us to say, "this is the *way* you improvise" is hypocritical to the nature of the art form. [...]

Ours is a process of changing your life and adapting improvisational values. And like I said, a possible outcome is that you'll perform improvisational theatre. But about 60% of our students don't have any intention of ever performing in public. They could care less. That's what I meant that we've been blessed with an isolationist world up here [in Minnesota]. The competitiveness that drives the Chicago scene simply doesn't exist because not many people think that you do improv in Minneapolis and then you're on *Saturday Night Live*. The truth of the matter is it happens. [...] What we are most proud of is the person who comes through and says, "I've had an abusive husband for the last 10 years of my life and after a year of learning how to declare my point of view at the top of a scene, I finally told him that he couldn't hit me anymore. And now I've left him and I have a new life. Thank you for teaching me that value in improvisation." To me and Jen that's so much more impactful and powerful in the universe than, "Hey guess who just signed a new contract." (personal interview)

In fact, Sweeny and Lilledahl incorporated improvisational values into their wedding vows. Said Sweeney, "I'm Irish Catholic and I go to church once in a while. Improv is as much a part of my spirituality as anything I've ever learned in the Bible or church" (personal interview).

Finding that balance has been the work of Keith Johnstone for years. He maintains that education has diminished the creativity and spontaneity of many students, and that working improvisationally is a key to getting back the creativity and spontaneity we are born with. He explains:

At school any spontaneous act was likely to get me into trouble. I learned never to act on impulse, and that whatever came into my mind first should be rejected in favor of better ideas. I learned that my imagination wasn't "good" enough. I learned that the first idea was unsatisfactory because it was (1) psychotic; (2) obscene; (3) unoriginal. The truth is that the best ideas are often psychotic, obscene and unoriginal. (Impro 82–83)

Yet, it cannot be denied that the goal of many improvisers is to make a living, not to have a community building experience with their fellow improvisers or to learn the art of improvisation as a philosophy for life. In chapter 4 of

this study, Bernie Sahlins mentioned that by keeping his theatre in Chicago in the late 1960s, he took some pressure off his players by allowing them the right to take risks and occasionally fail, as Chicago was not as competitive a theatre scene as New York at that time. Such is not exactly the case today, as described by Sahlins, "One afternoon early in the decade [1970s] I wandered backstage in Chicago and overheard a member of the touring company on the telephone. I shamelessly listened in as she uttered the words 'pilot season' and 'residuals.' I was astounded. A rank beginner and *she had an agent*! 1959 was never like that!" (91). As the success and fame of actors who began with improvisational experience has evolved over the years, some improvisers see the necessity of moving beyond the community aspect of performing improvisation for the sheer joy of performance to earning a living at what they do. In some ways, this might appear at odds with the guide-to-life approach stemming from improvisation, but both the philosophical perspective and economic necessity on performing improv are combined in that the former creates a way of life, while the latter provides a means of living. Ultimately, the goal of the performers will dictate which area of improvisation philosophy will be emphasized over the other, and if those performers are lucky, they may be able to balance them both.

SENSIBILITY AND GOALS + FUNCTION
AND FORM = STYLE

As we have seen, the same form of improv (short form, long form, or sketch-based) in the hands of different theatre companies can create new styles, new approaches and evolving takes on the art of improvisation. The style of the forms a company plays will ultimately be dictated by the sensibility of a production team.

Sensibility, a mental or emotional responsiveness toward something, has played a role in the creation of contemporary improvisation performance styles. In the case of improvisation, that mindset in some improvisation directors, teachers, and performers has shaped how they use improvisation. A troupe that wants to perform improvisation is driven by performance sensibility to improvisation. A teacher who wants to use improvisation to help foster creativity in her elementary classroom is driven by an educational sensibility. That's not to say the teacher and students can't perform and the performance troupe can't teach, but the mind frame that drives these groups sets a path for their style. From a *sensibility*—that emotional response to the task—specific *goals* emerge.

Goals for performance groups emerge quickly, whether discussed prior to the creation of a group or developed along the way. Goals for performance groups are akin to a business model: some businesses start with a clear plan,

projections, and loads of preparation before opening their doors. Others start by a small product made in the basement as a hobby, which eventually grows in popularly to require a factory and several stores. The sensibility of the business will dictate how the goals emerge and what kinds of goals they will be. Groups that aim to perform in order to launch their careers, to find fame and fortune, will have different goals than groups that are driven by the fun of performance or the desire to provide live theatre to a community. These goals of improvisation in performance may dictate the form a particular group will use, but in addition to this, the goals are instrumental in developing new forms based on how much risk a group is willing to take and still meet their objective.

Everyone has heard the adage form "follows function," and that is true in improvisation as well. Based on their sensibility, which leads to the creation of specific goals, these directors, teachers, and performers of improvisation then develop a way to operate—or to function—in performance that meets their goals. From that *function*, a *form* appears, perhaps slightly different or more specific than other forms of improvisation because of the particular goals. For example, Spolin developed improvisational games with a sensibility of a teacher and drama director, with the goal to use them as an acting tool. She directed children's theatre, created the living newspaper performances, and eventually coached Second City performers using the games she developed. Other improv performers in this study used the same games, but with a different sensibility and goal that made those games into performable short form improvisational pieces in their own right. Likewise, The Compass and then The Second City looked for a way to create fresh and relevant sketch comedy using improvisation for performance. They used the short form games to develop a form that fit their needs. The result of that sensibility and goal was a sketch-based improvisational format.

Johnstone had a deep feeling that theatre should attract the populist audiences of pro-wrestling. He made a goal to create an improvisational performance that functioned in a way to fulfill this goal. The performance that emerged was Theatresports, a form of team competition short form improvisation. The creators of *Whose Line Is It Anyway?* saw the entertainment value and commercial gain of an improvised television show, and this sensibility and goal created a form that functioned to emphasize the comic talent of the performers and de-emphasized the competition of short form. Using the same games, River City Improv approached short form with a different sensibility that led to a different form. RCI founders sought an outlet for creative expression and found a noncompetitive short form improvisation venue that suited the needs of the performers. ImprovOlympic founders felt the need to experiment with the forms of short and sketch improv and move beyond them. From the goal to experiment with improvisation, the

theatre developed a new way to function that made it possible for long form to become a well-established format of improvisation. In all of these cases, a form emerged that met the goals of the performers, but because the sensibility and the goals of each group were slightly different, each group has found a different form of improvisation to suit its performance needs on stage.

Because there can be a vast number of sensibilities that drive a new improvisational performance venue, there can likewise be a vast number of types and formats that emerge. Still, as we have seen from the examples in short form, while the goals of Theatresports, River City Improv, and *Whose Line Is It Anyway?* are quite different, they all manage to do a style of improvisation that can be categorized as short form, despite the differences in the execution of the form.

Chapter 3 discussed a chart of long form improvisation where segmented long form shares some characteristics with short form—for example, the audience is approached more than once for a topic or idea, and the scenes are not necessarily connected. It is the long form sensibility, the feeling of creating a sustainable scene, that makes this type of improvisation long form in a performance. That same long form format could be inserted into a short form performance, and it could then be perceived as a short form game because it is approached with the other principles of short form dominating its play, for example, going for laughs and performing with a fast pace.

It is also quite true that a performance may not adhere strictly to the principles of one given format. A group might do short form games in the first half of their show and one long form format in the second half, or short form on Monday nights, long form on Tuesdays, and sketch-based the rest of the week. This creates further overlap of categories. The nature of experimentation allows for new techniques and mergers to be introduced in performance. If players in a short form game revive a scene that they have played before, only applying a new situation or audience suggestion to the characters, the short form game now starts to merge with a sketch-based improv, where the players work from an existing sketch or idea as they approach a scene. The same can be true for long form players who might recycle characters from one show to the next. And while in theory all sketch-based improv starts with an idea born in an improvisational set or rehearsal, in reality a player might come to rehearsal with an idea already sketched on paper, blurring the lines between scene writing and improvisation. There is gray area in all attempts to categorize performance that is made improvisationally.

This is not only true of performance improvisation but of other types of improvisation as well. As we have seen, improvisation doesn't stay put within the branch of performance improvisation. Contemporary short form, long form, and sketch-based improvisation have blended older forms of improvisation to create new performance forms. Such is the case with the entire

tree of improvisation. Improvisation used for social change, like the work of Augusto Boal, may not have performance as its first and foremost goal, but performance is a part of this work. Performers at Second City may not have social change as their primary goal, but their satire and commentary on today's society can certainly have an impact on social change. And as already mentioned, Spolin's games have been used as both a tool to teach and a means of performance. It is the performance itself, once again, that dictates on which branch of the improv tree a performance will hang.

Still, goals build and blend on what has gone before, so new forms have the potential to always emerge beyond the short form, long form, and sketch-based improvisation categories defined in this study. Indeed, a new form may be emerging at the moment, currently unnamed but played passionately by an improvisation performance group. This is how it has always been in performance. The sensibility of a group or a culture creates a goal for a performance. The goal drives a function, and a format emerges. Ancient Greek culture had a sensibility to worship Dionysus in a community event setting. That sensibility created a goal of live performance that highlighted the positive elements of Greek culture and religion which the community wished to esteem. The goal drove a function and a format. When we look at the physical remains of ancient Greek theatres, nestled in a hillside overlooking nature, the architecture of the space—the form of the space—followed the function of the theatre. Greek theatre was at all times clearly mindful of their place in the natural world of their gods. Roman's had a different sensibility— they had an appetite for entertainment and a desire for world dominance. The theatres they built blocked out the natural world and highlighted the events on stage. Their plays were less about community, religion, and culture and more about situational comedy and entertainment—and their theatres were built to suit. The medieval church's theatre had a sensibility of religion and worship, creating short plays and scenes that taught Godly lessons to the community. These plays needed to function in a way to teach a largely illiterate flock the story of the Bible while holding their interest and allowing them to participate. The form that emerged was the cycle plays performed on wagons with guilds taking ownership of stories suited to their trade. The examples go on and on throughout theatre history, which is ultimately the story of the sensibility of a culture or a time creating a form of theatre that fits its goals and meets its function. In this sense, the current world of improvisation is truly no different from any other time in theatre history.

NEW TREES IN THE FOREST

Still, while improvisation is old, sometimes it is difficult to see the forest for the trees when examining current trends. As contemporary improvisation

has the potential to be in a state of constant change, any study is inherently limited in its comparisons and analyses. New directors and performers enter the improvisational scene who have the potential to change and combine existing ways of thinking of improvisation—and from this act, new styles of improvisation altogether may emerge. Furthermore, as much has been written on The Second City in Chicago, this region has been well studied both in this study and in others. The spread of improvisation to other areas of the United States, and indeed the globe, have been less well documented, as seen by the lack of material written on the Brave New Workshop, which, opening one year before The Second City in 1958, could well claim to be the oldest improvisational company continually operating in the United States.

Improvisation continues to morph and take root in more traditional places. The popularity of improvisational training centers in all of the major styles creates a large number of actors with improvisational training seeking work not only in improvisational venues, but also in more traditional settings. It is therefore no surprise to see improvisation in performance taking hold in more established theatre companies. Traditional theatre companies across the country have noted that their core season ticket holders are aging, and passing, at an alarming rate. Bringing improvisational performances to traditional theatres has helped some companies find younger audiences. A new trend that is becoming increasingly popular for theatre companies to expand their hold in their communities is the phenomenon of 24-hour theatre.

A hybrid of traditional play writing, 24-hour theatre is infused with elements of improvisation. Generally, individuals who participate in 24-hour theatre events have exactly 24 hours to write, cast, stage, memorize, and tech a show. These 24-hour events generally bring several playwrights together, each writing one play, which is directed by a different group of individuals, resulting in a number of short, unrelated one-acts. The time constraint of doing all the work of a regular play in 24 hours forces participants to think improvisationanally and to take risks on the fly—much as improvisational performers do. Because these plays are written and rehearsed to some extent prior to the performance, and because the evening results in several short one-acts, this type of performance falls nearest to sketch-based improv, but certainly can be influenced by all three areas of improvisation.

Started in October of 1995 in New York, Tina Fallon saw inspiration from a comic book composed in one day and brought this idea to the stage. Reportedly, this experiment was meant to be done only once, where short plays were written, rehearsed, and performed in a 24-hour period. From the success of the first performance, Fallon went on to found the 24 Hour Company. The company has performed in Chicago, Los Angeles, and at the Old Vic in London (24 Hour Plays). The idea of 24-hour theatre has caught

on, and many different formulas for the basic concept have started to appear in cities across the United States and beyond. A basic Web search of 24-hour theatre will list hundreds of groups doing theatre in a short period of time, from professional theatres in London, to small high school drama groups in the Midwest.

Like Theatresports, The 24 Hour Company has developed a licensing program for groups to use their formula, but other groups seem to have simply heard of the concept and made the idea their own. Mercury Players Theatre in Madison, Wisconsin, which has been doing a 24-hour theatre event annually since their 1999 season, created a formula where a group of playwrights, directors, actors, and technicians are selected to participate in the event. The team meets at 8:00 pm on the evening before the scheduled performance. Ideas are generated for playwrights to use as a topic—some companies use props for inspiration, some pull words or phrases out of a hat, others let playwrights develop ideas on their own. The playwrights have 12 hours to work on the script before turning things over to the director and actors at 8:00 am the next morning. Actors are cast blindly in various plays, assuring that a role will exist for them if they are part of the project, as assignments are often made the night before. Actors then have 24 hours to memorize and rehearse with the director. Tech is simple, but if props or special costumes are needed, a handful of people are assigned to find these things throughout the day. A running order is developed, though some companies leave this choice to the audience. And at 8:00 pm, 24 hours after the process began, the show goes on.

Pete Rydberg, former artistic director of Mercury Players, found the event to be an enormous success for their company:

> It sells huge! It's like NASCAR—and people think it's strange when I use this analogy, but I think it works. People go to see a great race, but what they *really* are watching for are the crashes and burns. People love the risk involved.
>
> Even if you lessened the impact 24-hour theatre has on our audience base, the experience of 24-hour theatre is great for our company. It hits on so many instinctive reactions. In a short time, you do a whole play. As a director you ask yourself how do I do a show and maintain a level of actor creativity in such a high stress environment? But somehow, you do. (personal interview)

Mercury has had no trouble attracting audiences to their event, known as a *Blitz* in Madison. According to Rydberg, it has been their most popular event and attracts their most diverse audience, because the event itself features a wide range of talents and actors who want to be involved in theatre but can't always commit to a full rehearsal process. That group of performers

brings new faces to the audience, which can help build the audience base for their regular season (personal interview).

Throughout this study there is evidence that immediate forms of theatre seem to appeal to younger generations. A case in point, Alamo Basement, based in Milwaukee, Wisconsin, has been doing a version of 24-hour theatre since 2003. On their Web site, they state their hopes for 24-hour theatre quite clearly "to get younger generations excited about theater" (Alamo). In addition to 24-hour theatre, Alamo Basement cited other nontraditional performances amount its repertory, including improv, dramatic vignettes, and sketch comedy that they aim to perform in nontraditional venues like café's and other found spaces.

The traditional American theatre scene suffers from age—not of the theatres or the play but of the audience. While some theatres might die off with their older subscription base, others will reinvent themselves to speak in the language of the day to the issues of the day. As long as human beings exist, theatre will continue—the question is only what form it will take. The need to connect with other individuals in the moment, to see something live, to be part of an event is part of the human experience. Previous generations worried that television and film would replace live theatre, but it used to be that the media of television and film were "events." If you missed a television event in the 1960s or 1970s, you would never see it again, until, perhaps if you were lucky, it was reaired. Likewise, before videos became widely available, when a film left the theatre, audiences who missed it had to wait in hope it would be aired on television. In this post-VCR age, where TiVO and pod casts, YouTube.com and cell phones make entertainment available 24 hours a day on the audiences' timeline, the need for live theatre isn't diminished, it is heightened. To connect with others who experience the same thing as you in the same time is a connecting force for humans, sometime for tragedy, but just as often for comedy.

What theatres attract young audiences? Head to any one of these theatres on a given night: Second City in its various locations, The Groundlings in Los Angeles, Dad's Garage in Atlanta, Planet Ant in Detroit, Mercury Theatre in Madison, Wisconsin, Brave New Workshop in Minneapolis, The Upright Citizen's Brigade in New York, The San Francisco Mime Troupe and The Bay Area Theatresports in San Francisco, The Annoyance Theatre and ImprovOlympic (IO) in Chicago. Name a theatre company where the audiences are hip, young, or young at heart, and chances are they are writing their own material, making 24-hour theatre part of their season or dedicating at least a portion of an evening if not an entire night to improvised performances. More often than not, these companies offer training to their actors in improvisation, *Commedia dell' arte*, and scene writing and thereby building a talent pool and an audience. They are taking risks,

commenting on society and doing so with polish. They also aim to be more informal and nonelitist. Chances are also good that beer is available on the premises and can be consumed in the theatre.

Improvisation feeds much of pop culture because improvisation teaches actors to be students of the world. You have to make an effort to understand a topic in order to satirize it successfully. Skilled improvisers read the newspapers, listen to NPR, read books not related to improvisation, and are aware of their world. They are, more often than not, *actors* who have worked in theatre, went out for the plays in High School and college, and know the basics of the art and craft of performance. Improvisation gives them an artistic voice—it lets them perform their own words, thoughts, and ideas and express the feelings of their generation.

Why do so many improvisational performers go on to write for television and film? Because serious training impacts how one looks at the entire world. Through this process, individuals learn how to write, how to break down scenic structure, and how to tell a story. The best improvisers are also trained actors or seek training as actors. They take what they have learned from improvisation and a more traditional approach to character and scene work and combine the two. Successful improvisers also learn the value of working with a group. The stereotype of the ultra diva or egotistical actor flies in the face of solid improvisational work. If your goal on stage is to make others look good, then there isn't much room on stage for a diva. This sort of training rubs off into one's personal interactions. No one wants to hire a difficult personality, so if an actor learns how to work with others on stage, chances are he or she will work well with others off stage as well. Those performers who do develop these skills have a stronger chance of networking because they develop a positive reputation in the small world of theatre.

The actors who have these skills often go on to act, write, and produce television, film, and theatre. Major improv theatres proudly list many of the successes, of their alumni on their Web sites, and the accomplishments are impressive and diverse. The training seems to unleash a wave of creative thinking that has permeated our society. Still, regardless of their physical location, improvisational companies remain slightly outside the mainstream. And maybe that is where they need to be in order for the creators to take risks. As both Bernard Sahlins and John Sweeny noted, being outside the mainstream allows improv companies the latitude to do crazy things. If little is on the line, then little is lost if it flops.

BLENDING OF THE FOREST

The branches of the improvisational tree blend together with other types of performance to create new forms of improvisation. Improvisation does

not stay put—the combination of new ideas, targeted social commentary, entertainment, and popular culture creates a force that continually adds to the range of styles and forms. What does remain constant in improvisation in performance is that its main goal is to provide comic and/or thought-provoking entertainment, but how this entertainment is executed is in constant flux. Likewise, the elements of each style of performance improvisation that make it distinct are always linked to the expectations of the majority of the audience. An audience member going to a short form improvisational show will expect specific qualities and characteristics different than those expected by another audience member attending a long form or sketch-based performance. And as the experienced audience member has specific expectations for an improvisational performance, the experienced improvisational performer will also change his/her performance style and sensibility to match the style of the event. As many improv performers can play any style, the nature of the show at hand dictates their approach to the work. For example, a performer may have a different sensibility—an emotional quality or feeling—when improvising short form than when improvising long form.

Improvisation is the art of doing, not the art of critical analysis before action. It is an artistic act, performed, like any art form, to fulfill a need to create—perhaps to say something that might be important or fulfilling to the artist, and perhaps for the many joys of the creative expression itself. Consequently, new variations of improvisation develop before an audience in the temporal arena of live theatre. Just as quickly as a new form is created, it may well morph into something else, or be forgotten in the success of the next stage moment. It is not usually the intent of the artists performing live improvisation to analyze, but to re-act in the moment to all that surrounds them.

One can look at the individual elements of improvisation in performance, but to truly understand how it functions, the whole forest of improvisation must be kept in mind. Improvisation is a living art form that grows, changes, evolves, sprouts new branches, and morphs into something new. It is therefore not easy to classify as it changes quickly to suit the needs of the moment. Still, the classifications of improvisation in performance described here aim to provide a deeper understand of a performance venue that has established itself in the world of theatre to all those who explore and appreciate the ever changing forest of the arts.

TEACHING IMPROVISATION IN AN ACADEMIC SETTING—PLANTING SEEDS WITH THE PEDAGOGY OF IMPROV

ONE NEEDS VIRTUALLY NOTHING IN THE WAY OF RESOURCES TO DO improvisation. A theatre can have the bare minimum of equipment and be considered highly equipped for an improvisational show. The glitz and glamour of a large theatre house are often lacking. Props are mimed; costumes are suggested or consist of hats and accessories. As long as there are actors and a clear space, improvisation can happen. All in all, it *seems* to be a perfect solution for an academic setting where the arts are underfunded and understaffed.

Maybe you aren't an improv guru. Yet here you are, teaching acting classes, directing plays—doing something connected to acting in an academic setting. How did this happen? You wrote your dissertation on French actresses on the eighteenth-century stage, yet somehow you are expected to incorporate improvisation into your theatre program. Perhaps you majored in English or communications and are in one of those programs where theatre is glued to something else. You are a specialist expected to be a generalist. For Pete's sake, you're a designer. Perhaps you are in a high school where theatre is dumped on anyone willing or new. Maybe you are a student and no one is teaching this, but you have a hunger to do it anyway.

So you've read a lot of those "how to" improv books. There are some good ideas there—great games, great ideas. But you aren't trying to open the next Second City. You just want to introduce students to improvisation without looking stupid yourself or frightening the students off the topic forever. Or maybe you want to do a show, and improv seems like a good idea since you have a cafetorium stage (or perhaps no stage whatsoever) and you do not have to pay for rights, use costumes, have a stage or a running crew or a set or basically anything that requires a budget of any kind.

Maybe you are a student in a university or high school who is desperate to do improvisation but you aren't sure where to start or how to get a group going.

Or maybe you have an MFA in acting from a great school and you have done a lot of acting work yourself, but you've secretly harbored a fear of improvisation. Somewhere, someplace, someone made you feel like you could not do it. Maybe that someone was you. How could you possibly have the authority to introduce improvisation to a group of students who trust you to know your stuff? Stanislavski? No problem. Meisner? Piece of cake. Direct a bunch of fairy tales for children? You can do it with your eyes closed. Produce an improvisational review, let alone be in one? Sweaty palms.

A persistent and common misconception exists in the world of theatre that one needs to be an expert on improvisation to teach it. Certainly, expertise has the benefit of strengthening one's status when beginning, but an exciting thing about teaching improvisation (and teaching in general, really) is that if the leader is open, that individual will also learn while doing. This happens by simply following the idea that it is your job to make everyone else look good. When your students (who might also be your peers if you are a student leader) understand that you are experimenting, that you are willing to take risks yourself, then the expectation of "expert" is removed from the work, and the group will take more ownership for the process.

The work of studio arts has a strong heritage of learning by doing, and improvisation is perhaps the culmination of this kind of approach. It might help to think of yourself as a guide—someone with slightly more information, but not all the answers. Someone on the journey *with* the group, not someone handing them a map and saying, "Good luck."

There are two main ways to go about introducing performance improvisation in an academic setting: 1) creating a group, class, or workshop that is dedicated to improvisation and 2) weaving improvisation into an acting class. I have done both, and I've found when it is possible to do both, the class work feeds the performance group. This chapter is designed to provide practical advice on how to work improvisation into an academic setting. If you teach acting and can incorporate improv into your classroom, the

information that follows can be adapted to your lesson plans. If you are forming an improvisation performance troupe on your campus or want to organize an improv workshop, information specifically on that is in the second part of this chapter, but almost all of the information for the classroom can be easily adapted for rehearsals or workshops.

Teaching performance improvisation in a traditional acting class or even in a workshop environment can be difficult, especially with beginners, who risk a lot by showing their art. Unlike painters or writers, it can be difficult for actors, especially beginning actors, to separate themselves from their art. Criticism feels personal, even when it is aimed entirely at the work, not at the person. With traditional theatre, scene work is most often at least *written* by someone else, so there is a small buffer between the individual and the art. With improvisation, actors create their own scenes and their own characters. Criticism feels more personal because the work *is* more personal. That alone can be reason enough for theatre educators to avoid improvisation in the class room, beyond warm up games or exploratory character exercises that have become standard fare in many acting courses. I have taught improvisation as part of my acting courses for several years now. I have incorporated improvisation into my acting and directing courses, and I have mentored student groups aimed at performing improvisation—sometimes with great success and sometimes not. The following is a guide for both models, consisting of things I have learned along the way through trial and error.

INSTRUCTOR PARTICIPATION

It can be risky for teachers to actually participate as it can seem to lower their status if it doesn't succeed. Prevent that by lowering your own status before you begin. It can be a good idea to play the warm up games along with the students and participate in some of the exercises and games in the classroom. Show your class that you are going to work with them, take risks, and sometimes fail. Demonstrate how to make mistakes and laugh at your own errors. If you get caught "no butting" all over the stage, own it, laugh at it, talk about it, and move on. Being the infallible guru who only comments and never participates does not give your students the opportunity to learn through demonstration. It is useful for them to see how to do improvisation well, but equally useful for them to see how to admit to error, take a note, and move on. You don't have to be brilliant, just willing to take a risk. You also do not have to play all the time—you don't want to hog the stage, but you do want to join when it feels right.

If you have not practiced improvisation for awhile, do not fear the rust, embrace it. Maybe you used to do some improvisation, but you haven't for a long time and you feel like you will look like a fool. If you feel that way,

chances are your students feel that same sense of fear, that same pang of anxiety that they will look stupid. Embrace it—it helps you understand not only yourself, but also your students.

INCORPORATING PERFORMANCE IMPROVISATION IN AN ACTING COURSE

Build slowly. When I teach improvisation in a beginning acting course, I introduce it "officially" toward the end of the course. However, I have used it throughout the course in various forms, just never calling it performance improvisation. I have found giving students a chance to work together for a few classes (or weeks, depending on the type of course) gives them a chance to build ensemble and community—to develop trust. They trust each other, but they also learn to trust me. They learn that I am not going to make them look like a fool, that I am going to support them and give them direction and feedback that will actually improve their work. Students who sign up for an acting course are not always ready to improvise. (And no surprise, students who sign up for an improv course or workshop are not always ready to act, or even know the most basic fundamentals of acting.) Building slowly allows students to gain a sense of confidence through legitimate successes on stage.

I am often reminded of Keith Johnstone's story about school when introducing improv to my college acting students. Johnstone explains in *Impro* that he was assigned to teach students who had been labeled as unteachable failures, yet he managed to break them of that self-defacing label and move them forward in their education by not believing the label and treating the students accordingly. His students had been given a label they believed and when he gave them a different label—brilliant, creative, talented—their abilities completely turned around (*Impro* 20–23). Improv is exciting and scary to students. Some embrace the idea. But a larger group has somehow been told that there is no way they can do improv. Perhaps they tried it in high school and were made to feel they couldn't do it well, or perhaps they feel they have nothing to say and need someone else's lines to be comfortable on the stage. More often than not they feel as if they are not funny and they believe, rightly or wrongly, that improvisation is all about being funny. I stopped putting improvisation in the beginning of the syllabus for Introduction to Acting because it would strike such fear in the hearts of a handful of students that I worried they would drop the course before giving it a try. But just because it is not officially in the syllabus until the end of the course does not mean we aren't learning improvisational techniques. We do improvisation from day one. We also do more traditional introductory exercises, but warm ups and games that build confidence for

improvisation are part of the curriculum from the start. These games have the added benefit of being useful far beyond performance improvisation and fit neatly into the studio work of scripted scenes and character development expected in an acting course. The following are some ideas on how to weave improvisation skills into your acting course. Some ideas can be simply inserted into any course—like a new warm up game—without reworking the course in any way. Other ideas might require a new segment of the course or a new assignment. Adapt these ideas to fit your needs and situation, knowing that any improvisation skills taught in class can help foster a performance group on your campus.

GROUP WARM UPS

Anyone who has taken any kind of theatrical performance class is most likely familiar with the concept of group warm ups as they have many uses beyond performance improvisation. Use that familiar ground to your advantage by tilting them to improvisation. Not all the warm ups in my acting classes are group warm ups where actors interact with others, but a fair number of them are sprinkled into the course early in the semester. In addition to the group warm ups, I usually start the class with physical and vocal warm ups. A game caps the warm up portion of the class. Some games work on picking up the cues or the pace, being in the moment, acceptance or physical readiness. I start improvisational training with big group games; inevitably, if you ask for volunteers, there will be one or two people in a class who will never, ever volunteer. Help them build confidence by beginning with some nonthreatening group activities. Eventually, these nonvolunteers might take the stage for a two-person improvisation scene with a gentle prod. Don't expect big returns right away.

There are hundreds of group warm up games, and you might use your favorite and adapt it to highlight the mindset of improvisation. A quick search of the Internet will reveal loads of examples; simply search "improv games" and some great lists appear, some complete with descriptions. One thing about warm ups: every acting class does them, but not every acting class bothers to explain why. "Energy builder" is a term that I often hear, which is all well and good, but often it does not go far enough. Take half a minute to explain the goal of the warm up, either before, during, or after. You might discover other merits to these games that are not listed—feel free to add them to the list of good reasons to do these games.

Here are some that work particularly well for both training traditional acting students and building to improvisation in performance. For the most part they are old standards, some with a new twist, that are familiar to many in the theatre world. This is by no means an exhaustive list, so feel free to

add games that suit the needs of your group. Pick one or two per class—that is enough to get the group focused and ready without using too much class time for warm ups. Sprinkle them in as needed throughout the semester. Start the course with easy games and build to more challenging games depending on the skills of your group. There is no need to completely master one game before introducing a new one. Returning to the easier games after more difficult ones have been introduced can be a great way to measure the progress of the group and to remind the class of how far they have come.

Zip, Zap, Zop: (Easiest)

Players stand in a circle. Ask everyone to repeat the following three words: Zip, Zap, Zop. When they have done this, they have just learned the lines for the game. Imagine that every player has a little piece of mirror attached to their fingertips and an imaginary laser light is bouncing around the circle directed by the players. Every time a player says Zip, Zap, or Zop, the laser bounces to a new mirror.

A player starts by saying "Zip" to anyone in the circle while pointing directly at that person and making eye contact. The person who received the Zip responds quickly by pointing to someone else and making eye contact while saying "Zap." The person who was zapped responds by pointing to another person and saying "Zop." The person who received the Zop restarts the three-line bit by beginning again with Zip. The goal is to go very quickly back and forth in the circle. Students should not think about to whom they will give the Zip or Zap, and they need to stay focused and follow the "laser light" while remaining in action-ready poses. Anyone with hands in pockets or head focused downward should be instructed to be ready to receive. Do not be afraid of stopping the action if it isn't going well, correcting or clarifying, and then starting again. This is a relatively easy game and builds confidence fairly quickly. It can be played with a circle of 5 and can accommodate about 20—more than that and the players can get bored.

After the game, take a moment to explain the purpose, which is to help pick up cues, to give and receive smoothly, and to avoid anticipation of action. These skills are useful in traditional acting but also quite important for improvisation.

Redirection: When the game is lagging, it is often because actors are not being clear to whom they are pointing, not holding the point until the person who is the recipient understands he or she has been chosen, or not picking up the pace quickly enough. Direct actors with hands in pockets to stand in an action ready pose. Stop the action and demonstrate a "bad Zip" by pointing to the floor or between two players and moving slowly. Show

students how *not* to do it, and then challenge them to do it as fast as possible. This is a great game to play *with* students. Don't watch, participate.

007: (Easy/Moderate)

Once students have mastered Zip Zap Zop, move onto 007, unabashedly based on the James Bond series. Here I ask students to strike their best James Bond pose. I also inform them that we shall be embarking into a game that involves pretend gratuitous violence making it semi-inappropriate, which undoubtedly makes the group more interested.

Here, players stand in a circle, as with Zip Zap Zop. Like that game, they are shooting one word at a time across the circle to anyone they like. Instead of a series of three words, however, this game has a series of five steps: Zero, Zero, Seven, Bang, Ahhg. Player one shoots another player across the circle and says "Zero." The person who was shot then shoots another person across the circle and says "Zero" again. The third person shot then shoots a fourth person across the circle and says "Seven." So far, this is exactly like Zip Zap Zop, except with Zero Zero Seven replacing the words; this is where it becomes more interesting. The fourth person shot, who received the Seven, now shoots someone else across the circle and yells "Bang." The person who received the Bang gets to act as if they have received a flesh wound while the two people standing *next to* the person who was shot yell "Ahhg!" and react in quick mock horror by raising both of their hands. The player who received the flesh wound then starts the cycle again with zero. Repeat.

The goal of this game is to keep the pace *fast* while adding more steps and more difficulty than Zip Zap Zop. The game should be played to a beat as if on a metronome with no pause between rounds. The Ahhg should take as long to act as a Zero. Players not only have to pick up cues, they have to react to what is going on around them and keep the cycle moving.

Redirection: This game falls apart for some of the same reasons as Zip Zap Zop, so recycle those notes. If players are unfocused or unready, direct them to get into an action-ready pose, ready to receive and give. In addition to that, this game can disintegrate when students act wounded for too long, fall on the floor, or become so overdramatic with either their flesh wound, super spy impersonation, or mock horror that they lose the pace of the game. Redirect them to make all the interesting choices they like, but to do it quickly without tampering with the beat of the game.

This game has many of the same goals as Zip Zap Zop, but adds an element of character development and, most importantly, attention to the others immediately on the left and right that Zip Zap Zop does not provide. Take a moment to mention the goals when done.

Ach So Coe: (Difficult)

This game is for groups that have mastered Zip Zap Zop and 007 to the point where they might be a bit bored with the easy games. It is deeply useful for groups to at least know Zip Zap Zop before introducing this game to them.

Players stand in a circle. In a nutshell, players pass Ach, So, and then Coe to each other in a similar but more complex manner as the previous games, with some important differences and more intricate rules. The first player in the sequence starts by saying the word Ach and pointing with the left arm to someone on their right or pointing with the right arm to someone on their left. The palm is facing up and the arm goes across the body. For example, if I initiate the game I say the word "Ach" and bend my right arm across my body, palm up, pointing to the person on the left. I have the option of doing that same move with my left arm and pointing to the person on the right. Before moving on, I ask actors to do that move a few times: Ach to the right with the left arm, Ach to the left with the right arm—palm up.

The person who receives the Ach (either on the right or the left of the person who gave the Ach) repeats the sequence, this time saying the word "So" but now with the palm facing *down*. So if the person standing on my left received the Ach, she can either say "So" back to me or to the person on her left, by pointing across her body with the palm facing down. Again, practice this basic move for a moment.

Next, the person who receives the So can point to anyone in the circle and say "Coe." This is accomplished by putting both palms together and pointing with both hands to anyone in the circle. The sequence begins again, started by the same person who received the Coe, with Ach, So, Coe. Usually, when I teach this, we play a bit like this before learning the next rules. Actors need a little time to master the palms up/palms down, arms across the body elements of the game.

After the group is comfortable with facing the palms up or down and pointing with arms across the body, introduce the next element: anyone who receives the Coe can refuse it by crossing both arms in front of his body and saying "No." When this happens, the Coe is bounced back to the person who tried to give it, who must try again with a different player until someone accepts it by saying Ach and initiating the next cycle. When someone accepts it, the round begins again as usual. After no more than three or four refusals, coach the group to have someone accept it—more than that and frustration builds.

Finally, Ach So Coe is an elimination game. When someone in the group errs by using the wrong arm, taking too long to respond, or saying the wrong word, anyone in the group who caught it will say "Yen Ching" while simultaneously putting one arm in the circle and raising it up and out, hokey pokey style. The rest of the players join with the Yen Ching as soon as they

see it. Before adding the elimination element, play for a while by inserting the Yen Ching move and starting over when players see an error by using the Yen Ching. The game is the most successful when players are short and crisp with Ach, So, and Coe. Arm movements should be sharp.

When ready to actually eliminate players who make a mistake, let the group know that you are going to start the elimination round. When a player is eliminated, the player leaves the circle, but rather than dejectedly watching from the side, the job of this person is now to try to distract the other players who remain. This person can talk directly to the players or do other things in the room, but may not touch any of the players or enter the circle. When there are three remaining players, consider them the victors.

This game takes a bit to decode, but truly does build group mind and focus. Usually, it descends into a bit of chaos toward the end, but it has the interesting effect of freeing the eliminated actors to act uninhibitedly when they have a clear *goal* of eliminating other players. There is usually much to talk about after this game in terms of ensemble work.

Redirection: Beginners can get frustrated with the palms up or down. If this is making your group crazy, eliminate this part of the game. Also, a player who is trying to give the Coe but keeps getting refused can kill the pace of the game by pausing in frustration when someone says "No." Help them to keep the pace by thinking of the game like a metronome. The game should have a clear rhythm of one word syllables: Ach, So, Coe, No, Coe? No. Coe? Ach, So, Coe, Ach, So, Coe, Ach, So, Coe, No. Coe? And so on. Breaking the game down into small digestible bits is helpful when explaining it the first time. This game does not work very well with a very large group. Between six and fifteen or so players is ideal.

Zip Zap Zop, Bing Bang Bong: (Moderately Difficult)

Like Ach So Coe, this is also an advanced game. Basically, it is two games of Zip Zap Zop played in the same circle at the same time, but this time one "line" is using Zip Zap Zop, and the second line is using Bing Bang Bong. Designate someone (or do it yourself) to start the second line of Bing Bang Bong after Zip Zap Zop has been running for a little while. This is a great game for focus and concentration, and is useful for a group that has mastered Zip Zap Zop rather quickly, but does not have a lot of time to spend on group warm ups, as it is easy to explain once Zip Zap Zop is known.

This game sharpens focus and asks players to juggle more than one element in performance at a time—something actors often must do in a live performance and something improvisers do when acting all the time.

Redirection: If the group is having a great deal of difficulty keeping both threads alive with the invisible laser, add a soft small beanbag or other non-dangerous tossable object to the Bing Bang Bong line when it is introduced. Actors would literally toss the object when they say one of the words in the Bing Bang Bong line while continuing to point at each other with the Zip Zap Zop line. It is possible to use a beanbag for both the Zip Zap Zop and Bing Bang Bong lines, but they should look quite different to avoid confusion.

Who Are We, What Do We Make, What's Our Slogan?: (Easy)

Players stand in a group, facing the leader (which to start should be you). Inform the group that they are at a corporate rally, and are getting ready to create a new corporate slogan. (It is useful to act a bit, when playing the leader, as if you are one of those high energy corporate trainers/wanna-be rock stars.) The leader points to someone and asks "who are we?" The chosen individual responds with the name of the company, which can be *anything* at all. Players who can't think of anything can just say whatever they see. Or they can get creative and come up with wild sounding companies. They can even say the names of real companies. It completely doesn't matter. If that individual says "umm" very loudly for a long time, call yourselves "umm" and move on (but give that individual a chance to redeem himself later in the game by picking him again). When the name is said, everyone in the group repeats it enthusiastically, shouting it. The leader then points to a new person, who asks, "what do we make?" The person who was pointed to responds enthusiastically by saying anything at all, whether it fits with the name of the company or not. Again, once it is said, the whole group repeats it enthusiastically. The leader then asks a new player "what's our slogan?" The player yells out a short phrase or word, which again, is repeated enthusiastically by the whole group. This cycle is repeated until everyone in the group has had at least one chance to say something, though it can go on as long as you like. The pace should be relatively fast, without big pauses between what is said and what is repeated.

This is a great game for a group or class that seems to fear improvisation or is low energy. Every idea, no matter how strange or silly, is accepted enthusiastically by the group. No surprise, this simple game quickly boosts the confidence of the group. If you play the leader, pick those students more than once who seem to struggle with improvisation to shout out something. If they can't think of anything, side coach them to say whatever they see in the room, or a favorite color, or the name of their pet. It does not matter. What does matter is that players respond.

King of France: (Moderate)
This game helps students remember the names of other classmates and is useful to introduce a week or two into the semester when students know most but not quite all the names of the other students in the class. In addition to learning names, it helps them respond in the moment, pay attention, pick up cues, and deal with being the focus of attention. It is also great fun. This game can be played with numbers or names. Advanced groups might be able to skip the number round. Other groups might play the number round and build to the name round.

Players stand in a line, shoulder to shoulder, facing the director. Actors are informed that they have all been drafted into the director's personal army. They will have lines to remember and must respond correctly or they will be booted to the end of the line and will need to work their way back through ranks. It is useful for the director to take on the personality of a drill sergeant. Yell at actors to shape up, stand up straight, and respond in a loud, clear voice when spoken to. (Remember to support the sound from the diaphragm or vocal cords can suffer.) Begin by having all the actors say their names, one by one, in a loud, military fashion. The "army" has some dialogue to remember that will be the basis of the game. Ask players to repeat the dialogue a few times before going further:

> Sergeant: The King of France has lost his pants and BLANK knows where it is at. *(Sergeant inserts the name of a player for BLANK and stands in front of that person, pointing to him or her.)*
> Player: Who sir? Me sir?
> Sergeant: Yes sir, you sir.
> Player: No sir, not me sir.
> Sergeant: Then who sir?
> Player: It was BLANK *(insert new name)*, sir!

Before the sergeant is able to move to the new player mentioned, the player whose name was just said needs to step forward, salute, and simultaneously say "Who sir? Me sir?" If the player beats the sergeant, the game continues by repeating the dialogue from that point. If the sergeant beats the player and gets to that person before they step forward, salute, and say their line, that player moves to the end of the line. For example, if the first player says "It was John, sir" and the sergeant moves to John and yells "John, I got you!" before John can step forward and salute while saying his line, John moves to the end of the line.

When a player moves to the end of the line, her name does not move with her. The name of the player becomes the name of the spot in which she is standing—akin to numbering the slots, but substituting the names of the players for numbers. Consequently, if Kelly is standing in the first spot next

to Dave in the second spot and Ashley in the third, and if Kelly is sent to the end of the line, Dave moves to the first spot, but now must respond to the name "Kelly." Ashley now responds to "Dave" and so on. Kelly assumes the name of whoever was standing in the last spot. It is possible for Kelly to move back to her name if other players make mistakes and she does not, permitting her to creep slowly forward as the game progresses.

Just as if the spots in the lines were numbered, the names do not move. If numbers are used, "one" would always be the first slot, "two" the second and so on. In this example, that first slot would be named "Kelly," the second spot "Dave" and so on. It can be useful the first time the game is played to ask players to write their names on a piece of paper and put them on a row at their feet, physicalizing the slot while simultaneously naming it. The goal, though, it to play the game without the helpful props or nametags.

Think of a line of objects where the slots always must be filled. If one object is removed from the middle of the line and put at the end, there must be no gaps—all the objects that are lined up after the removed object must slide over one spot to fill the vacated slot and create a new spot at the end for the removed object to fill. If someone at the front of the row moves, everyone in the line has to shift a spot, but if the second to the last person makes a mistake, that person goes to the end of the line, and only the actor who faulted and the person in the last spot need to move.

When a player moves to the back of the line, the sergeant begins the dialogue again, from the first "King of France" line, and chooses a new name to start the action.

Redirection: Numbers can be easily substituted for names if a group is confused by the names, as the first slot remaining the number one slot is easier to remember than a name for that slot. But that move defeats the purpose of learning names and thinking in a new ordering system. Groups that start with numbers should eventually move to names after the game is understood by all.

The director's challenge is to remember the order of the names and move to the correct "slot" when a name is said, regardless of who is standing in that slot. The director can send people to the back of the line for anything he or she chooses—sloppy posture, forgotten salutes, anything that furthers the game and mixes the line. The game can be fairly physical for the actor playing the sergeant, who must move quickly from player to player while maintaining the guise of a drill sergeant.

One Letter Alphabet: (Easy)
This is an excellent game for a group that is struggling to work as an ensemble, lacking in focus, or perhaps *too* high energy. It's rather simple. Players

stand in a circle and say the alphabet, one letter at a time. They are not instructed to go around the circle, rather, the alphabet letters should be said in any order they like. The goal is to get through the entire alphabet without any player saying the same letter of the alphabet at the same time. Anytime two or more players say the same letter, the group needs to start the sequence over with the letter "A."

I have had great success with this game by doing it at the beginning of a rehearsal or a class and repeating it at the end of the session. Often, the group at the beginning cannot get through the alphabet. By the end of the session, they often can. This creates an opportunity to talk about ensemble and "group mind."

Redirection: This can frustrate actors, so encourage them to make eye contact with each other and communicate without words or gigantic gestures. Don't let individuals "conduct" their group. If a group nonverbally discovers they can accomplish this goal by going in a circle, let them have this pattern, but when they finish, challenge them to do it without the pattern.

One Word Story: (Easy)

This is one of those rare improv warm up games that can actually be easily modified for performance. (See Story Genre and Dr. Know It All in performance games.) For a warm up, I have the group sit in a circle and tell a story, one word at a time. Before we begin, we decide on a made-up title for our story. Each person can only say one word, hopefully building to a story that makes sense and is related to the title.

Redirection: The first time, this game often fails—usually because some students have a preconceived idea of where they want the story to go and ignore the last word that was said; even if their word no longer makes sense, they say it anyway, forcing it into the story. Sometimes students will pick words they think will get a laugh but make no sense in the context of the story. Let a bad story go for a while and then talk about what happened. Encourage students to accept what comes to them and build on it. This can be a great game for actors struggling with partner work. The game focuses the acceptance of ideas from others, which can be useful in any creative setting where one must work with others.

WEAVING IMPROVISATION INTO THE CURRICULUM: EXERCISES AND ASSIGNMENTS

As mentioned earlier, in my introduction to acting classes I blend traditional scene work with performance improvisation. But before I get to what I call

performance improvisation in my acting class, I give students assignments and classroom exercises that build their improvisational muscles. Many exercises well-known to acting teachers could work for this segment of the course, often by simply steering the discussion of an exercise to highlight its improvisational qualities or referencing the exercise when performance improvisation is introduced. The following are projects and classroom exercises that have worked well in my classroom, specifically for building to performance improvisation. Again, this is by no means an exhaustive list, but a small sample of ideas that can be used or developed into projects that work for your circumstances. Some of these exercises are old standards known to many, some I have tweaked for my own classes. All of them have been successful in building improvisational performers.

Like many acting professors working in the contemporary world, my approach to acting is Stanislavski-based. Indeed, it is difficult to determine if any current Western acting methodology cannot trace its roots either to Stanislavski or to a reaction to Stanislavski. At any rate, we spend a fair amount of time talking about objectives, obstacle, and character tactics. Throughout the early part of the semester, I incorporate a few character exercises into the class. They work well to build strong characters in traditional scene work and to strengthen the skills needed for improvisation in performance.

Issue Scenario Assignment

Students create a group scene that is performed in front of an audience of their peers. While it is ultimately sketch-based improvisation, I call it the "issue scenario" and reference its sketch-based improv qualities later in the course. I divide the group into four or five smaller groups of relatively equal numbers. Groups no smaller than three and no larger than six tend to work best, but modify for your own situation. I try to mix the crowd, combining upperclassmen with freshmen so that some people will know the theatre or at least the college while others will be completely new. Though this is not always possible, I try to make sure that people who are obviously excellent friends are not in the same group.

Each group works together to create a performance based on a series of instructions that are provided during a succession of classes early in the semester. The group will explore the creation of a scenario by making an outline of a performance based on an issue of the group's choosing. (I have occasionally assigned a broad issue related to events on campus—such as the issues covered in a campus-wide common reading. For example, when our campus read *The Omnivore's Dilemma*, the focus of the assignment needed to somehow connect to food issues, even if they veered from the specifics of the common reading book itself. Students were given the latitude to explore

an element of this issue in the way they chose.) The goal is to get each group to write a play consisting of five scenes based on the issue they have chosen. Everyone must be in the performance. Groups are given some class time to work on their issue plays, but the majority of the work is done outside of class. When the scenarios are due—about two or three weeks after the assignment is given—a final performance is giving in an open class. Each scene needs to be no shorter than seven minutes and no longer than nine minutes. Anything goes, but students are instructed to avoid using outlines that parody television or film, for example using a reality show or sitcom format.

This assignment is usually given during the first or second week of class, when everything is still a bit new. It is the first scene work students do together. They begin by getting into groups, introducing themselves to each other, exchanging contact information, and so on. Then, over the next few weeks, I devote one hour of class time for them to get together with their groups and discuss various topics. I start with "something you are for," followed by "something you are against." The group is told to let individuals talk about this for a while. Eventually, I ask the groups to—by consensus and not by voting—pick a topic they are either for or against. It does not have to be serious, but I encourage them, as I walk around the room, to pick topics that are at least worthy of exploration and will give them things to say. Each time I do this exercise, I change it a little bit. Sometimes I give them many odd things to consider and discuss—a favorite vacation, what kind of super power they would choose, a person who inspires them. Sometimes I don't. Some groups need more idea starters than others, so flex as needed. Ultimately the issues chosen by the groups have ranged from body image to animal testing to social cliques to parking on campus and more. Groups are instructed not to tell other groups the issue they have chosen.

After students pick an issue, their next assignment is to create a five-scene outline and develop five still life pictures of their scenes, with no movement, that represent the essence of the scene. These frozen vignettes are presented to the rest of the class about a week after the assignment is first given.

The vignettes are presented by asking a group to take the stage, while the rest of the audience watches. In between the frozen pictures, as the groups are getting into position, the audience is instructed to close their eyes or look down. When the group is ready, someone from the group says "look" and the audience considers the picture. They can have five separate scenes or one long scene with five distinct beats, but five elements are required to highlight the five-act structure used in many plays and stories.

When the vignettes are presented, I ask the groups *not* to tell the others in the class what their issue is before they start—the job of the rest of the class is to simply watch and see if they can guess the issue at the end of the

presentation. If the class cannot guess, that tells the group their storyline might need clarity or that they might need to make bolder visual choices.

After this exercise, I give students a chance to work with their peers as I visit each group, helping them clarify their ideas, work on characters, or revise the flow of their scenes. Finally, about two or three weeks after beginning the assignment, depending on how much in-class time is used, students present their scenes. I encourage them to bring whatever pieces of costumes or hand props they need to make the scene work. They can incorporate music if they want, or not.

Since this is the first scene of the class, my main objective has been to create a sense of community and collaboration, but I also neatly discover which students are confident on stage and which are insecure, which students use jokes to highlight issues and which go for jokes over issues, which take the rehearsal process seriously and which do not. The students create scenes based on discussions and character work, which gives me a springboard to discuss ensemble work, script analysis and *Commedia dell' arte*. Throughout the course, we have these scenes to use as an example of sketch-based improv. To a large degree, I've encouraged my students to do sketch-based improvisation without calling it that, simply by channeling the *Commedia* scenario–based elements and harnessing their natural story telling abilities. Later, when they learn more about improvisation, I refer back to this exercise, giving the class a boost when they realize they have already done sketch-based improvisation.

Hot Seat Exercise

Also known as Twenty Questions, this exercise is a nifty blend of improvisational techniques and Stanislavski's "magic if" in action. I've also found it to be an excellent way to introduce the idea of improvisation later on in the course. Prior to this exercise, students are assigned different scenes from the same play. (Though this could work if the class uses scenes from several different plays, it is more effective for the audience to know the play.) I assign students to do a written character analysis, where they go into detail about their characters' likes and dislikes, their past histories, memories, and the like. Students must answer the questions based on the answers in the play, but if the play does not provide an answer, they must use the "magic if" to fill it in—"if I were this character, my favorite food would be steak," for example. This is completed and handed in. The day the written analysis is due, students perform the Hot Seat Exercise.

Place a chair on the stage and ask students, one by one, to start from the side and enter the playing area, sit in the chair, and introduce themselves as the character they will be playing in their upcoming scene. Once they are seated, I say a word of welcome and ask the group if they have any questions.

The actor then needs to answer questions from the class while remaining in character. Students in the audience can use questions from the form they just completed or create new questions.

The exercise is useful in its own right as a way to flesh out characters and explain the concept of the magic if in a hands-on setting, but I reference this exercise when I introduce performance improvisation later. What is amazing here is that the actors who think they cannot improvise clearly *can* do it when they have a clear, strong character in mind and understand the format. They can be in character without a script and answer questions that may or may not be covered in the script with ease. Later, when we do improvisation scenes or games, I reference this by reminding students they are just playing Hot Seat, but they are the only ones who know the script.

Hitchhiker

Hitchhiker is a popular game known to many actors and is useful when building to an improvisation segment of the course. It can be used as a warm up or at the end of a class when you might have a little extra time to fill. It is not a good game for performance, though I have seen it done. It does not often work well in performance because its strong character format actually works against the creation of any scenic through line. It also quickly gets muddy and chaotic with beginners, which is fine in an exercise, less fine with an audience.

This is great for a larger group. Three actors start in a car, sitting on four different chairs: driver, front passenger, back seat left passenger. The rest of the group stands in a line so they can see the action, but can also remain in a line—curve a line that works best for your space. The first person in line approaches the car as if hitchhiking. Someone in the car, usually the driver, but it can be anyone, says "oh look, a hitchhiker." They pretend to stop and pick up that person. The job of the actor playing the hitchhiker is to take on a clear, strong quality or character and enter the car while plainly demonstrating that choice. The "character" can be a full fledged character from a scene, or a person with a funny quirk like the hiccups, or a passion for the local sports team. The other passengers in the car have to observe and listen to the character in order to *also* take on the *same* qualities of that character or characteristic; it's as if whatever the hitchhiker brings to the car is contagious. They chat for a while, usually a minute or less, until the next person in line enters the playing area. Someone says, "oh look, a hitch hiker" and the game repeats. This time, everyone moves over one seat: the driver goes to the back of the line, the front passenger becomes the driver, the back left passenger moves to shot gun, and the newest member of the car slides to the left, making room for the next person. This shift should happen fairly quickly. This little scenario repeats itself over until either everyone has gone

thought the circle at least once, the group tires of it, or you run out of time. If you get though the line more than once, ask those in line to stand by someone new to shake up the order.

A variation of this game is to play "Elevator," which eliminates the need for chairs. Characters change and rotate when a new person presses the elevator door button and respond accordingly. Otherwise, all the elements stay the same.

The purpose of this exercise is to let actors experiment with characters. It also gives you a chance to talk about acceptance, listening *and then* responding, as well as working as a team. This game often frees actors to make bold choices, which can translate into going for laughs. When played as a warm up, that's fine—it can actually be a confidence booster for beginners. Actors might discover the idea for a character they can flesh out later. They might have gotten a big laugh with a funny line while playing a distinct character. If those characters reappear in future scenes or games, encourage the actor to go beyond simply repeating the character. What if the funny sports fanatic was now in a different setting like the mall, the grocery store, or a tailgate party for the opposing team?

In a traditional acting course setting, this game is useful to free actors who have difficulty making bold choices on stage—whether physical or vocal. Even if a struggling actor does not initiate a bold character, inevitably someone else entering as a hitchhiker will, forcing that person to take on some bold, crazy attributes. This game also gives instructors a platform to discuss the difference between interesting character qualities and stereotypes, which can veer into offensive if gone unchecked.

Redirection Games

When responding to scene work in class, I often give direction by asking students to play a game. I tell my students, as I introduce the note, that what I am asking them to is just a game, so some of it will be strange or silly but the actors might find at least one thing that they can actually use in their scene.

For example, two student actors are doing a scene from the play *Proof,* by David Auburn, set on an outdoor patio of an older house in Chicago. The characters are sisters. The older sister, Clair, is offering what she sees as helpful advice to her younger sister, Catherine, who finds Clair annoying. It is morning and they are having coffee. In their first go with the scene, the two actors had thoroughly memorized their lines and sat at a table, never ever moving. The scene was boring because the actors made almost no physical choices and what choices they did make were small and timid. They were afraid of looking stupid and both felt a lot more comfortable when they had a table to hide behind. I asked them to play a game called "chase and get away." They needed to do the scene again, but this time, the

older, controlling sister's goal was to try to physically hug her sister, fix her
hair, or in some way touch her to let her sister know she cares about her.
The younger sister Catherine's goal was to sit down and drink her coffee
without having Clair touch her or hug her. And since it was a game, she
was forbidden to leave the stage. Because I introduce this as a game, the
fear of looking stupid is diminished—"we're just playing; who cares if it
doesn't work." In fact, most of it won't work—that's fine. We try it anyway.
Inevitably, the actors discover some movement, some connection, and some
physical element that makes the scene stronger. They also often do some-
thing that gets a laugh, appropriate or not for the scene, which lets the actor
know the audience is not bored and actually paying close attention, which
can be a huge confidence booster for beginners. We talk about it, they sim-
mer and sift through what they did, and the scene gets better. Sometimes,
when they redo the scene, the students only do a few lines before it descends
into chaos and I stop the action—but often even in that short bit there is at
least one bold move, one risk, one interesting thing that the actors invented
in that moment, without a lick of rehearsal, that worked.

Occasionally, I have encountered this same problem with actors and
changed the location of the scene, from a porch to a cotton candy factory,
or behind the counter of an ice cream parlor. The actors, who know all their
lines, now must make up movements that fit the location. The incongruity
of the scene and the location can be comic, but the lesson that movement
creates meaning is not lost. Angrily scooping ice cream and stuffing into a
cone can be translated by the actors into something more appropriate for
their scene when they work on it later.

Not all notes and scene work can or should be "games." Different actors
have different needs and the coaching they receive should address that.
But by sprinkling games into notes when it works, it is possible to reap the
benefits of students familiar with games when performance improvisation
is introduced later in the semester. Because I introduce this as a game, when
we get to performance improvisation, the class has already done a little bit
with success. If unsure how to begin, review Viola Spolin's books—really
any of her works, but particularly *Improvisation for the Theatre*—and adapt
some of her games for your specific needs.

INTRODUCING PERFORMANCE IMPROVISATION
IN THE CLASSROOM

Toward the end of the semester I introduce improvisation to my introduc-
tion to acting class more formally. We start with a quick overview of the
basic rules outlined in Chapter 1 of this book. I also explain the three major
types of improvisation—short form, long form, and sketch-based improv.

Here, I have a chance to explain to the students all the improvisation they have already done throughout the semester. However, most of the time is spent *doing* improv. We play a least one warm up game not yet introduced to the group and work on giving and receiving, as well as three-line scenes that incorporate acceptance. We then move to short form games and eventually long form structures. Starting with short form games creates a platform of knowledge on which long form and sketch-based improv can be built.

SHORT FORM GAMES

The following is a list of games used as illustrative examples throughout the book. The instructions on how to play the games are expanded here. This list contains a mixture of categories, difficulty levels, and player numbers. None of these are original and might well be found on the Web under different names. These games have been easy and useful to introduce to classes, but supplement with games that fit the needs of your class or group. They are listed in alphabetical order.

Alphabet

 Category: Short form verbal justification game

 Player Level: Easy

 Hook: Two actors must create a scene based on the suggestion provided by the audience while at the same time having the first word of each line in alphabetical order.

 Players: Two players

 Time: 2 to 5 minutes

 Suggestion from Audience: Occupation works well, but just about anything that can provide the basis of a scene

 Particulars: A. Two actors get a suggestion from the audience on which to base a scene. If the actors are fairly new to improvisation, ask for an occupation.

 B. Once the occupation or other suggestion is obtained, actor one begins the scene with a word that starts with the letter A. Actor two must respond with a word that starts with the letter B, but can say as much as he or she likes. Actor one responds with a line that starts with the letter C and so on.

 C. Once the actors have gotten though the alphabet, the scene is done.

 Pitfalls: The scene needs to make sense, and should come to some kind of conclusion as it gets closer to the end of the alphabet. The scene can

sometimes be slow if the actors are unsure of themselves or get muddled with the order of the alphabet. If an actor forgets what letter he/she is on and says an incorrect line, the rest of the team might make a buzzer sound and provide the actor with the right letter.

Variations: Instead of ending alphabet with the difficult XYZ sequence of lines, ask for a letter to begin the action as well as an occupation. The scene is done when the action gets to the same letter at which they began.

Team Alphabet: Actors divide themselves into equal numbers. The scene is played much the same before, but this time, whenever anyone makes a mistake by using the wrong letter or being too slow to pick up of a line, they are replaced by someone else on their team who assumes the same character. Actors one and two will have respective groups of equal numbers waiting to rotate in when they falter. Because some players do not make as many mistakes here, it can be useful to go through the alphabet twice.

Blind Date

 Category: Short form guessing game

 Player Level: Moderate

 Hook: Two characters have to guess each other's identities while going on a fictitious blind date.

 Players: Two players and one emcee to introduce the game

 Time: About 5 minutes

 Suggestion from Audience: Two characters, real or fictional, living or dead, who would be unlikely to go on a date with each other; and a local spot for a blind date

 Particulars: A. Two actors leave the playing area and go out of earshot. The emcee asks the audience for two characters who would be unlikely go on a date. The audience also provides a local spot as a location for a date. The emcee also instructs the audience to cheer wildly when the actors guess correctly who they are.

 B. Once the names have been provided, the audience and emcee call back the actors, and the emcee tells both actors the location of their date. The emcee then tells the first actor who the other actor's character is. Meanwhile, the second actor can grab a chair or table or whatever is needed for the location. Once the first actor has the information needed, the emcee moves to the second actor and quickly tells the second actor who the first actor is. So the actors now know who the *other* actor's character is, but do not know their own identity.

C. Once this is established, the actors begin their date and build a scene about the awkwardness of a blind date, mixed with the knowledge the actors have about their partner's character. Throughout the scene, the actors provide clues as to the identity of their partner. The clues should be subtle in the beginning and then crescendo into obvious as the game progresses. When guessing their identity, players should state the name of the character they think they are by inserting it into the conversation. When both names have been stated, the scene ends.

Pitfalls: The game is not just about guessing—the comedy ensues when the two actors actually act as though they are on a blind date and behave accordingly. Their behavior will modify as they start to guess who they are, which then layers a need for justification of past "out of character" phrases or choices into the scene. Coach players to do more than just guess names.

Another pitfall occurs when both actors guess the characters immediately and the game is over too quickly. Even if an actor immediately knows who he or she is, it can be useful to work on building the scene before guessing and ending the game.

Occasionally one actor will guess immediately who they are, and the other actor will have no idea for some time; in this case, the actor who knows his identity should focus on building the scene further while taking on his assigned character in addition to dropping clues to his partner.

If either actors has never heard of one of the characters provide by the audience, the game can seem to go on forever. It can be useful for the actors to play a bit of "sounds like" charades in the conversation. It is also useful if, after some time, another team member enters the scene (perhaps the emcee) as a likely "extra" in the location—if a restaurant, then perhaps a waiter who can serve them drinks and drop a few clues.

Dr. Know It All

Category: Short form verbal restriction

Player Level: Easy

Hook: Actors must answer questions from the audience while speaking one word as a time.

Players: Five: four doctors and one emcee to field questions

Time: 5 minutes

Particulars: A. The emcee introduces the game while the four actors stand in a line and look smart. The emcee tells the audience that Dr. Know It All has all the answers of the universe and

will happily reveal them if the audience is brave enough to ask a question.

B. The emcee takes a question from the audience and repeats it so that everyone in the audience can clearly hear it.

C. The four actors playing Dr. Know It All, upon hearing the question from the emcee, make a joint noise of contemplation (like "hmmm") and execute a simple hand gesture simultaneously—perhaps all four members cross their arms while saying "Hmm," for example. Whatever the sound and gesture, they should be agreed upon before the game is introduced.

D. The actor stage right begins by saying one word. The next actor says another until all four actors have said a word. The action flips back to the first actor if the answer or sentence is not complete.

E. When the question has been answered, the emcee can "interpret" it if it is particularly fuzzy, or comment on it before taking another question.

F. Usually Dr. Know It All consists of three to five questions from the audience, depending on the length of time allotted for the performance.

Pitfalls: Dr. Know It All is the ultimate "yes and" game—actors have to accept whatever is said, even if they thought the answer was going in a different direction. Because they can only say one word, they have to accept what was said and build on it by adding a word. Trouble occurs when an actor, who had a clear and brilliant idea, ignores what was previously said and adds a word that does not make sense in the context of the words already spoken. The game should be rehearsed to accept and build by pointing out when an actor is layering on his own ideas rather than accepting what was given.

Problems can also occur when an actor has nothing to add and gives a nonbuilding word. For example, if the word "very" has been used, the next actor might say the word "very" again, which basically is the same as sitting out that round as it does not build the action. On the flip side of this problem, sometimes a clear answer has been produced and the question has found a natural conclusion, but the next actor keeps going anyway. Rehearsing the game and coaching players to listen and build, as well as hear endings, is a great way to prevent these issues.

One reason this game is great for beginning groups is that if one of the answers does not make sense, the emcee who fields the questions can "interpret" an unclear answer in a humorous way, justifying a weak or weird answer that didn't pull together before moving on to the next question. In

some ways, it has a built in safety net, assuming the emcee is quick on the
uptake.

ESPN

 Category: Short form physical restriction game

 Player Level: Moderate

 Hook: One character turns a mundane household chore into an Olympic
style sport while the other team members commentate as various members
of a sports broadcasting team.

 Players: Four

 Time: 5 to 10 minutes

 Suggestion from Audience: A household chore

 Particulars: A. One actor is the athlete, two actors are in the booth,
and one is on the athletic field. The two actors in the
booth start the game by asking for a household chore.
That chore becomes the sport of a championship play off,
sponsored by a name brand associated with the chore.
One of the actors in the booth plays the announcer, while
the other takes the role of "color commentator" and usu-
ally assumes a character that was the champion in this
event some years ago and now provides expert commen-
tary on the details of the sport.

 B. The action begins with the athlete doing stretches of
some sort that seem to fit the physical activity of the
chore while the commentators in the booth discuss the
sport, the sponsor, the color commentator's expertise,
and the strength and weaknesses of the athlete. Once
these areas have been covered, the announcer mentions
that they have someone down on the field. The action
then switches to the reporter on the sidelines who does
an exclusive interview with the athlete before the action
begins. When the interview is finished, the commenta-
tor mentions it is almost time to begin.

 C. The commentators speak a countdown and the athlete
begins the chore, doing it with precision, speed, and style.
The color commentator usually pretends to have seen the
routine earlier and warns the audience (and the athlete)
of big moves coming up, usually with outlandish names
vaguely related to the task. The routine should be judged
both on speed and execution as well as style. The athlete has
a choice to either win or lose the event either by perform-
ing well and acting triumphantly or by tripping, falling, or
otherwise blowing the event and acting accordingly.

D. After the event, the booth comments on what was brilliant or poor, but rather quickly tosses the action back to the reporter, who gets a comment from the athlete about the event. Based on what is said, the booth will "break in" with "slow motion footage" of the sequence that won or lost the event. The athlete then repeats the sequence in slow motion, perhaps exaggerating expressions or reactions. At any time, the booth can freeze the action to comment on a particular element of the play, forcing the athlete to hold a position that can be awkward or funny.

E. At the end of the slow motion sequence, the commentators break in with the "score" from the judges, which they invent depending on the performance of the game. The athlete responds to victory or defeat with the reporter. After the score, the reporter asks the athlete about future plans and eventually tosses the commentary back to the booth, which signs out reminding viewers to catch the next championship game sponsored by a different product in an exotic world location.

Pitfalls: This game plays like a *Commedia* scenario and the main problems occur when players are unfamiliar with the outline of the action. If the reporter on the floor breaks in with an interview before the color commentator has had a chance to explain the athlete's championship season, confusion erupts and the pace can suffer. Advanced players can deal with more variations in the outline and find a way to weave all the information into the game even if it is out of order. Beginning improvisers tend to get confused and frustrated when beats are skipped or changed without warning. Make sure that all the players who participate understand their role as well as the order of the game.

The person who plays the athlete must be willing to make some outlandish physical choices and be physically able to hold some awkward positions. If a player is not ready for this challenge, then the athletic portion of the scene can be too short and not very exciting. The commentators should also be speaking on top of the action for the entire event, just as commentators do for ice skating or gymnastics or other sports where style is a factor in the presentation.

Freeze

Category: Short form group scene game

Player Level: Easy

Hook: Actors "freeze" the action of one scene, tap one actor out, resume the position of that actor, and create a new scene while justifying the physical positions and expressions of the previous scene.

Players: Four or more players, plus individuals to introduce the game

Time: 5 to 10 minutes

Suggestion from Audience: Very flexible; a location, occupation, or relationship are typical suggestions, but anything will do

Particulars: A. Players line up on the side or behind the playing area while the emcee introduces the game. Two actors get a suggestion from the audience and start a scene about that suggestion. At any time, another actor can yell "freeze," freezing the action on stage. The actor who yelled freeze taps one of the actors in the scene, resumes the same physical position and starts a totally new scene. (It can be helpful when performing for an audience without much knowledge of improvisation to demonstrate the "freeze, tap, replace, resume" aspect of the game by having actors pantomime this action during the introduction.)

B. When the new scene has gone on for a bit, any actor on stage can yell "freeze," tag out someone, and take the scene in a new direction. The actor tagged out returns to the line. This cycle repeats until the game ends. The scenes should be fairly fast paced, but should not be so fast that the scenes have no chance to build. A good rule of thumb is each actor needs to say at least two lines before the action is frozen as scenes that are changed too quickly make for muddy scene work. Certainly, they can say more than two each, and should if the scene is going well. The more interesting physical positions actors can create the more challenging it can be for the next person to justify the same body position. Consequently, Freeze can be a fairly physical and expressive game—though certainly not every scene has to contain extreme physical elements like warring ninjas or downhill skiing.

C. At some point, when everyone has had a chance to play at least one scene or the scenes have gone on long enough, the action is ended either by a technician in a light booth taking the stage to black, or by the person who introduced the game ending it by yelling "freeze freeze, freeze, and freeze," "and freeze," "end scene," or some other pre-established phrase that the performers will recognize as the end of the game.

Pitfalls: The beauty of this game is that a bad scene that is going nowhere can quickly be frozen and a new one started. Trouble happens when no one

on the team has an idea and lets a bad scene go for too long. Encouraging members to jump in and start something can be a problem for beginners who feel they must have an idea to jump in. Trouble can also happen when an overly eager team member freezes a scene that has just started and is going very well or hasn't yet established itself. It takes some practice to know how to let a good scene grow and when to rescue a dying scene. When these problems persist, a team can try playing Blind Freeze, the variation below.

Variation: There are many variations to Freeze, but one that works well for beginning teams (meaning either the individual members are new to improvisation or the group is new to working together, or both) is Blind Freeze.

Here, actors line up and play Freeze as explained above, but instead of any player randomly yelling freeze, the actors go in order of their line. The next person to enter the scene must turn around and only hear the scene. At any point, that person can, without seeing the scene, yell freeze. The actor then turns around, sees the positions, and then taps someone out and begins the scene again. The next person in line turns around as the new actor enters the stage. The actor tapped out goes to the end of the line. The cycle repeats.

Some groups play Blind Freeze where the next actor must tap out the actor who has been on stage the longest. Other groups omit this, which creates the possibility of the line order changing if the group wants to run through the line more than one time.

Mime Debate

Category: Short form group guessing game

Player Level: Easy to moderate

Hook: Two debaters have to guess a verb, adjective, and noun in the style of a formal debate while getting clues from team members miming action behind their opponent. The debaters have to justify all their guesses in the language of debate.

Players: Six players, plus individuals to introduce the game and keep time

Time: 5 to 10 minutes

Suggestion from Audience: V. A. N.: "ing" verb, an adjective, and a noun

Particulars: A. Two actors leave the playing area and go out of earshot. The emcee explains that two members of the team will be holding a debate but they need to guess what exactly they are debating. The emcee gets from the audience a verb ending in "ing," an adjective, and a noun. They do not have to make sense, and in fact the audience should be encouraged to provide suggestions that are challenging

to act. "Walking angry bananas" will be less challenging than "subsisting esoteric salad-shooters." The challenging suggestions will take longer, so keep time in mind when taking a suggestion. At least one of the words should be fairly abstract or the game will be over too quickly.

B. Once the verb, adjective, and noun have been selected, the team members out of earshot return to the stage. They face each other as if in a debate. Behind both debaters, two other team members position themselves to be seen by only one of the debaters. The debater, while pretending to seriously debate a topic, will watch the two teammates he can see as they "mime" the verb, adjective, and noun.

C. The debaters decide who will be for and who will be against the topic. The person for the topic always starts.

D. The action begins when one debater starts talking. The first team of mimes begin enacting the first word, always the verb. They have 30 seconds to act. The debater must behave the entire time as if in a serious debate and not simply playing charades. At the end of the 30 seconds, the timer yells "time" and the mimes who have been acting turn their back on the action so as not to see what the other team of mimes is doing to explain the word. After 30 seconds, the action switches to the debater who is against the topic. The cycle repeats until all the words are guessed.

E. The word is guessed when the debater actually says the *exact* word. The audience should applaud when the right word is guessed, signaling to the debater that the next word in the sequence will be mimed. The debaters should be aware that the words would be in the V.A.N. order.

F. When the word is guessed by an opponent, the debater who did not guess the correct word should start the next sequence by using that word in a sentence. For example, if the verb is walking, and it was guessed by the previous debater, the next debater should start her next turn with a phrase such as, "As someone opposed to the act of walking, I would like to outline my rationale against this dangerous act." This lets the mimes know that she has got the verb and is now guessing the adjective.

G. If the word is difficult, the mimes can use the symbols of charades such as number of syllables and "sounds like." The debater should find a way to say some of these

things in the debate so that the mimes know their symbols have been understood.

H. The game is done when one debater has guessed the noun. This person should then repeat what she is for or against to end the game. "And finally, I feel that walking angry bananas will end society as we know it," or some other outlandish debate platitude that will serve as the last line of the game.

Pitfalls: This can be a complicated game, and if it is not explained clearly to the audience, they can get lost or bored with the action. More importantly, all the players need to be clear on the details of the game. Once this is clear, the game should run quite smoothly.

The biggest problem with this game occurs when the actors who are guessing drop the guise of the debate and simply play charades. The game should be rehearsed and coached to keep the debate going strong. If the mimes are hopelessly out of ideas, other members of the team can jump in and join them. Better yet, the mimes should strategize quietly during their 30 seconds "off" about ideas that will help them explain the next word. Good communication between the actors playing mimes is a key to the game. If each mime does something different to explain the same word, the debater inevitably gets confused and the game suffers.

Don't panic if the debate takes a long time—part of the fun with this is to watch the suffering of the debaters as they struggle for a word. The payoff for a particularly difficult word can be huge, as the longer the word takes to guess, the greater the cheer when it is finally stated.

Questions

Category: Short form verbal restriction game

Player Level: Intermediate to advanced

Hook: Actors conduct an improvised scene in which all the lines are phrased as questions.

Players: Two players

Time: 2 to 5 minutes

Suggestion from Audience: A relationship, or an objective

Particulars: A. The actors get a suggestion from the audience. A relationship of some sort is a good way to start, but getting an objective, or something to accomplish can also be useful, as it can give beginning improvisers focus for their scene. The suggestion can be narrowed further with something to accomplish in the home, or something to accomplish on vacation or during the holidays, depending on the time of year.

B. The actors begin an improvised scene, but phrase all the lines as questions.

C. If the game does not come to a natural conclusion, after about three or four minutes, the actors, other team members or the technician find a good ending line and end the scene. This can be accomplished with a black-out or a designated other team member stepping onto the playing area and saying "and scene…" or some other ending phrase.

Pitfalls: This is a simple game to learn but because it is so dependent on the creation of the scene, this is actually a better game for advanced players. Beginning players either get stuck and forget to respond in a question, or quickly turn the game into a fight by responding in a confrontational manner "Why are you asking me?" It's not to say an argument cannot ensue in this game, but if the scene quickly turns to a fight on line two, it tends to top out quickly as it has nowhere further to go. Avoid this pitfall by practicing the game before performing it and encouraging players who do not do well with it the first time to try again. Coach actors to further the scene as well as pose questions.

This is the type of game that some people feel they "just aren't good at" perhaps because they didn't do well the first time. One way to rehearse this game is to use the format of Team Alphabet, where, when an error is made or a team member is too slow on the uptake, an actor is replaced by another waiting in line. Be careful, though, if using that format, of forsaking a fast-paced energy for building a scene.

For some reason, audience members forgive a stumped player in Alphabet more readily than they do in questions. Perhaps that's because Alphabet tends to produce more interesting scenes about the occupation or objective of the players and questions tends to move into high-pitched arguments very quickly. Practice playing questions without arguing, or if an argument is unavoidable, aim for passive aggressive conflict rather than a shouting match.

Story Genre/Literary Genre

Category: Short form group elimination game

Player Level: Easy to moderate

Hook: Actors must tell a cohesive story while cross-fading into different genres without repeating transition words or floundering with the story. Actors must flavor their segment of the story with a genre supplied by the audience.

Players: Five or more players (can accommodate up to ten to twelve before it becomes unwieldy) plus one director

Time: 5 to 10 minutes

Suggestion from Audience: A fictional title for the story and a different genre for each player

Particulars: A. The director explains the team will be playing an elimination game to the audience. Whenever a player falters by not making sense, being slow on the pick up, or repeating a word, that player is eliminated.

 B. The actors ask the audience, one by one, for a genre. Actors can be creative with this, either asking for a genre and taking what comes, or being more specific by asking for a type of mystery or a popular author. The actors shouldn't ask for anything they are not familiar enough to perform.

 C. Once every player has a genre, the director asks for a made-up title for the story.

 D. The actors arrange themselves in a semi circle around the director, who might kneel or sit on the floor. The director points to an actor and the story begins. The actors should infuse their segment of the story with their style of genre.

 E. When an actor makes a mistake, the director eliminates that person. The audience can be called on to help with eliminations by yelling "out" when they hear a falter.

 F. The director can speed up the action by pointing rapid fire from one actor to another in hopes of tripping one of the actors.

 G. When only one actor remains, the game ends and that person is declared the victor.

Pitfalls: This game can take forever if the director isn't savvy about switching the story from actor to actor or willing to eliminate people. Actors should practice this game by focusing on telling a cohesive story flavored by their genre. Often a genre takes over a segment of a story, making the plotline secondary to the style.

Talk and Touch

Category: Short form verbal and physical restriction game

Player Level: Intermediate to advanced

Hook: Whenever a character speaks, that actor must touch one of the other characters. The objective then becomes to justify touching others while carrying on a scene.

Players: Three players

Time: 2 to 3 minutes

Suggestion from Audience: A location that fits on the stage, an objective, or an occupation

Particulars: A. An actor or emcee gets a location from the audience. The actors begin a scene, but whoever is talking must find a justification to touch one of the other characters. As the emcee is introducing the game, it can be useful for the actors to grab chairs and create acting "areas" that fit the suggestion given.

B. At some point, when the scene has progressed enough, one of the actors, a designated teammate or a technician will end the scene.

Pitfalls: Like Questions, this seemingly simple game can be difficult to watch on stage if the actors do not find a scene within the game and only play the physical comedy of talking while touching the other actors. Recycle the notes from Question as appropriate.

Variations: Sitting, Kneeling, Standing: like Talk and Touch, actors perform a scene, but at any given time, one actor must be standing, one sitting, and one kneeling. Whenever one moves, the others must find a reason to change their positions.

CRITIQUING PERFORMANCE IMPROVISATION IN THE CLASSROOM

Institutions of higher learning have become obsessed with assessment. That isn't all bad, but sometimes topics that are difficult to assess are abandoned for areas that make tidier graphs. If proof cannot be shown to the dean or the chair that this is a successful element of the program, if students are not provided with a way to assess their progress, it can feel like too much work to bother introducing something new. Improvisation is one of those things that seems particularly difficult to assess; if students are just making this up, and your goal is to free their imaginations and make them feel empowered to tap into their own creativity, how can you use a little chart to assess that? Here it is.

While it can be difficult to assess something that is made up in the moment, the rubric in figure 4 was developed to incorporate some of the rules and ideas covered in this study. This can be used for short form games, long form scenes, or sketch-based improv. Instructors should make it their own by adding the elements on which their classes or groups are working.

Instructors can give written feedback to students with this rubric, or simply use this chart as a guide when talking about an improvisation scene.

Improv Rubric					
Category/Type of Performance:	Excellent		Middling		Needs Work and Attention
	1	2	3	4	5
Acceptance—agreed to reality in the first moments and throughout					
Furthering the scene with Yes and					
Know your other— no strangers					
Avoiding questions— dumping scene on partner					
Avoiding jokes—going for funny over building a scene					
Justification—establish who/what; who/where					
Sharing the scene with your other					
Listening and building					
Establishing a physical reality					
Pursing a goal					
Comments					

Figure 4 Rubric for Responding to Improvisation in the Classroom

For some students only getting oral notes and immediately applying them can be deeply challenging. By giving students written feedback, the rubric gives actors with learning styles that require them to read and reflect on new material an opportunity to receive more than one form of feedback. This gives them a little more assistance while giving the instructor a platform for more uniform discussion. The rubric can also provide the instructor with a record of actor progress, which can be useful for grading, particularly if a student challenges a grade.

When scenes do not work at all, often one or more of the elements on this basic list have been neglected and the rubric can neatly identify what needs work. Often, it is useful to ask actors who have just completed a scene or a game to repeat the same scene or game (with small changes since they do not have a script) and focus this time on fixing the problem area. They

should be instructed to let the scene go in a different direction if that seems to be where it is headed.

At the same time, anyone who has taught an acting class and used any kind of rubric knows that, unless a chart is insanely detailed, a scene that accomplishes all the elements of a rubric with excellence can still, as a whole, fail to achieve *overall* excellence—maybe it's good, just not exactly *great*. Following the rubric is like following the rules of improvisation—they do not guarantee success. This rubric simply provides a platform to discuss some of the elements with which many beginners struggle. In improvisation, if the elements of the chart are in place and the scene is still not working, it usually lacks strong characters or a general topic/goal that is worthy of exploration. Actors may have made safe, uninteresting choices because they were afraid to break the rules, resulting in a tepid scene—not dreadful, but not great either. When using a rubric like this, it is important to point out its limitations to the group.

The rubric also provides a platform for praise when things go right. Sometimes when a scene works, it can be difficult to analyze it beyond simply praising it. "That's the way to do it," will certainly make the performers feel great about their abilities, but it doesn't give them, or the others watching, much useful information on how to replicate the success of a scene. Understanding what went right is just as important as understanding what went wrong. Chances are, when a scene goes extremely well, it has accomplished the elements of the rubric with excellence and perhaps tapped into something beyond the list on the sheet. It's not magic or muses, more likely it is strong character work and a sense of self on stage that can be nurtured in a regular acting class.

Be generous with your praise. Yes, yes. Academics suffer from grade inflation. Millennials have been told over and over again that they are "super special." No one wants to be the benign instructor who fears telling students when their work is poor. But improvisation is risky. It is easy for students to get discouraged and just say "I can't do improv." When something works, give it high marks. When someone does something correctly, point it out, hold it up, praise it! Students can learn though the demonstration of what is right from their peers' successes. No one wants to create diva monsters who think they can't do anything wrong, but this is challenging work, so celebrate the small successes.

Letting the students help discover what works and what doesn't work is perhaps the best teaching tool. You can tell them "here are the rules" but if you get them on stage doing improv and then talk about what worked and what didn't work, using the rules to frame the discussion, it makes a stronger impression. Better yet, let them lead the discussion. Encourage them to use the rubric and to ask themselves where they felt they did and did not do

well. Theatre educators have different ideas on how much students should give feedback to other students. If the culture of your classroom is such where peer critiques are frowned upon, then give the rubric to students and let them fill it in and talk about their own work individually. Journaling their reflections is another way to work on self-assessment with the rubric as a guide.

TRAINING IN AN ACADEMIC SETTING

Too often, improvisation is seen as something other than acting. The best improvisers are not stand-up comedians (which is not improvisation in the definition used by this study but a series of finely polished monologues performed with the audience serving as the scene partner), but actors who understand the importance of character work. Developing strong characters is the basis of good improvisation. What you *do* with those characters when you do not have a script is where the scene work comes into play. And the basis of good scene work comes from an understanding of the world in which we live. All the Stanislavski-based, Meisner-inspired, movement- and voice-orientated actor training an improviser can receive will only help with the creation of strong characters who reflect our world. Furthermore, exposure to and analysis of published scene work will help students of improvisation understand how performance dialogue should flow. Understanding different periods and styles will strengthen their range for future characters.

In short, good improvisers have to be well-rounded and smart. They need training in improvisation and acting, but also in the world in general. Understanding something about history, politics, psychology, literature, and art will only strengthen their abilities on stage. A liberal arts education (whether formal or informal) with actor training will serve an improviser well, providing performers with the tools they need to embrace the stage, and the knowledge they need to say something worth saying while on it.

Improvisation, like all the arts, gives the performers a platform to say something important to an audience willing to listen. Sometimes the important thing to say is simply that life shouldn't be taken too seriously—go ahead and be silly. Fair enough. But as we have seen in the examples throughout this book, connections can be made to bigger issues—in fact, the best comedies, the most enduring comedies of humanity do that. They comment on our world while entertaining. They can be domestic arguments of *The Grouch* or *The Odd Couple*, or they can tackle hypocrisy in religion like *Tartuffe*, or the never-ending battle of the sexes like *Lysistrata* or *Much Ado About Nothing*. Like these classic plays, improvisation has the ability

to comment on the human condition while entertaining. The improvisers most familiar with the human condition and the world in which we live have more material on which to draw and will, therefore, speak to a wider audience. Encourage students to study areas outside of their majors and to weave this information into stage work.

CREATING A IMPROVISATIONAL PERFORMANCE GROUP

By incorporating improvisation into a traditional acting course, hopefully, you have fostered a group of performers interested in creating a performance improv group. This group, however, can be expanded by including people beyond those who take an acting course. Improvisation has wide appeal, and players can appear from all disciplines, not just the theatre department.

It can seem like a fair amount of bother to be the force behind a performance improvisation group, especially if you do not plan to be part of the performance team and have other traditional shows you need to direct, design, or build. It is an investment worth the bother, however, as it can have long-term benefits for both your program and the students. Improvisation is one of the deeply marketable skills not often taught in academic settings. Thinking like an improviser gives students the ability to create their own work, write their own shows, and be ready for a life in the arts which, for most graduates, is not going to be playing Shakespeare, Ibsen, and Shaw in repertory (as nice as that might be). Learning to craft scenes, to think on one's feet, and to feel comfortable in front of an audience has endless applications within the broad world of performance and beyond.

For a theatre program, creating a performance improvisation group gives students another opportunity to perform in what is often a deeply competitive environment—especially in larger programs. Theatre administrators are often quick to support improv groups when they see the lack of money and resources needed for results. And for the smallest programs where staff might be small or nonexistent and faculty must teach everything from acting to design to theatre history whether trained in it or not, an improv group can eventually shift some of the department leadership to the students, relieving the burden on the faculty and creating a valuable educational opportunity for the students. In all types of schools, a performance improvisation troupe creates a sense of excitement for the theatre, and smart programs and departments will harness this excitement to make their programs stronger.

The following are tips learned through trial and error when creating a student-based improv team on campus:

1. Open the improv group to anyone interested when just beginning. Theatre groups tend to use an audition model when starting, but before you hold auditions, let a group develop by interest. Often you will have a large group to start, but expect it to melt. That's perfectly fine. Sometimes students want to have auditions right away—and that can work if you have a huge group, but if you are concerned about interest, then it is wiser to skip auditions altogether and let anyone who wants to play do so. Eventually, a team can build to auditions, which can be useful by making it an honor to be cast. Students who are cast should view it as a privilege and should be more likely to seriously commit to a performance group.

2. It can be useful for the longevity of the group to include people from different years of study as leaders, so when a leader graduates the team does not have to completely rebuild from scratch.

3. Pick a time to meet that works best for the students who are the most committed. One or two hours a week works best. Reserve a space. A classroom is fine—you do not need to use a performance space to rehearse. In some ways it's preferable to rehearse in a space not designed for performance as it forces the group to adapt to any playing area.

4. As the leader, rehearse with the students whenever possible for the first few sessions. Demonstrate games and forms as well as explain them.

5. After you have a core group, assign members to lead the rehearsal on a rotating schedule. They should be responsible for picking warm up games or teaching new ones, and perhaps teaching the group a new game they found on the Internet or in a book, or choosing an older game on which to work further.

6. When leaders emerge, explore becoming an official student group. This can provide the group with more benefits in the campus community. Sometimes student organizations have access to money that can be used to take the group to see other improv shows or to provide special training for the group. It might also help student organizations to know of the existence of a performance group on campus to tap for future events. Help your student leaders with any red tape involved in this process.

7. At rehearsals, let the leaders lead. Eventually, it should be less important for faculty to go to rehearsals. Once the leaders have established themselves, if faculty does attend rehearsal, they should rehearse, not watch.

8. Create a performance date, usually at the end of the semester or the year for a team just beginning. Rehearsing without performing gets dull quickly. A group gains focus quickly when they realize they have a show to do in a few weeks and they only know three performance games. A little friendly pressure can be a good thing but expect last minute results—it is improv after all. Do not overcommit to a packed performance schedule too quickly. One performance a month is a good goal to set for students groups so students have time for studies and other activities. But one performance a semester is a realistic goal when just beginning.

9. Unless the group feels strongly otherwise, start with a performance of short form games. If one game fails, it can be forgiven quickly. It is easy to put together a line up, and it provides variety and confidence boosting laughs. If the group is passionate about long form or writing their own materials, by all means, forge ahead. Supplementing those ideas with a few games can round out a show. A short form "act one" followed by a long form or sketch-based material creates a full length show. Shows that are just short form work well for about an hour's length.

10. Use the student organization services to your advantage. Don't just depend on word of mouth or the theatre people to make a show successful. Student offices are often looking for entertainment to round out their events calendars and a student group is a perfect fit because they are a homegrown attraction that highlight campus involvement (and don't cost their offices much, if anything).

11. If scheduling a performance space is a challenge, abandon tradition. If you cannot get the theatre, don't worry—use a lecture hall or a classroom. Generally, an improv show plays better if you have a full room, so when in doubt, pick a room with smaller seating capacity. Fifty people in a room that seats forty-five is a more exciting event than fifty people rattling around a large theatre that seats five hundred. Avoid the outdoors for performace.

12. When determining what to perform, let each performer add at least one favorite game to the schedule. Your goal is to make everyone look good, so let the players pick games they enjoy and feel confident playing.

13. Keep rehearsal professional. Demand that players attend in order to be allowed to perform. Demand that players be on time. For a group to be successful, players need to trust each other on stage and off, and understand each other's strengths and weaknesses. That develops through the rehearsal process.

14. For high schools, consider hiring a college student or recent college graduate with an interest in improvisation to lead a high school improv team. This creates an excellent opportunity for a college student to gain leadership experience, gives the student team a leader with more authority than a peer, and relieves some of the pressure on the overworked high school faculty.

CREATING A SHOW: THE ALL IMPORTANT PERFORMANCE SCHEDULE

Putting together an improvisation show is a simple thing in a lot of ways—there are not a lot of technical needs and no need for a long, technical rehearsal. Thinking of a show a bit like a concert can help when putting together the order of the scenes. A cover band that wants the audience to dance doesn't play five slow songs in a row. Likewise, when putting together a show, particularly a show featuring short form, variety is the key.

By way of example, imagine that an improv team with eight players has emerged. The team consists of two seniors, two juniors, two sophomores, and two freshmen. The upperclassmen have more experience, are stronger on stage, and have invested a great deal in the team, but the performance group was only begun two years. For example, let's say that the games described in this chapter are the short form games they want to perform in a show that is scheduled to last about 50 minutes. Figure 5 demonstrates an example of a show schedule for this fictitious team.

Time wise, eight games should be more than enough to fill a 50-minute to one-hour time slot. The games themselves can take longer than anticipated, especially guessing games. Plan on one to two minutes for introductions and each transition between games. Because this group is newer, the game Questions has been omitted. Questions and Talk and Touch are more difficult games, and for this short show, picking only one of those difficult games is a smart choice.

The schedule provides the players with a map for the performance. Giving each member a copy of the schedule before the show provides a reminder of what games they are performing and introducing, which helps enormously with the flow of the performance. For performances to move away from an amateurish style, transitions should be free of confusion. Players introducing the next game should confidently take the stage and enjoy explaining the game or fielding a suggestion. A form like this is a great tool to help create that flow.

The order of the games here is not haphazardly arranged. Note that the show begins and ends with a group game. The second game is a high

Improv Team: Spring Fling Performance									
	Cass Year:	Sr	Sr	Jr	Jr	So	So	Fr	Fr
Game	Ask for	Joshua	Pria	DeShawn	Madison	Samantha	Larry	Isabelle	Oliver
Freeze	Location	X	x	x	x	x	x	x	x
ESPN	Household chore		x	X	x		s		
Alphabet	Relationship and letter	x				X			
Mime Debate	VAN	db	S	db			x	x	x
Dr. K.I.A.	Questions			x	S	x		x	x
Blind Date	Two people and date place		x					x	I
Talk and Touch	Occupation	x	x		x				I
Story Genre	Genres for story	x	x	x	x	x	S	x	x

x = play the game
X = introduce and play
s = special role
S = introduce and special role
I = introduce
db = debaters

Figure 5 Show Schedule Example 1

energy, physical game that keeps the momentum going after a game of Freeze. It is followed by a small, two-person scene that isn't usually as physical as ESPN. The two guessing games, Mime Debate and Blind Date do not follow each other. They are broken up with the verbal restriction game, Dr. Know It All. Talk and Touch, the most difficult of the games in line up, is put toward the end but not dead last. The line up ends with an elimination game, providing the opportunity for the group to declare a winner of the scene and end the show in one swoop. Certainly, there is more than one way to arrange a show with these games with great success, but some arrangements lead to less success than others. Putting similar games back to back creates a sense of fatigue in a short form audience—variety is the key. Categories of games but also size of games should be considered—a long string of two person games does not keep the energy high for the performance. It's also wise to put a game in which the groups excels early

in the line up, and save another highly successful game the group enjoys for the last slot.

Note also that players have similar numbers of games that they play. Frustrations on teams can build when newer players only perform once or twice and more advanced players seem to grab all the stage time. Giving players an opportunity to pick games they enjoy is a good way to build ensemble within a group. But this needs to be balanced with the reality that some members are going to be more skilled and confident than others. In this example, the freshmen Isabelle and Oliver are in the group scenes and play an equal number of scenes as the other players, but are in games that are easier. They will both be part of the ensemble of Dr. Know It All and will play mimes in Mime Debate. Hopefully, the success they build there will boost their confidence levels and strengthen their skills on stage, which will give them the opportunity to play different kinds of games next time. In this fictitious scenario, Pria has one more thing to do than the rest of her peers, but she is a senior and her extra task is to introduce Mime Debate and serve as the timer. Putting together a schedule like this is a balance between creating fair play time and matching experience and talent to the right game. Poor schedules with unfair or poorly thought out performance assignments can quickly lead to bitter feelings and dissention in a team, sometimes destroying a performance group entirely.

Some games lend themselves to an introduction by the players, some do not. Guessing games are difficult for the participants to introduce for obvious reasons. In the chart, Alphabet is introduced by a player, while Talk and Touch is introduced by Oliver. It would be perfectly fine for one of the team members playing Talk and Touch to introduce the game, but that would mean Oliver wouldn't introduce any games. Since this game's introduction can be done by anyone, in this case it is given to Oliver to round out the introduction schedule fairly.

The most important thing about a schedule is that the group understands the flow of the show. If the group doesn't need to have "ask for" on the schedule, omit it. If the group would benefit by adding more information to a game like ESPN—assigning reporter, booth members, and the athlete, then do that. Craft a schedule that suits the needs and strengths of your group.

Using this same example, it would be easy to modify for a 90- to 100-minute show that includes the long form La Ronde as the second act, as shown in figure 6.

Here, the team plays a regular short form improv set for the first half of the show, and adds La Ronde, the daisy chain long form described in chapter 3, as the second half of their show. It would be a fairly easy jump to play La Ronde as the first half of a show and then improvise scenes based

Improv Team: Improv Night in the Theatre									
	Class Year:	Sr	Sr	Jr	Jr	So	So	Fr	Fr
Game	**Ask for**	Joshua	Pria	DeShawn	Madison	Samantha	Larry	Isabelle	Oliver
Freeze	Location	X	x	x	x	x	x	x	x
ESPN	Household chore		x	X	x		s		
Alphabet	Relationship and letter	x				X			
Mime Debate	VAN	db	S	db		x	x	x	x
Dr. K.I.A.	Questions			x	S	x		x	x
Blind Date	Two people and date place		x				x	I	
Talk and Touch	Occupation	x	x		x				I
Story Genre	Genres for story	x	x	x	x	x	S	x	x
Intermission									
La Ronde	Topic	x	x	X	x	x	x	x	x

x = play the game
X = introduce and play
s = special role
S = introduce and special role
I = introduce
db = debaters

Figure 6 Show Schedule Example 2

on the characters created in that form for the second half of the show, also explained in chapter 3.

Overall, creating a schedule takes as much time and thought as the performance itself, especially for beginning teams. Plan at least an hour to craft a solid schedule for the first time, knowing it will be easier, and take less time the more practice it is given.

WORKS CITED

"Alamo Basement." http://www.alamobasement.com accessed 20 July 2005.

Aristotle. *Poetics. Dramatic Theory and Criticism: Greeks to Grotowski.* Ed. Bernard F. Dukore. Fort Worth, Texas: Holt, Rinehart and Winston, Inc., 1974.

Bernard, Jill. "An Interview with Colin Mochrie." Yesand.com. http://www.yesand.com/news/cif2002/postCIF/mochrie.html accessed 10 June 2002.

Bieber, Margarete. *The History of the Greek and Roman Theater.* Princeton, New Jersey: Princeton University Press, 1961.

Charbeneau, Chuck. Personal interview. 24 May 2001.

Coleman, Janet. *The Compass.* New York: Knopf, 1990.

"Comedysportz—History." http://www.comedysportz.com/history.htm accessed 16 June 2001.

Dinneen, Noel. "11 Questions with...Brave New Workshop." *Performink Stories.* http://www.performink.com/Archives/improv/Bravenewworkshop1110.htm accessed 2 June 2003.

Duchartre, Pierre Louis. *The Italian Comedy.* Trans. Randolph T. Weaver. New York: Dover Publications, Inc., 1966.

Edwartowski, Margaret Exner. Personal interview. 13 March 2001 and 28 June 2001.

Foreman, Kathleen and Clem Martini. *Something Like a Drug: An Unauthorized Oral History of Theatresports.* Studio City, CA: Empire Publishing Service, 1996.

Frost, Anthony and Ralph Yarrow. *Improvisation in Drama (New Directions in Theatre).* Hampshire, England: Palgrave Macmillan, 1990.

Fuzzyco.com the New Improv Page. "Improv Groups." http://fuzzyco.com/improv/groups-canada.html#Canada accessed 12 August 2007.

Goldberg, Andy. *Improv Comedy.* Hollywood: Samuel French Trade, 1991. Reprinted from Improv Comedy by Andy Goldberg, published by Samuel French Trade, © 1991.

Halpern, Charna. Personal interview. 9 July 2001.

Halpern, Charna, Del Close, and Kim "Howard" Johnson. *Truth in Comedy: The Manual for Improvisation.* Colorado Springs: Meriwether Publishing Ltd., 1994.

Hayden, Nancy. Personal interview. 7 May 2001.

Highfield, Clifton. Personal interview. 23 May 2001.

Janes, Joe. Personal interview. 9 April 2001.

Johnson, Cherri. Personal interview. 24 April 2001.

Johnson, Corrine Sue. "Dudley Riggs' Brave New Workshop: A Model for Improvisation Pedagogy." Diss. University of Oregon, 1989.

Johnstone, Keith. *Impro.* New York: Theatre Arts Books, 1979.

———. *Impro for Storytellers.* New York: Routledge/Theatre Arts Books, 1994.

Key, Keegan-Michael. Personal interview. 12 March 2001.

Kinugawa, Yuri. "Yuri Kinugawa of Yellow Man Group." *Improv Review.* Ed. Jeff Catanese and William McEvoy. http://www.improvreview.com accessed 13 June 2001.

Klein, Robert, narr. *The Second City, Two Audio CDs.* Compact disks. Book by Sheldon Patinkin, *The Second City: Back Stage at the World's Greatest Comedy Theatre.* Napperville, Illinois; Source Books, Inc., 2000.

Kozlowski, Rob. *The Art of Chicago Improv: Short Cuts to Long-Form Improvisation.* Portsmouth, New Hampshire: Heinemann, 2002.

Langguth, Rebecca. "Everything You Wanted to Know About Long Form Improvisation but Were Afraid to Ask." Yesand.com. http://www.yesand.com/features/archives/kozlowski.html accessed 24 March 2002.

Libera, Anne, et al. *The Second City, Almanac of Improvisation.* Evanston, Illinois: Northwestern University Press, 2004.

Los Angeles Theatresports Home Page. http://www.theatresports.com/carnalpeaks.shtml accessed 10 July 2002.

Madson, Patricia Ryan. *Improv Wisdom: Don't Prepare, Just Show Up.* New York: Bell Tower, 2005.

McKay, Anton. Personal interview. 1 May 2001.

McEvoy, William. "Three on a Match." *Improv Review* Ed. Jeff Catanese and William McEvoy. http://www.improvreview.com/Chicago/skl.htm accessed 29 June 2001.

———. "Whose Live Is It Anyway?" *Improv Review* Ed. Jeff Catanese and William McEvoy. http://www.improvreview.com/current_issue/Chicago/whoseline.htm accessed 29 June 2001.

Moore, Sonia. *The Stanislavski System.* 2nd rev. ed. London: Penguin Books, 1960.

Nance, Wendy. Personal interview. 24 April 2001.

Napier, Mick. *Improvise: Scene from the Inside Out.* Portsmouth, New Hampshire: Heinemann, 2004.

———. "Second City Mainstage." *The Second City Online Journal.* 30 Nov 1996–27 Feb 1997. 24 entries. http://www.annoyanceproductions.com/mainstage.html accessed 26 June 2003.

Patinkin, Sheldon. *The Second City: Back Stage at the World's Greatest Comedy Theater.* Naperville, Illinois: Sourcebooks, Inc., 2000.

Pierse, Lyn. *Theatresports Downunder.* 2nd ed. Syndey: Improcorp Australia Pty Ltd, 1995.

RCI: Leah Carpenter, Michele (Boonstra) Dykstra, Todd Herring, Tracey Kooy, Wendy Nance, Russ Roozeboom, Rick Treur, Joel Veenstra, Marty Wondergem. River City Improv group personal interview. 22 May 2001.

Roozeboom, Russell. Personal interview. 23 Apr 2001.

Rydberg, Pete. Personal interview. 10 August 2005.

Sahlins, Bernard. *Days and Nights at the Second City: A Memoir; with Notes on Staging Review Theatre*. Chicago: Ivan R. Dee, 2001.

Seham, Amy E. *Whose Improv Is It Anyway? Beyond Second City*. Jackson, Mississippi: University Press of Mississippi, 2001.

Shakespeare, William. *As You Like It*. Ed. Helge Kokertz and Charles T. Prouty. New Haven: Yale University Press, 1954.

Shapiro, Milo. "Freeze Tag Audition." IMPROVentures.com. improventures.com/stories/freeze-tag-audition.htm accessed 8 June 2001.

Smith, Hazel, and Roger Dean. *Improvisation, Hypermedia and the Arts since 1945*. Amsterdam: Harwood Academic Publishers, 1997.

Spolin, Viola. *Improvisation for the Theatre*. Evanston, Illinois: Northwestern University Press, 1963.

———. *Theater Games for the Classroom: A Teacher's Handbook*. Evanston, Illinois: Northwestern University Press, 1986.

Stanislavsky, Konstantin. *On the Art of the Stage*. 2nd ed. London: Faber and Faber, 1967.

Sweeney, John. *Innovation at the Speed of Laughter: 8 Secrets to World Class Idea Generation*. Minneapolis, Minnesota: Aerialist Press, 2005.

———. Personal interview. 10 September 2003.

Sweet, Jeffrey. *Something Wonderful Right Away*. New York: Avon Books, 1978.

Tollenaere, Tom. "Show Formats" *Improvland*. http://www.theatresports.com/articles/showformats.html accessed 10 June 2001.

"24 Hour Plays." http://www.24hourplays.com accessed 15 July 2005.

VandenHeuvel, Kiff. Personal interview. 24 April 2001.

Varnado, Victor. "A Funny Thing About Improv." *Yesand*. http://www.yesand.com/features/archives/formreform.html accessed 10 November 1999.

Watson, Jack, and Grant McKernie. *A Cultural History of Theatre*. New York: Longmans Publishing Group, 1993.

West, Ron. Personal interview. 26 June 2001 and 2 May 2001.

"Whose Line Is It Anyway?" http:abc.go.com/primetime/whoseline/about.html accessed 5 June 2001.

Yesand.com. "Improv Group Lists." http://www.fuzzyco.com/improv/groups-usa.html#MN accessed 2 July 2007.

WORKS CITED









Smith, Hazel, and Roger Dean. *Improvisation, Hypermedia and the Arts since 1945*. Amsterdam: Harwood Academic Publishers, 1997.



———. *Theater Games for the Classroom: A Teacher's Handbook*. Evanston, Illinois: Northwestern University Press, 1986.

























CREDITS

INDEX